Liquid Iguana Studios Presents

FREAKSHOW

By Joslin Edinger

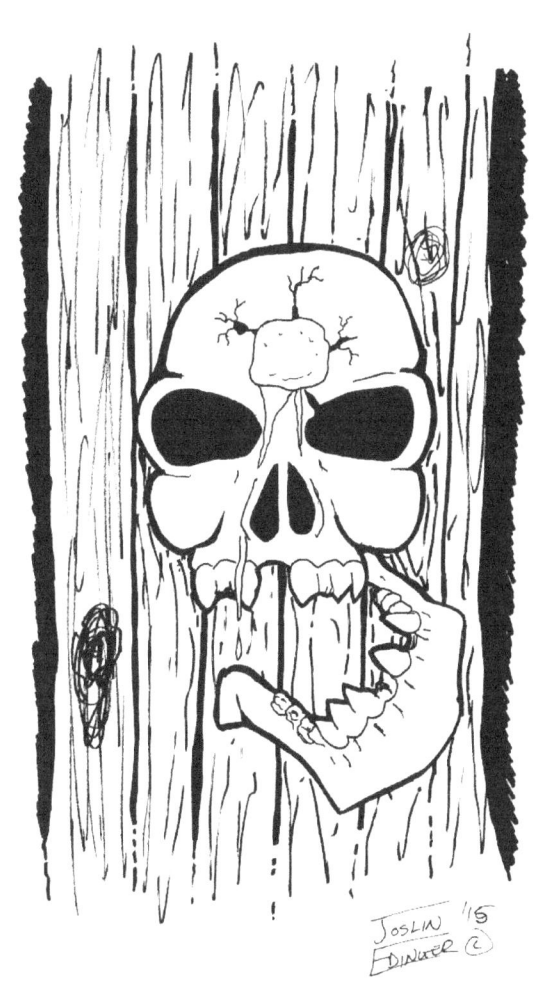

I've been drawn to creating as long as I can remember. I have been drawing virtually since I could hold a pencil. Art was one of my favorite classes in school. My talent was nurtured by school (accentuating the need for art in schools) and family.

My grandmother was the person who initially taught me how to paint. She was a very talented artist. I learned more throughout high school and college. It was like I could not absorb enough about different artists or techniques.

When I was about 15 years old I came up with the name Liquid Iguana Studios.

I studied art in college and got my associates degree. After I graduated I became a scenic artist. I thought I had finally found my place.

Unfortunately, the scenic industry was very volatile. I had other responsibilities and pushed my dreams aside. After family and pursuing other degrees, I lost focus.

Fortunately, the burning ember was always there. I may have forgotten my art talent but it didn't forget about me. I have been working on this ever since.

www.liquidiguanastudios.com

Welcome to the Freakshow!

Freakshow is a collection of horror-based artwork. This is all my original artwork designed to create an awesome journey!

Feel free to make these pages your own. Color them however you envision. Most importantly have fun!

I created Freakshow to create a unique coloring book from anything out there. Thank you for taking this journey.

Check out more artwork at our website www,liquidiguanastudios.com!

Thank you again,

Joslin Edinger
Lead Artist/CEO
Liquid Iguana Studios

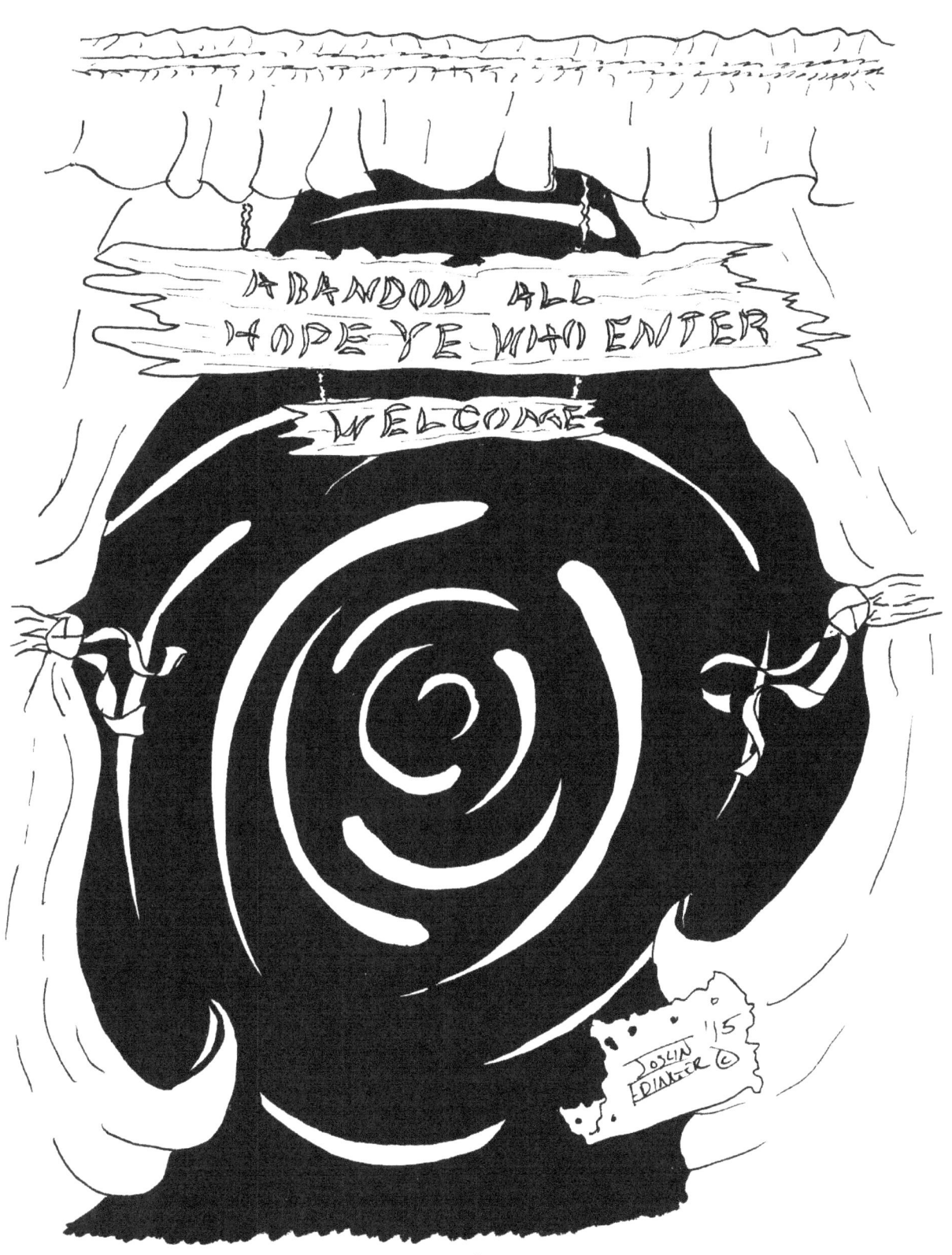

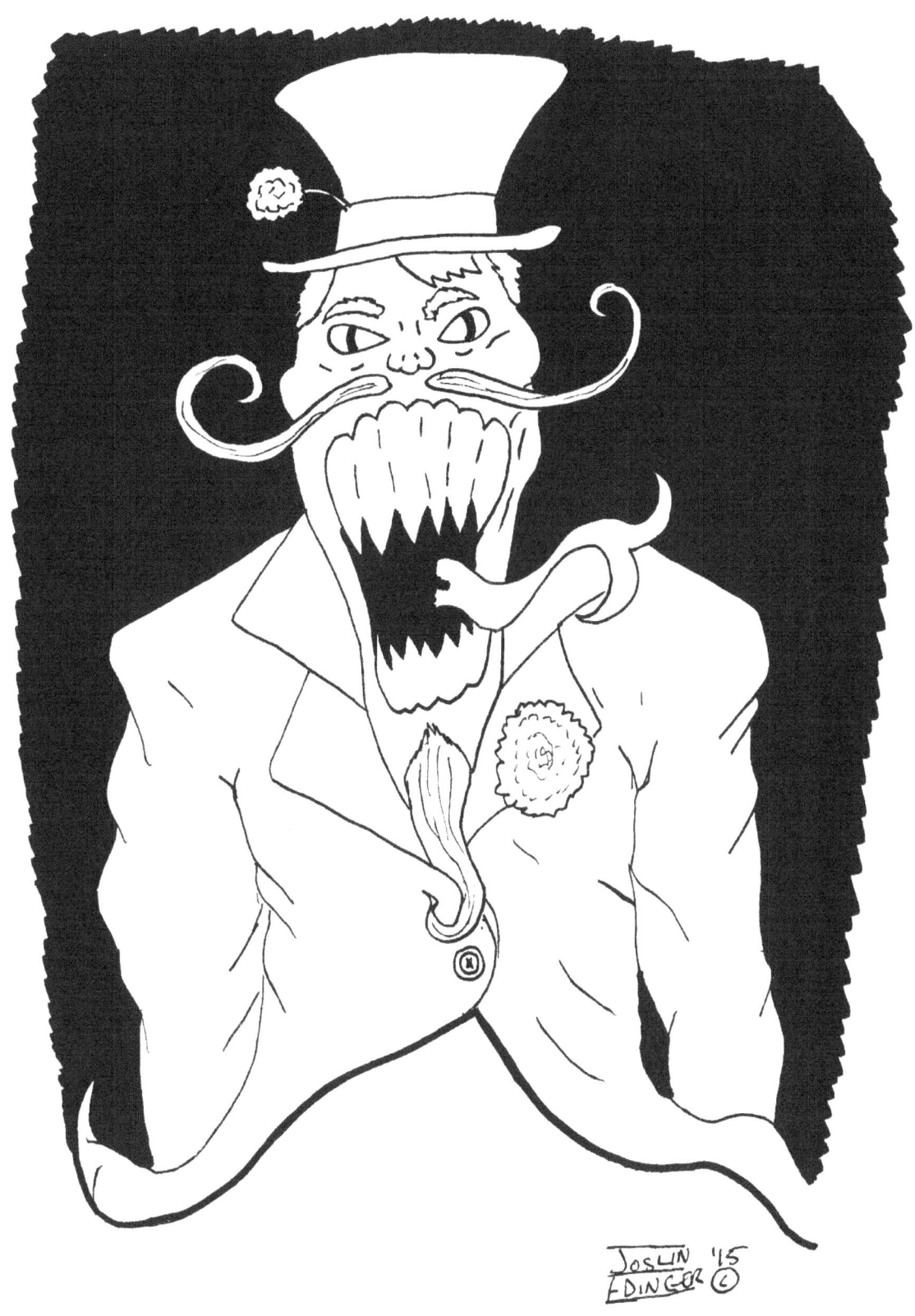

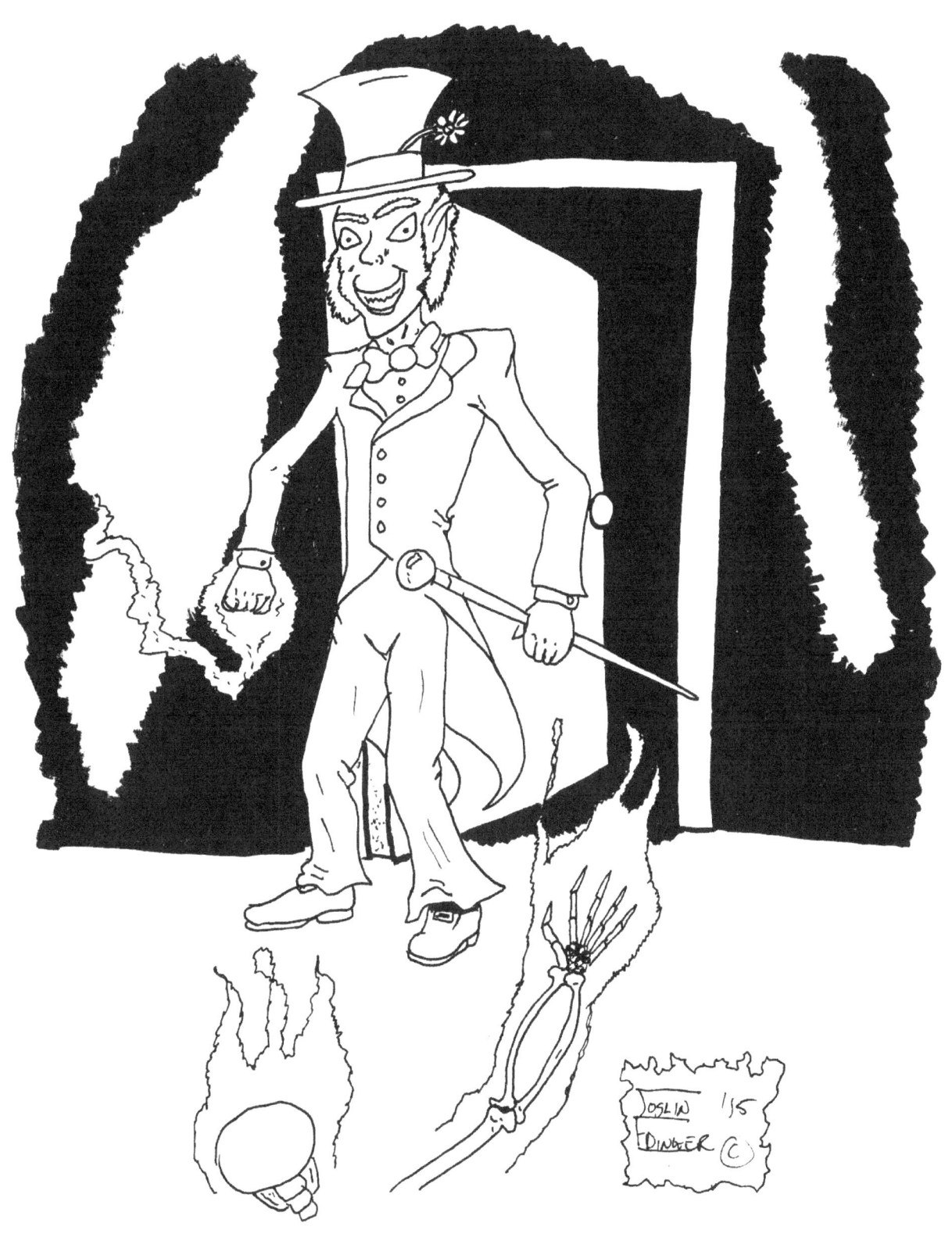

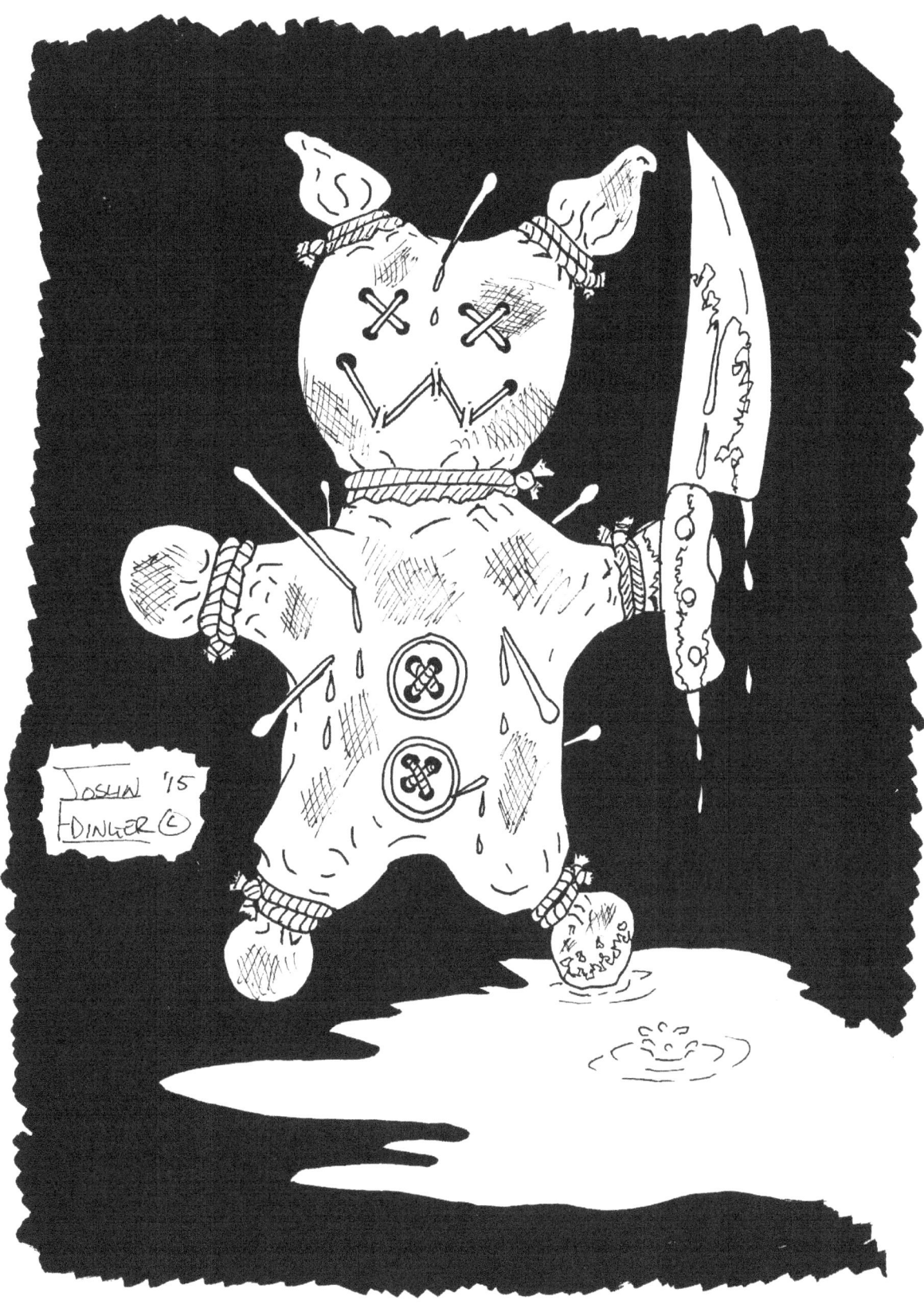

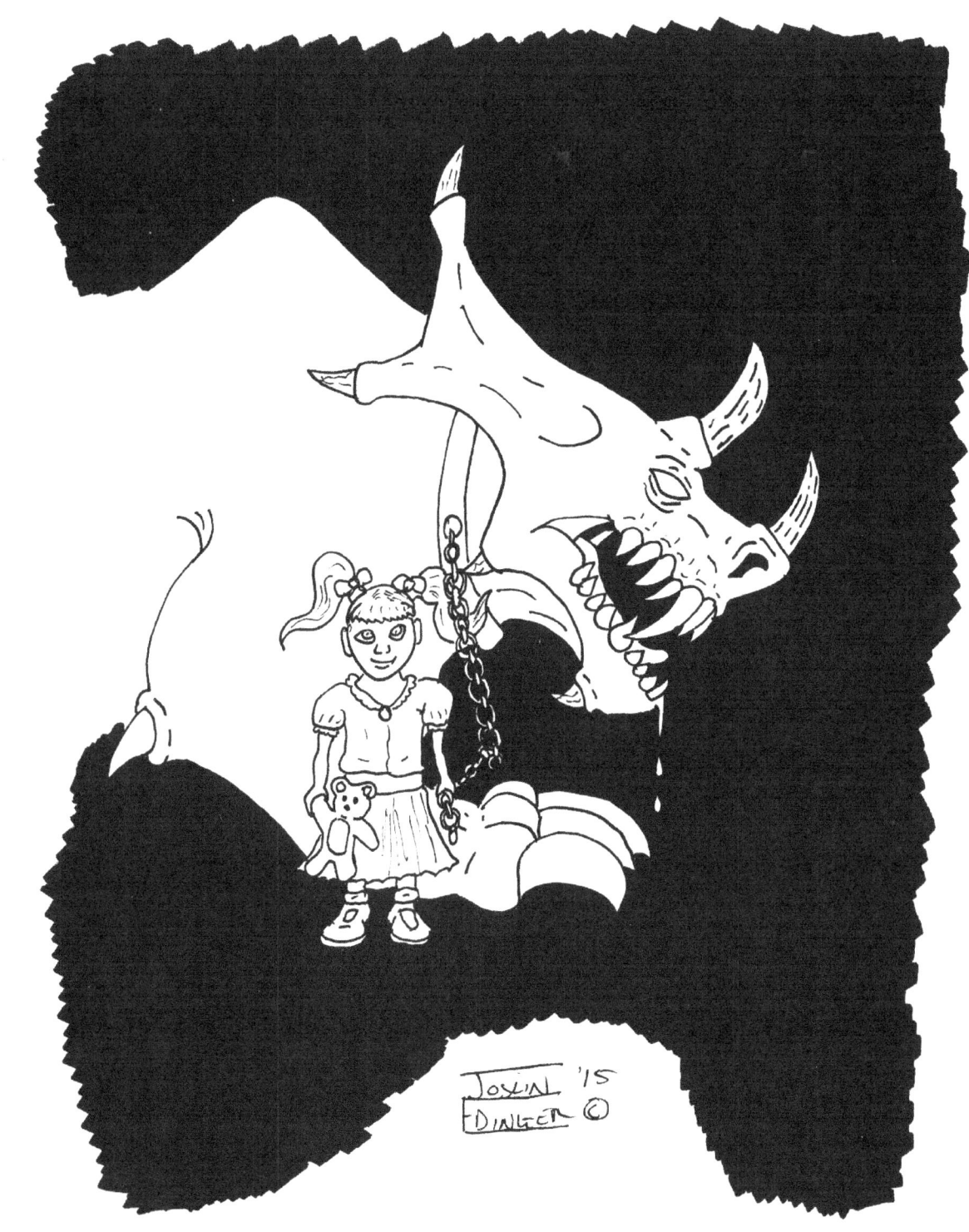

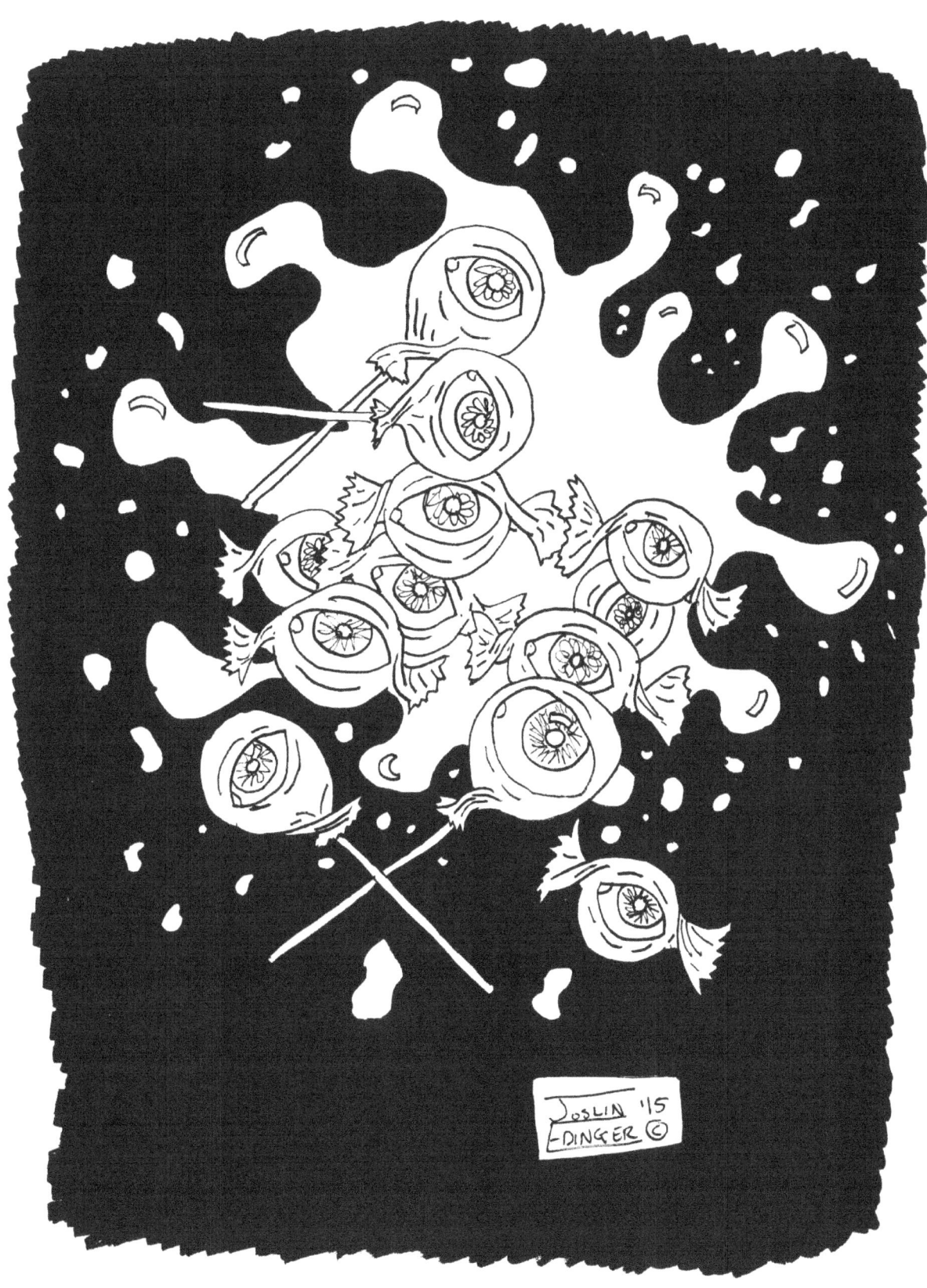

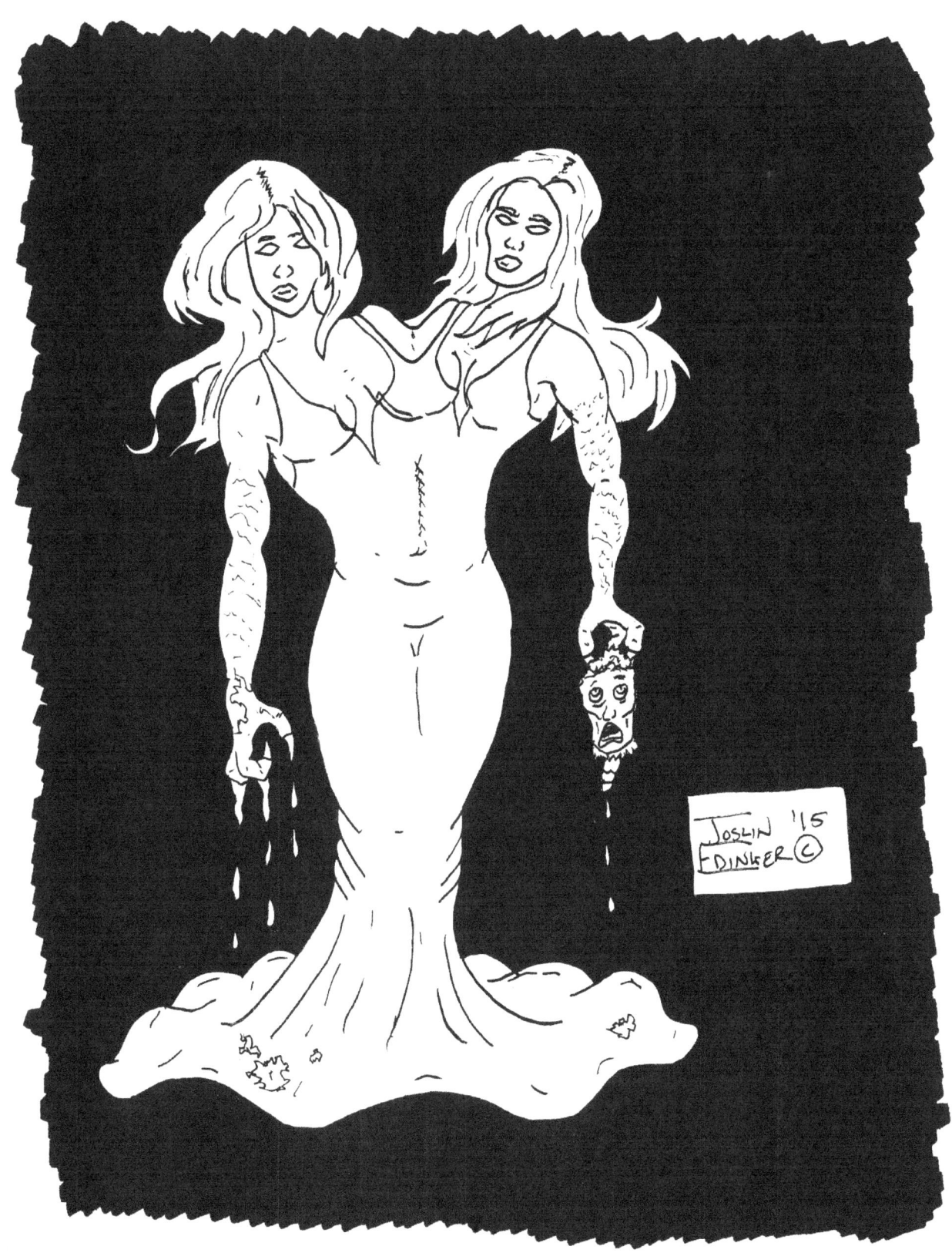

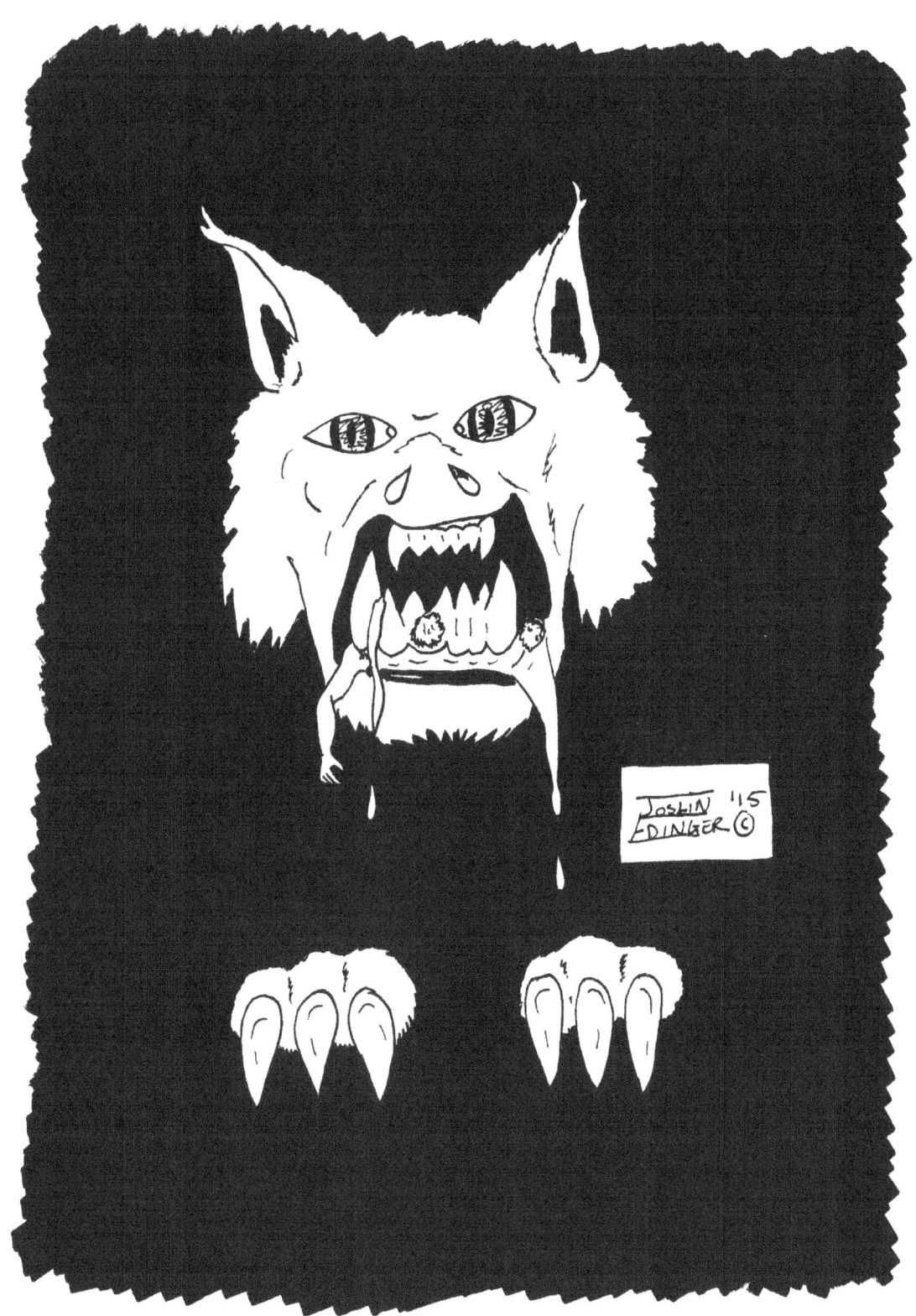

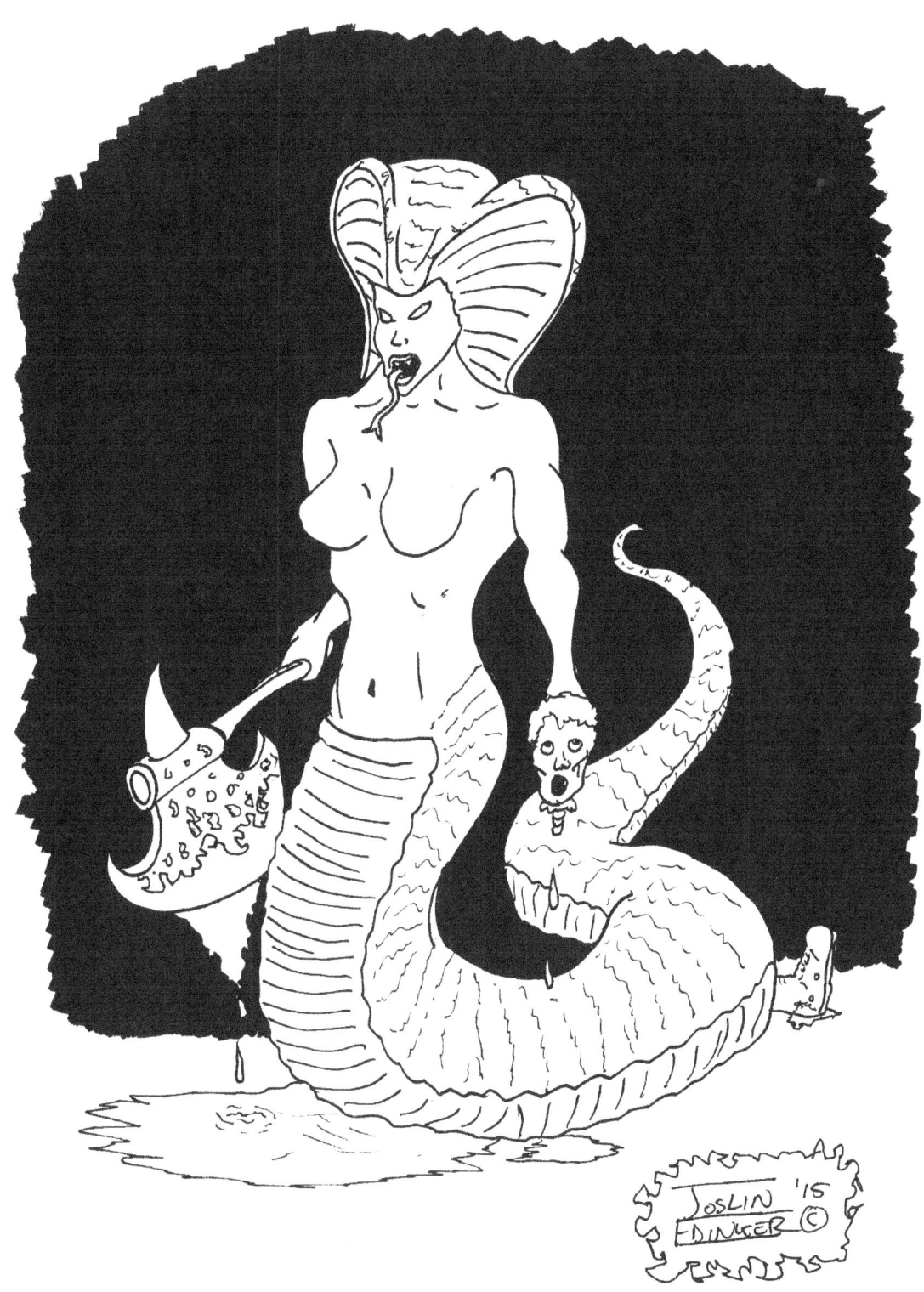

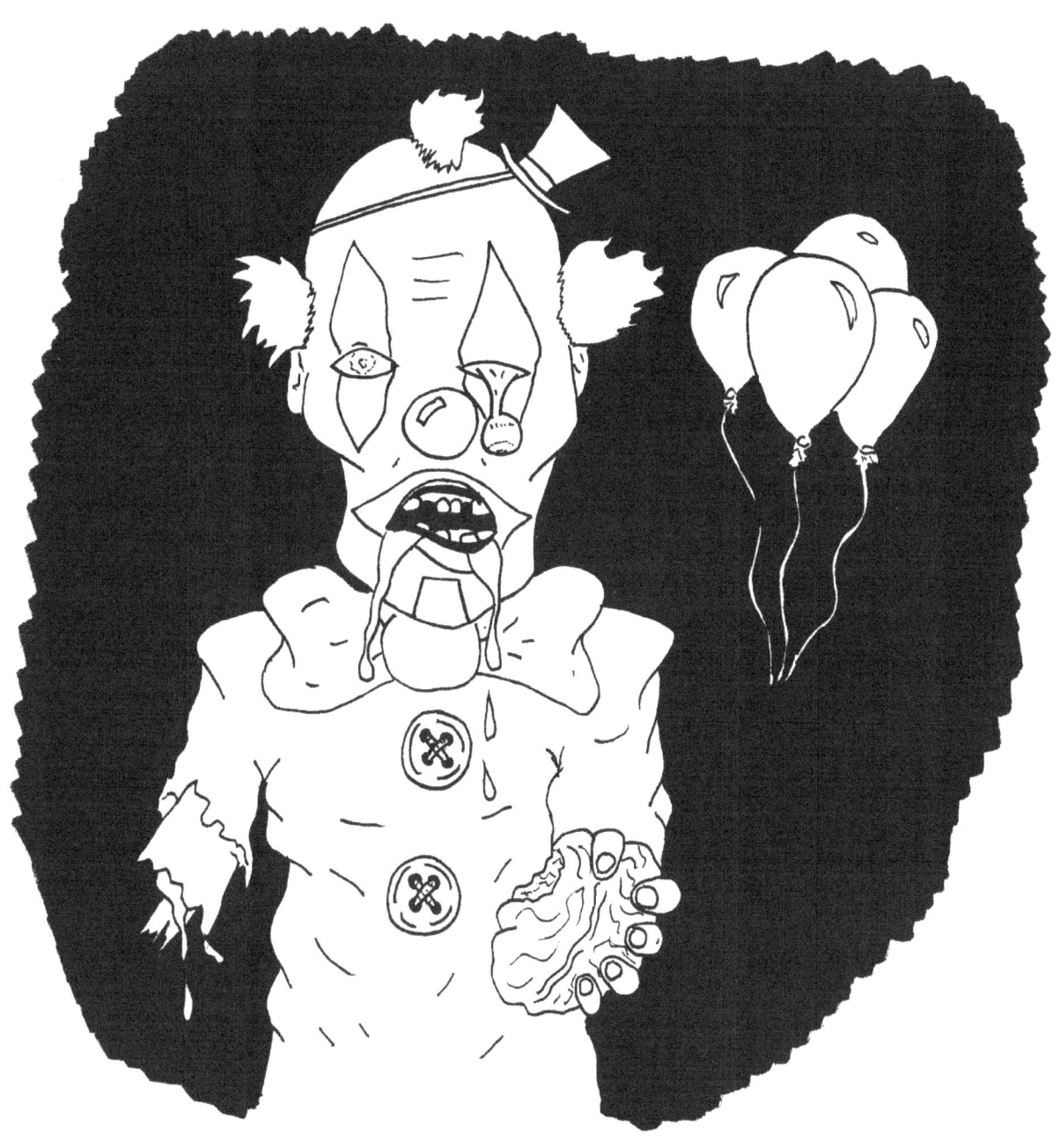

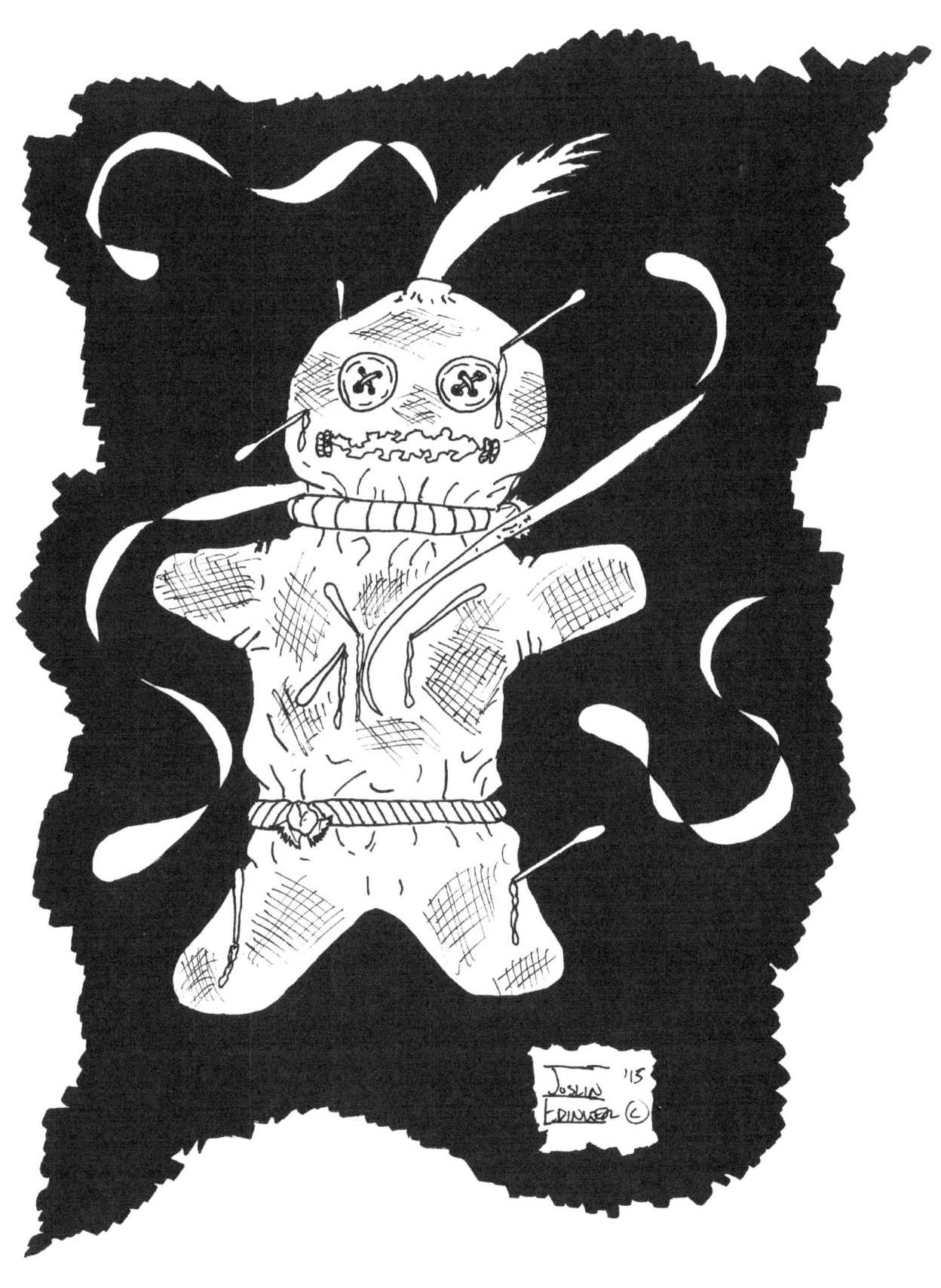

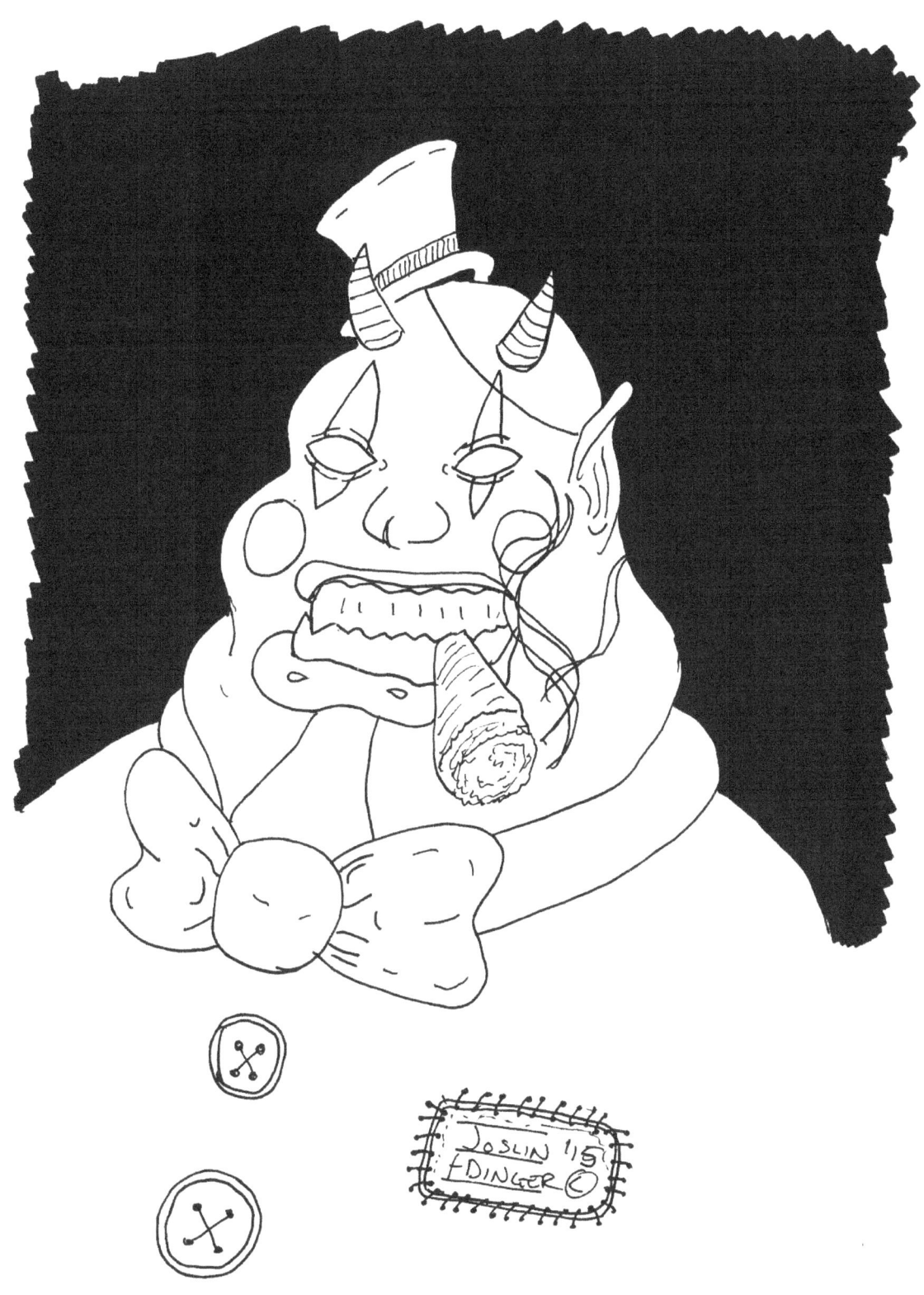

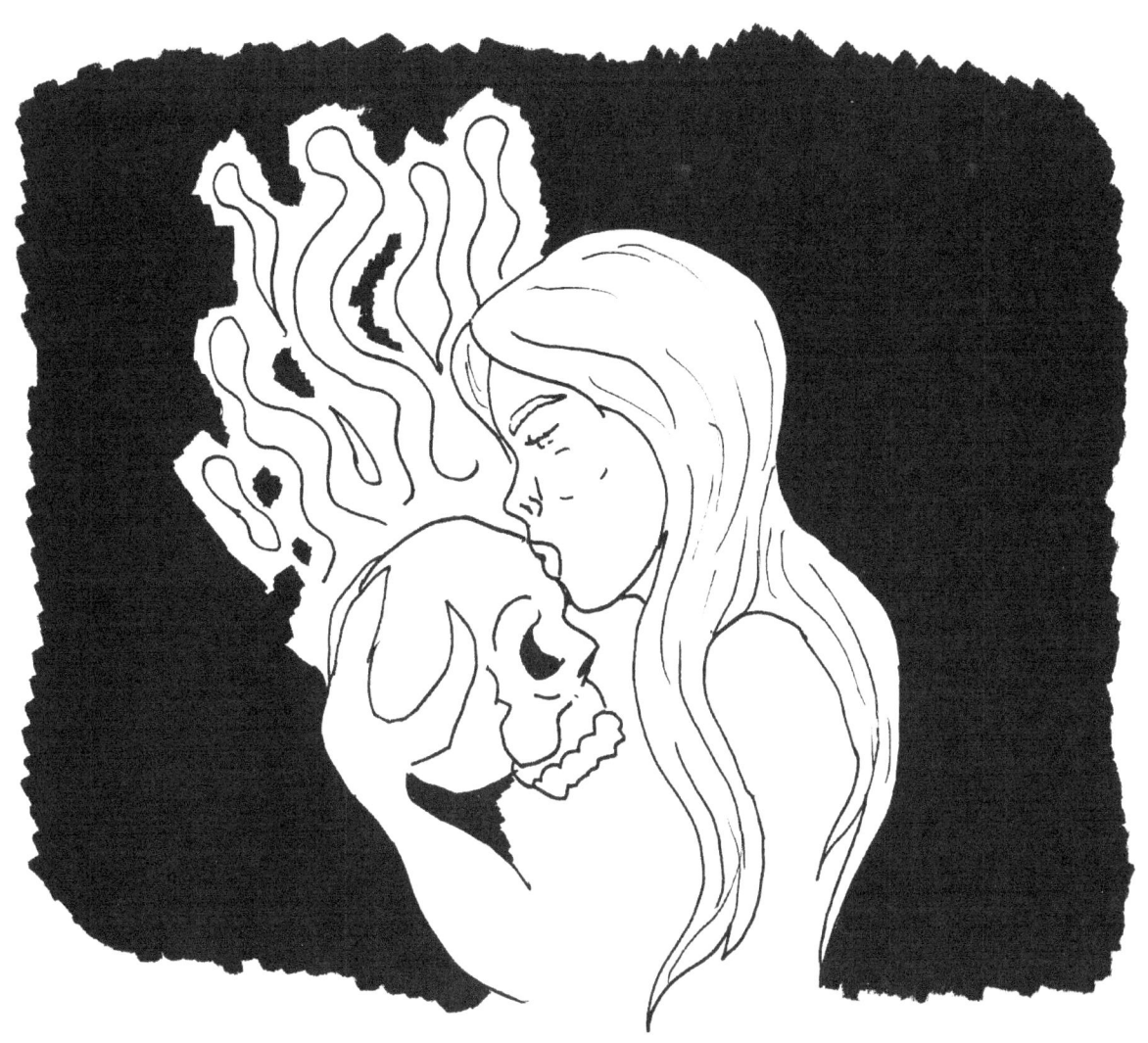

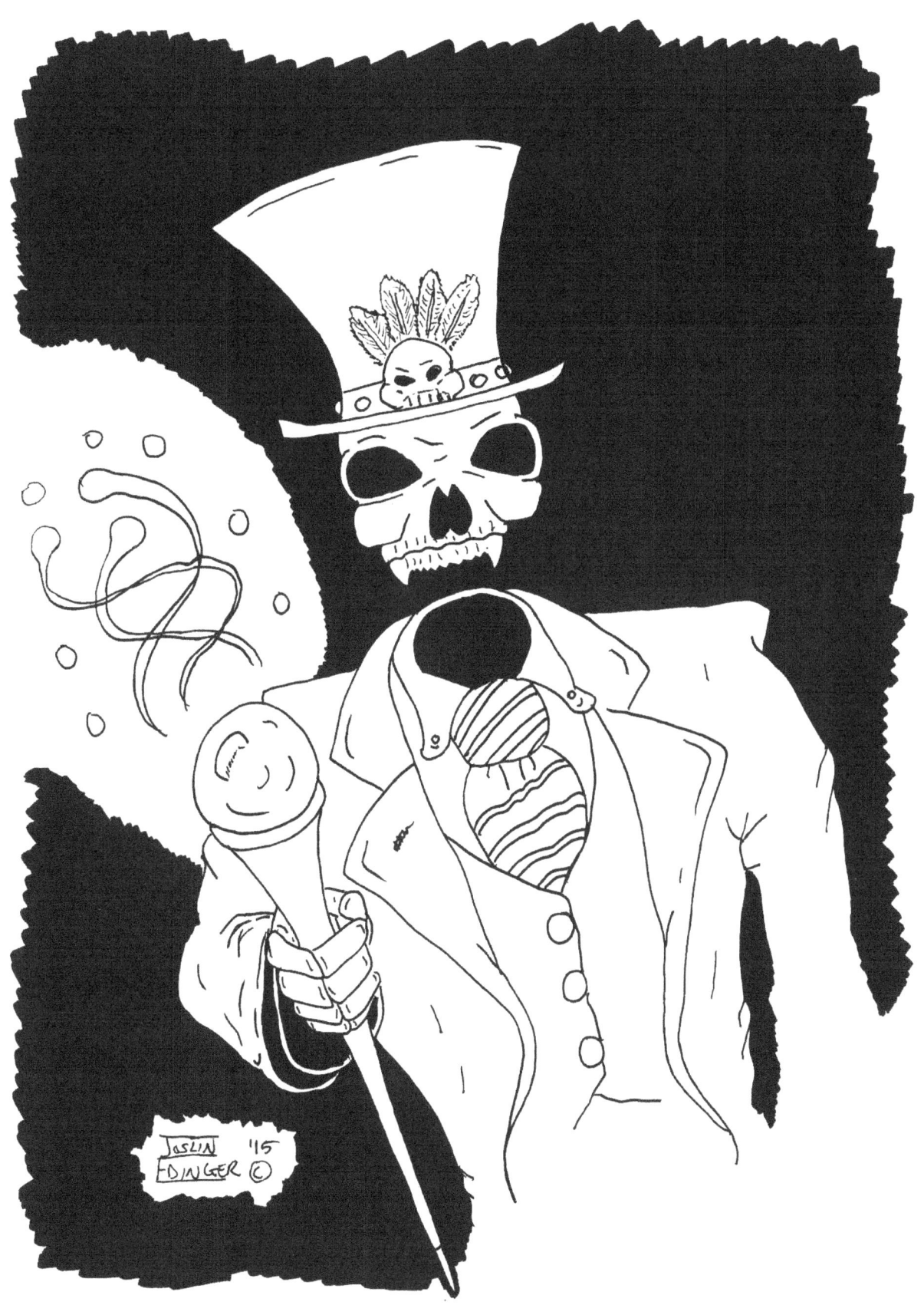

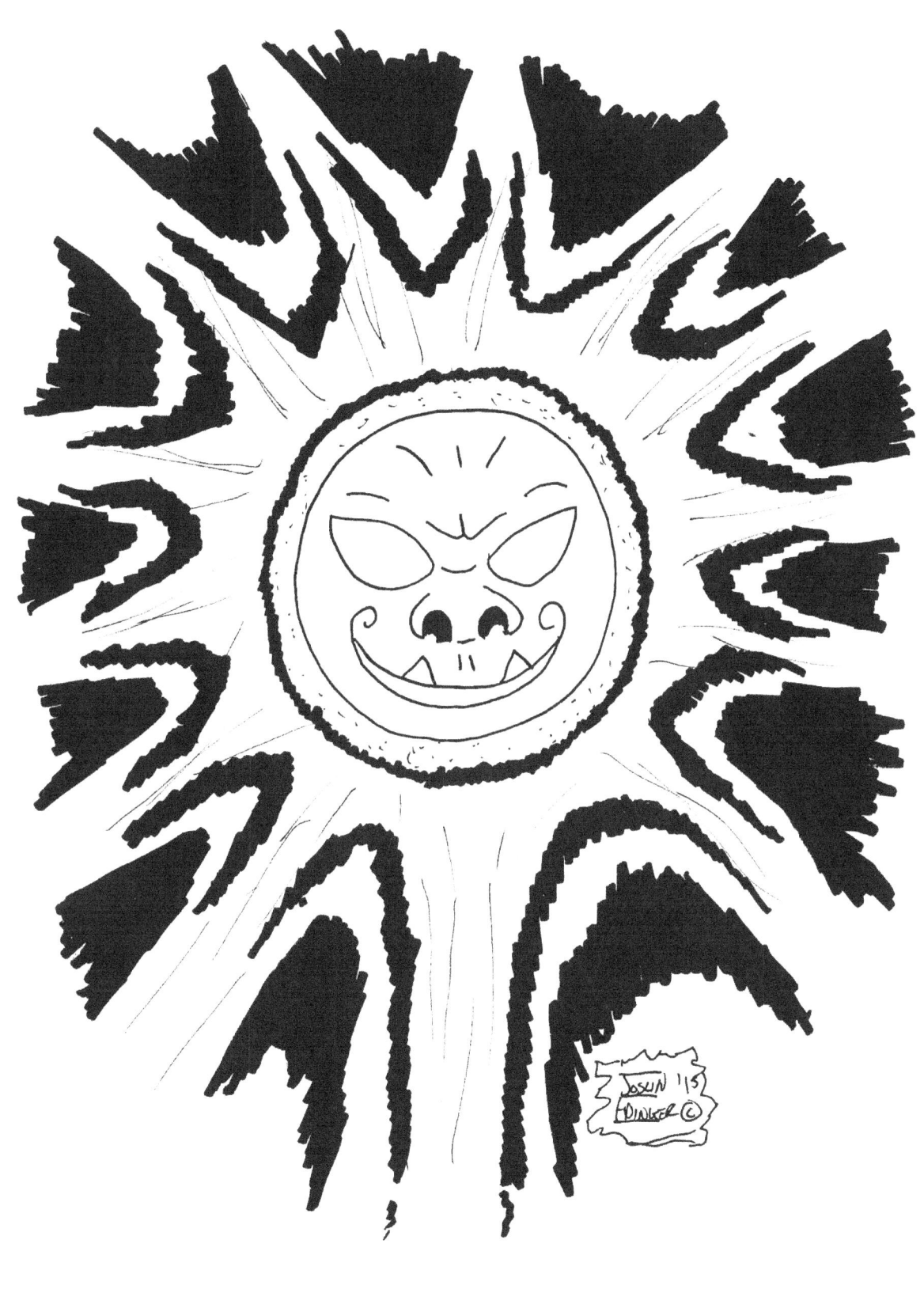

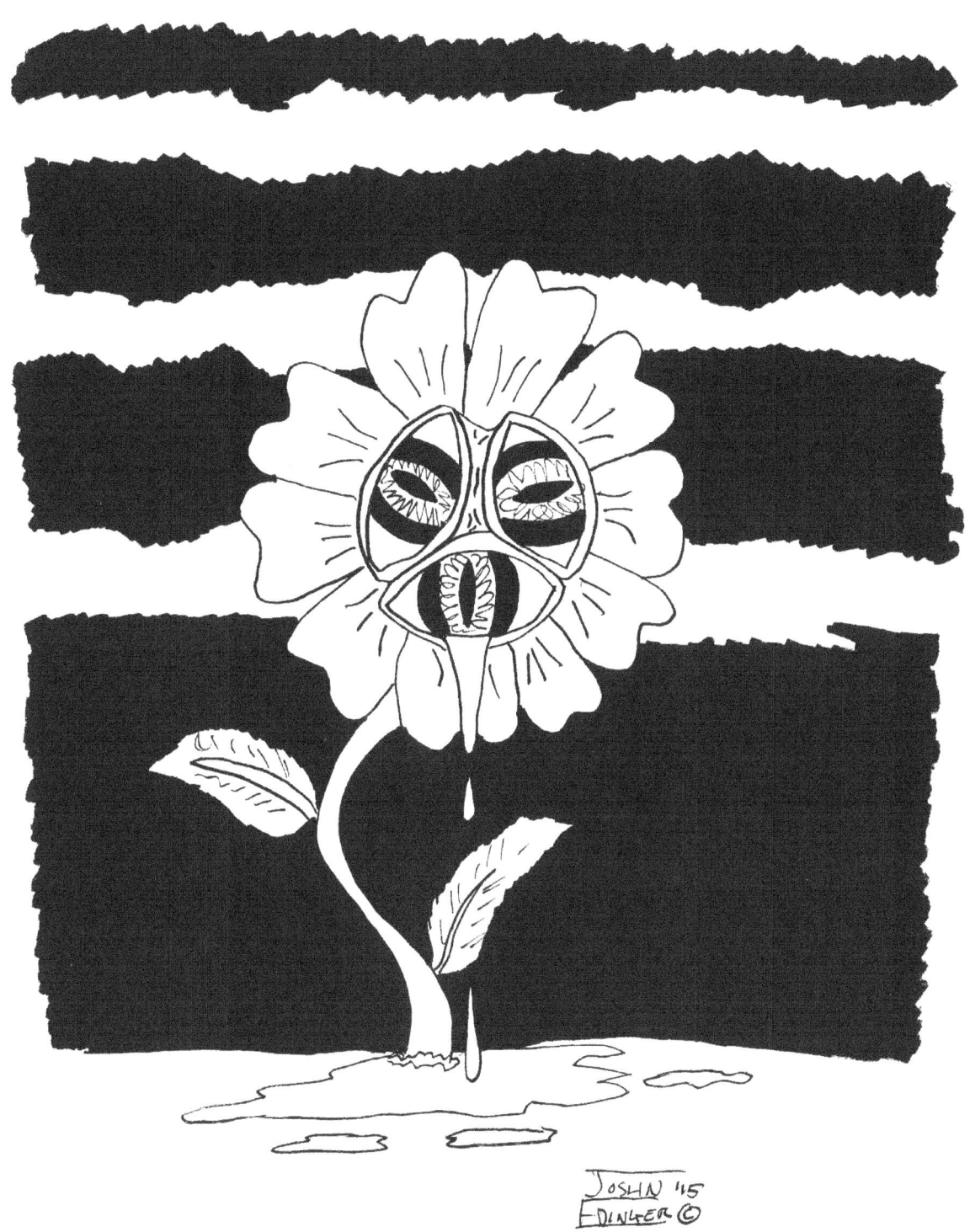

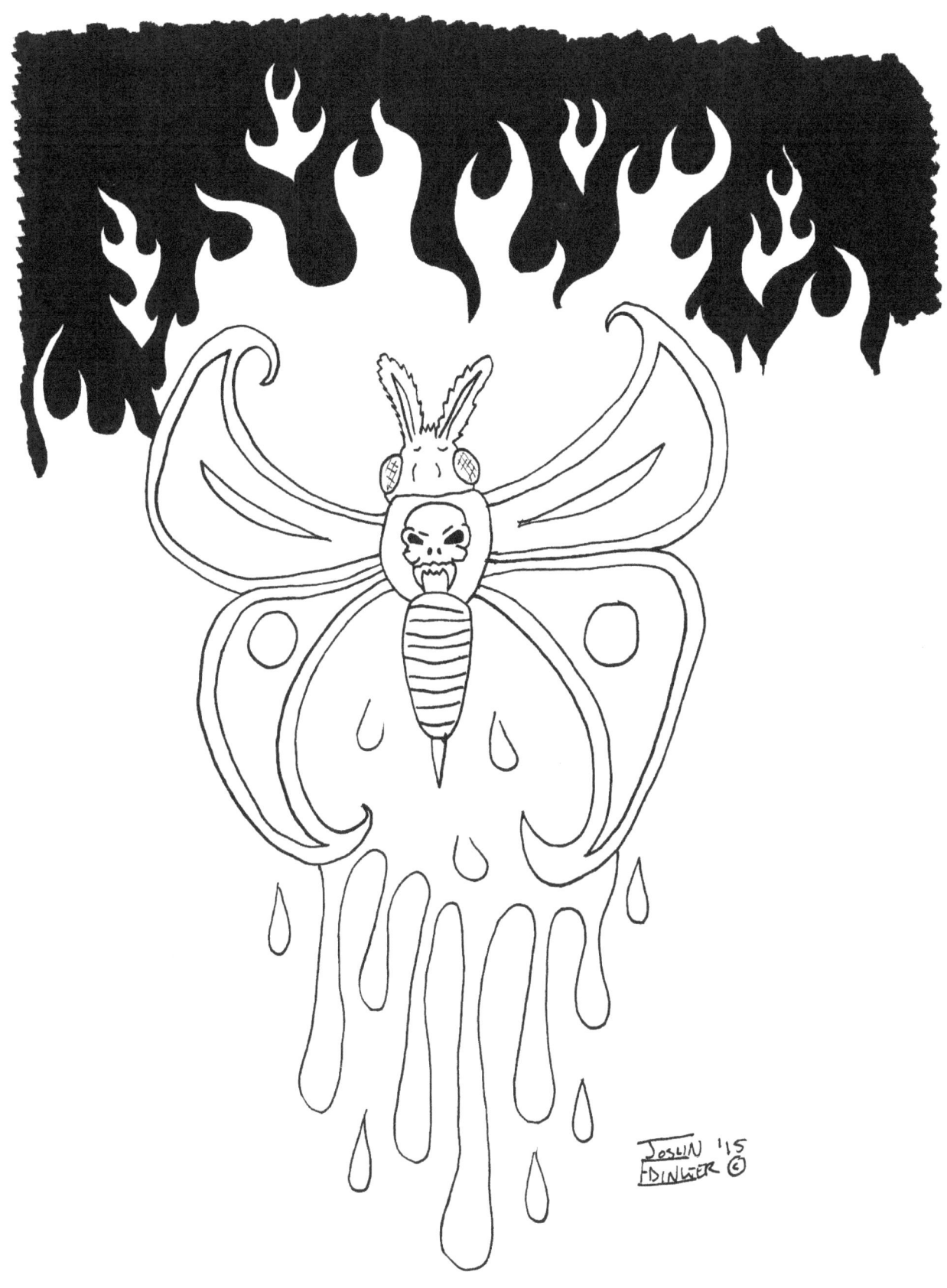

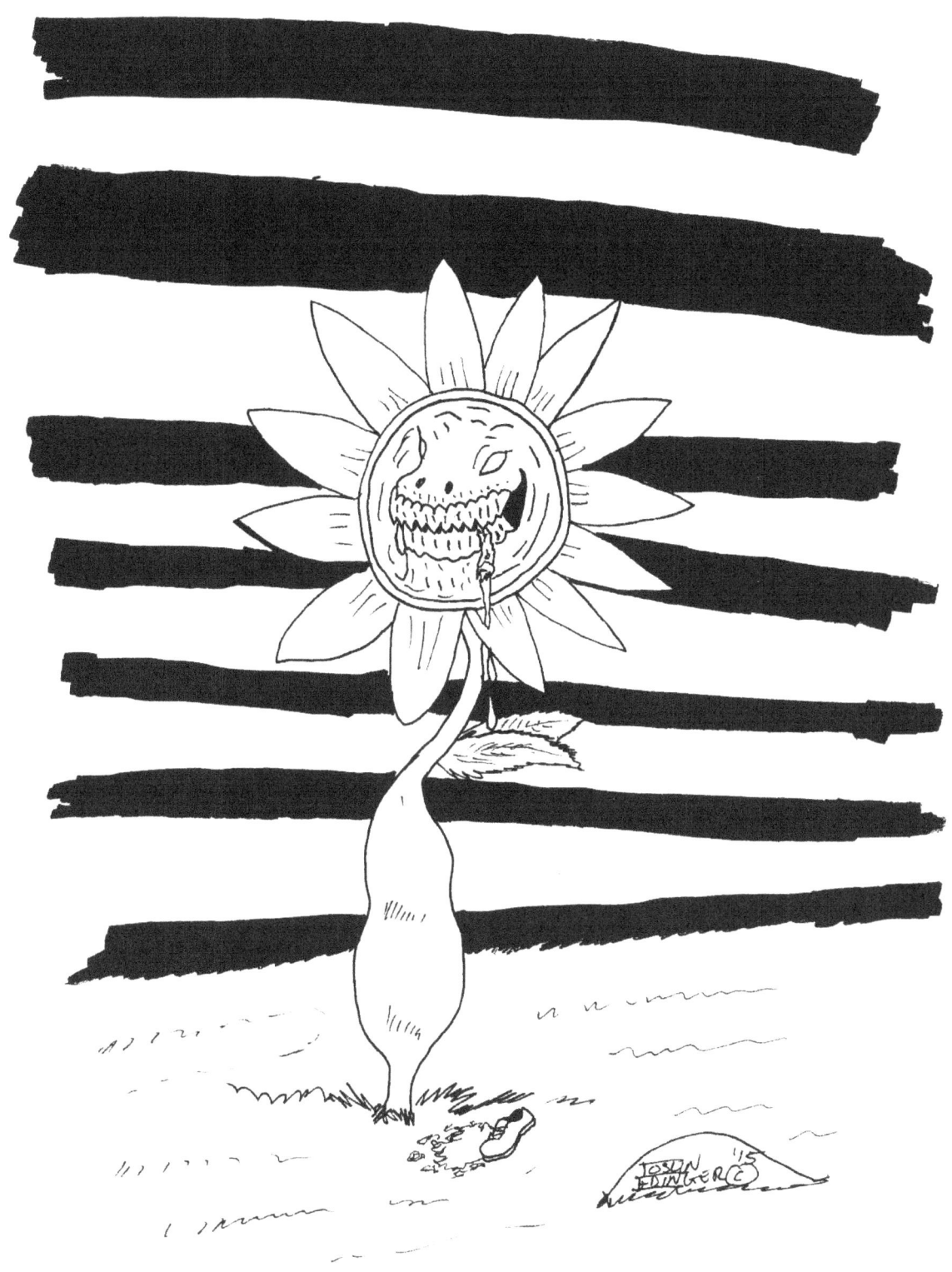

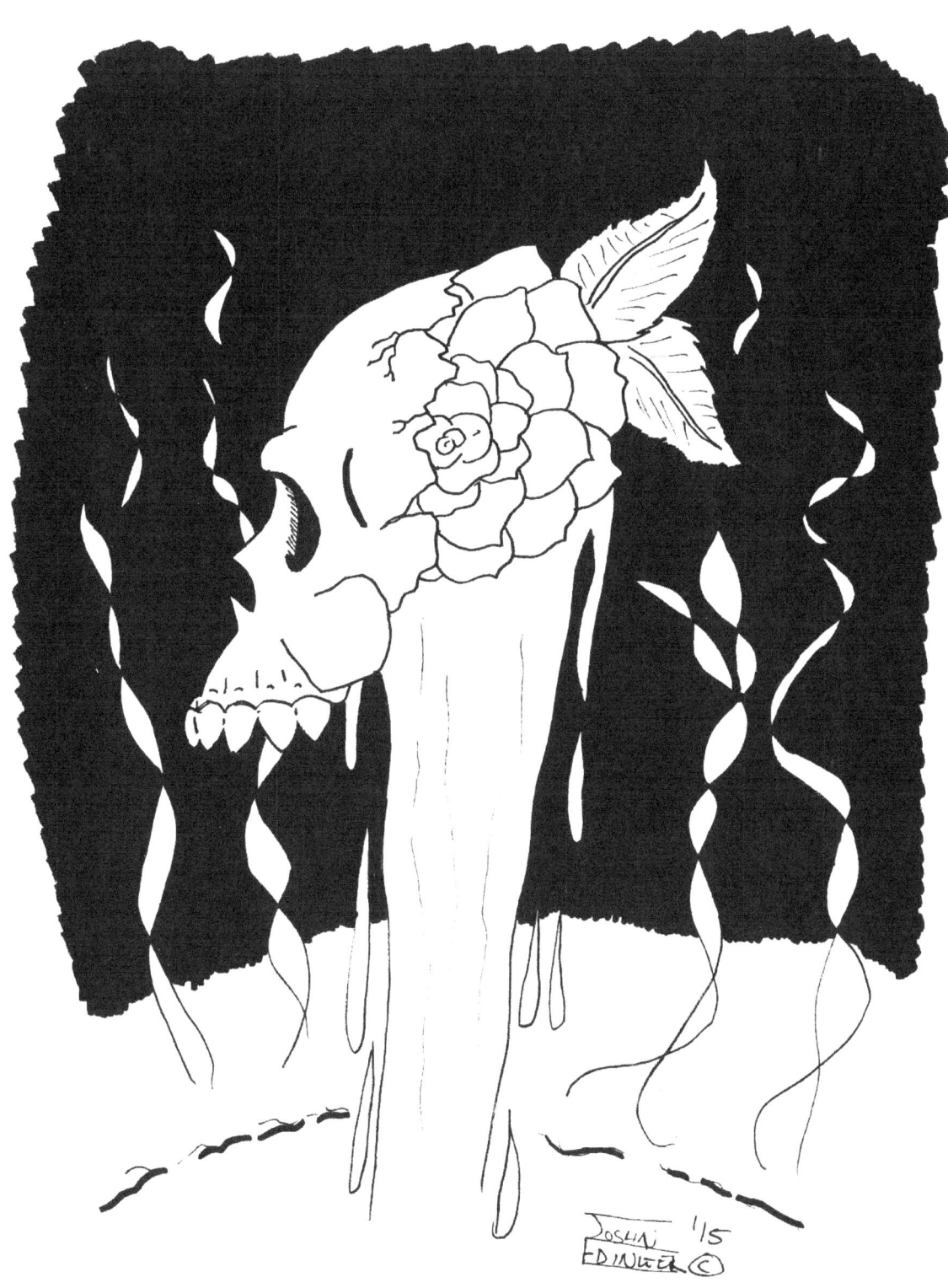

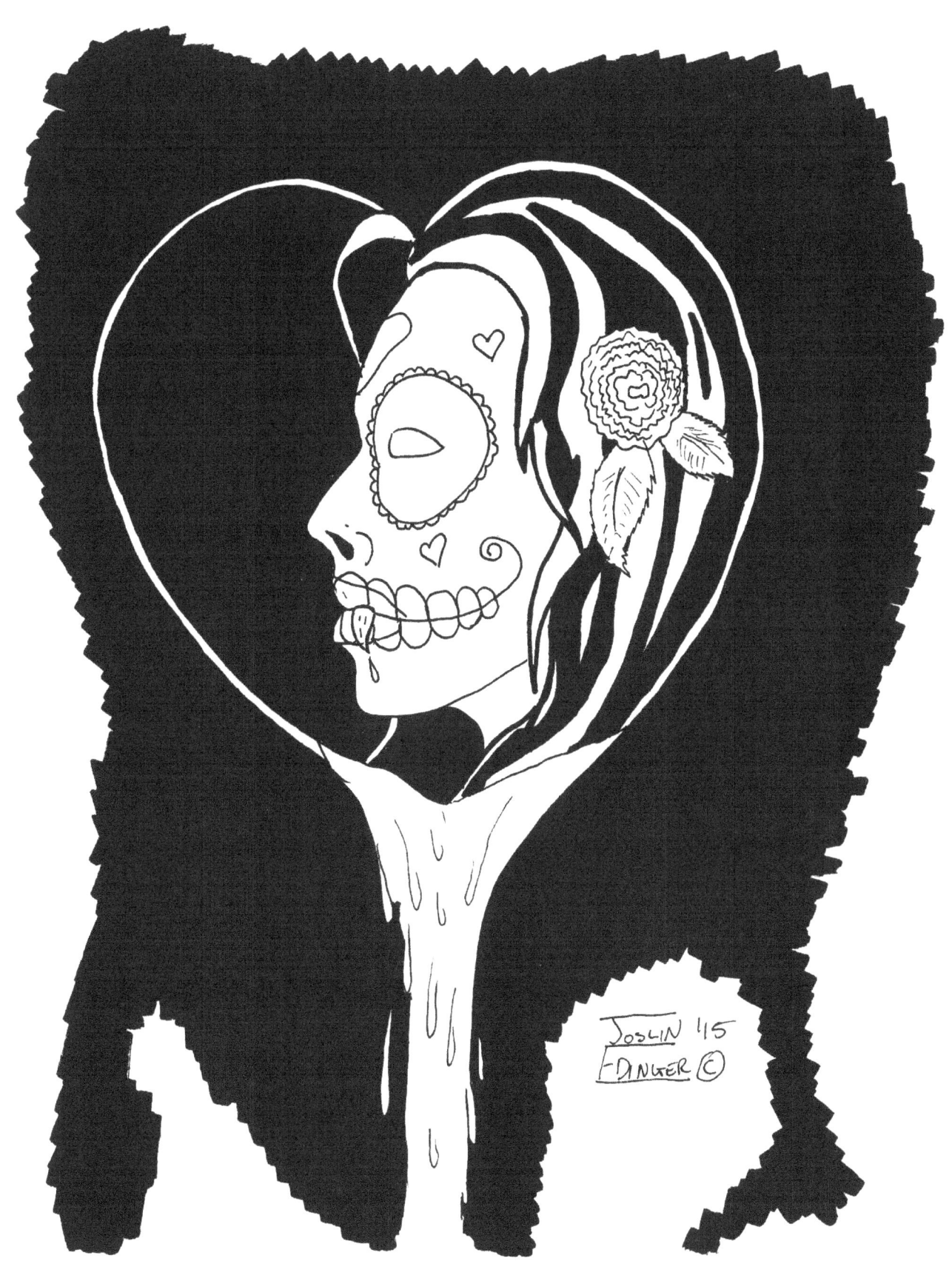

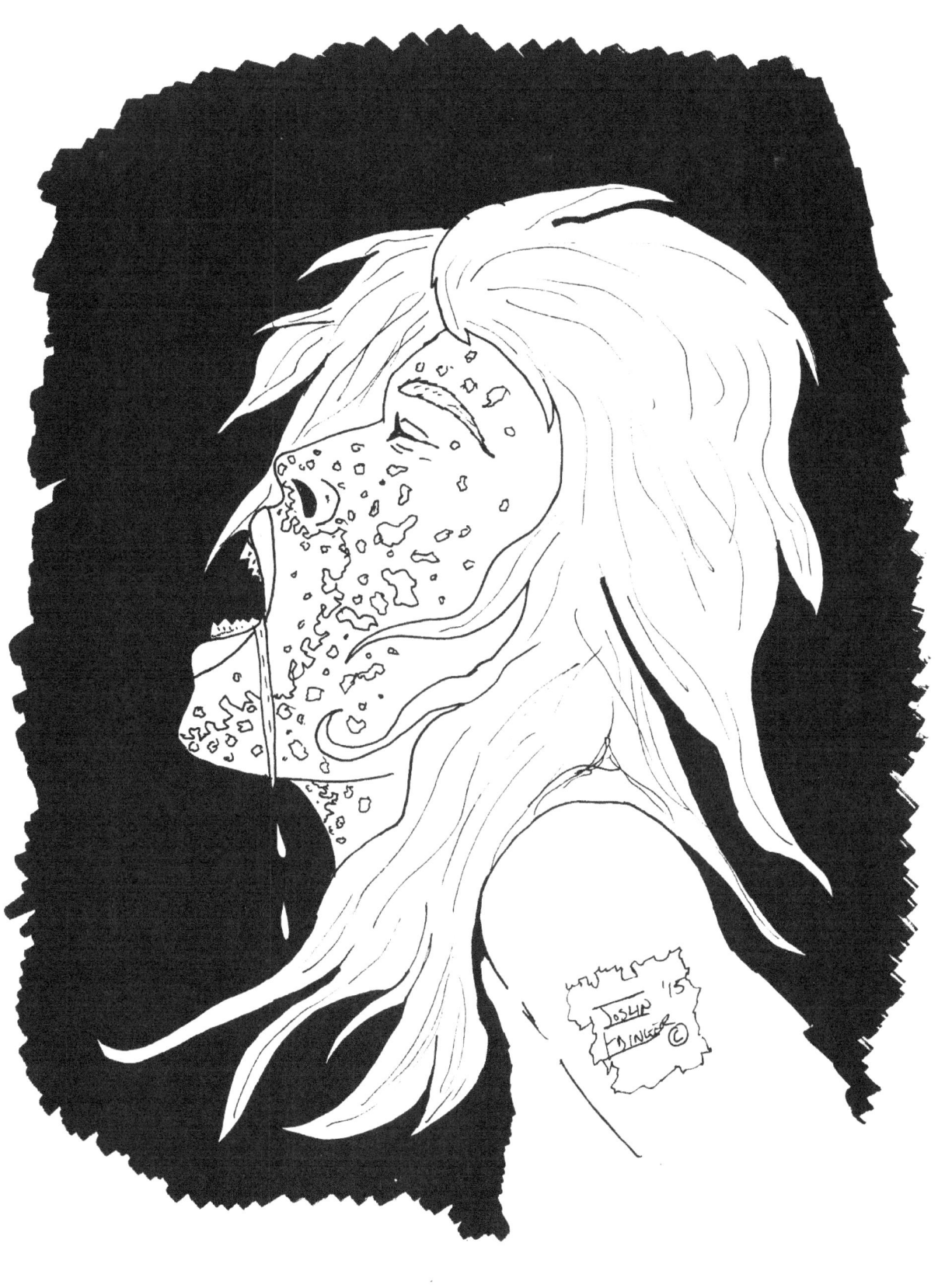

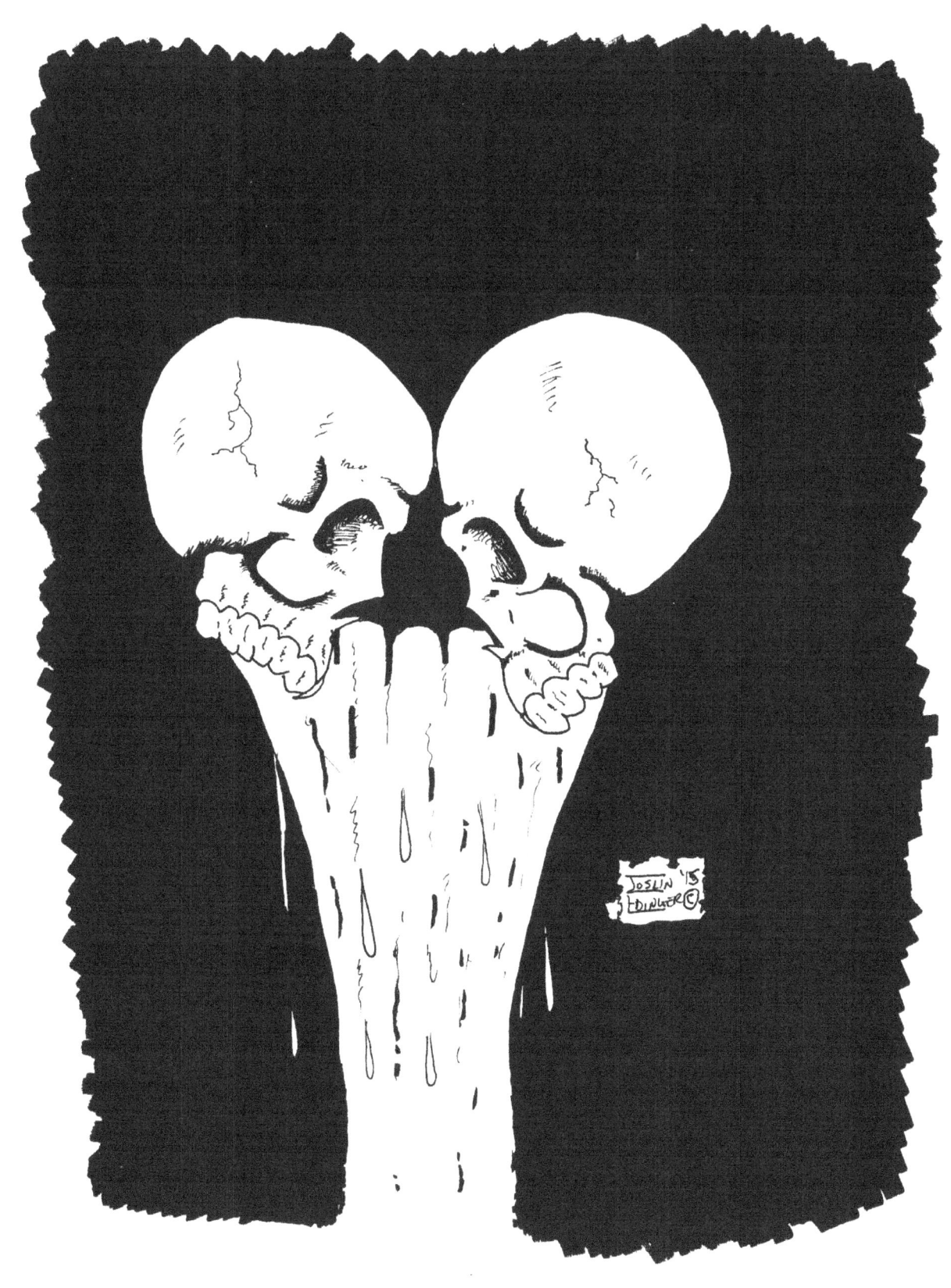

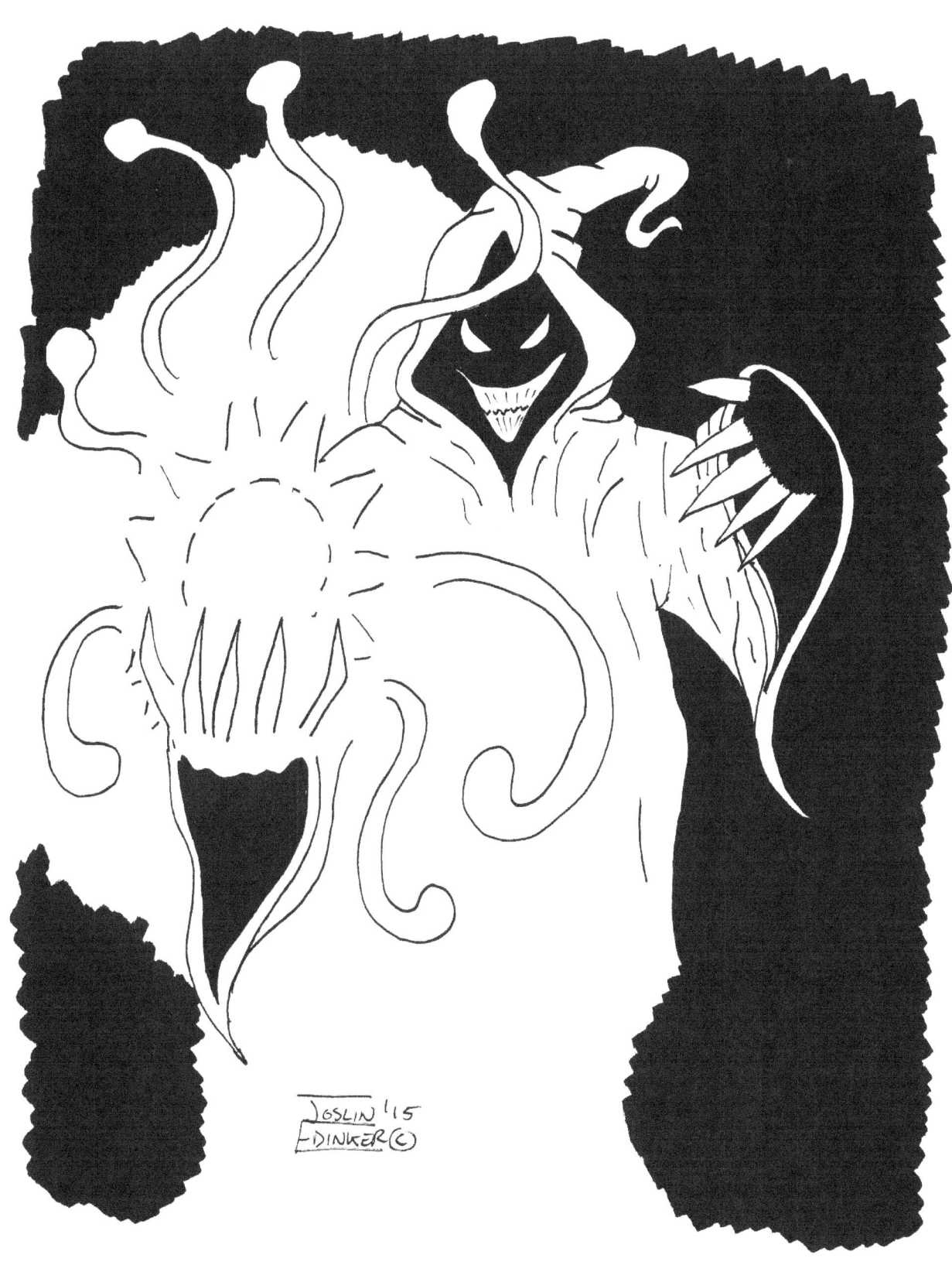

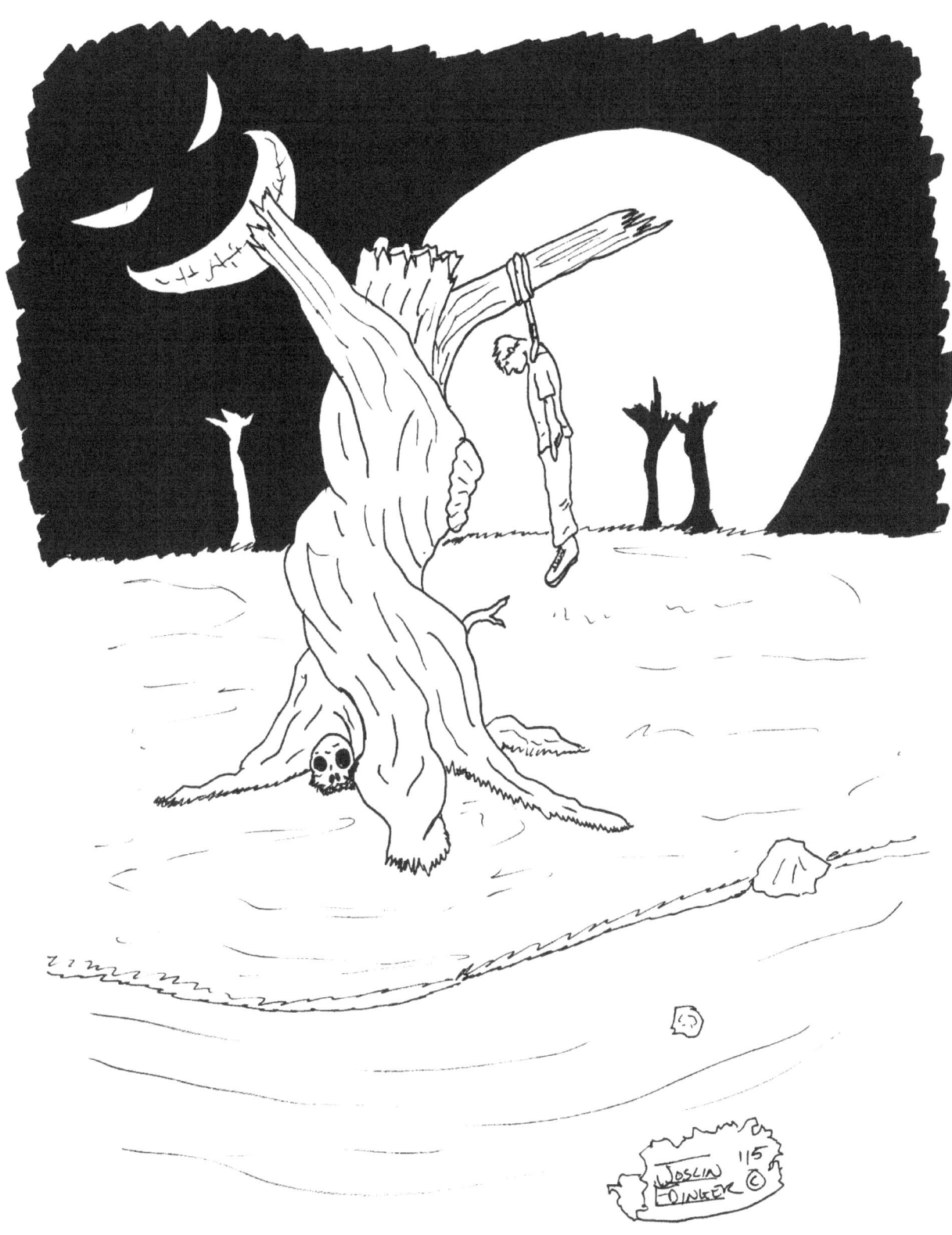

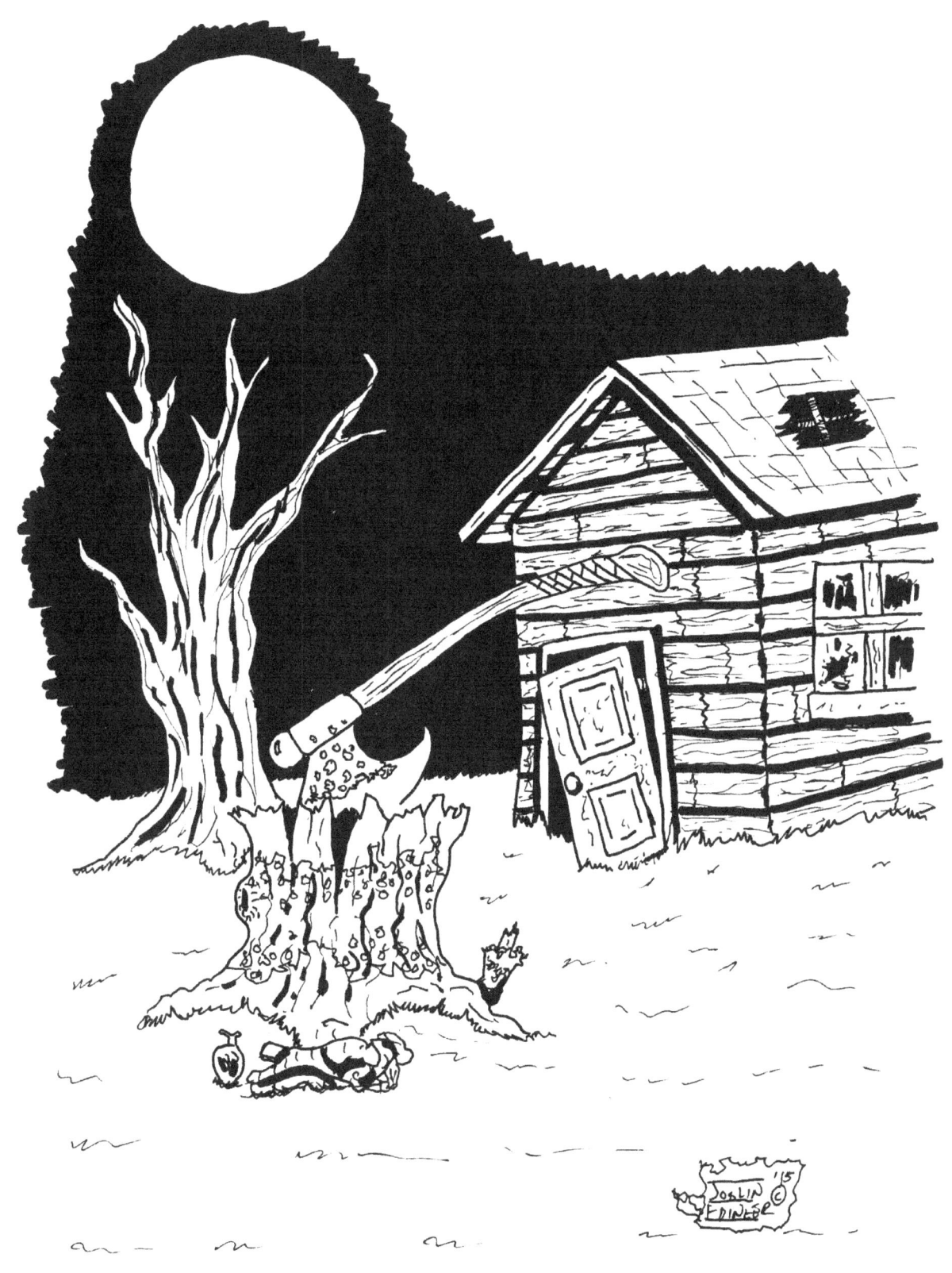

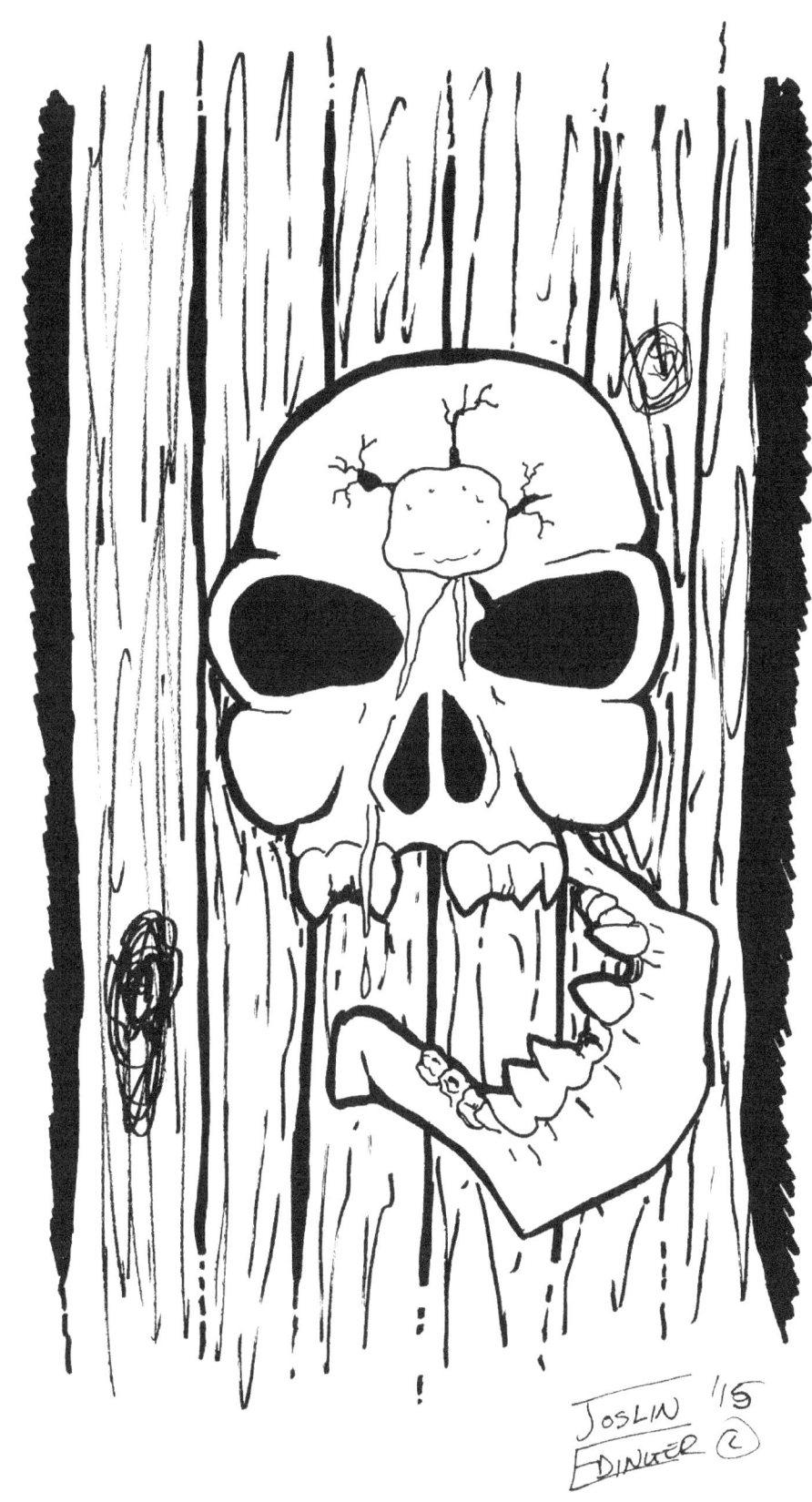

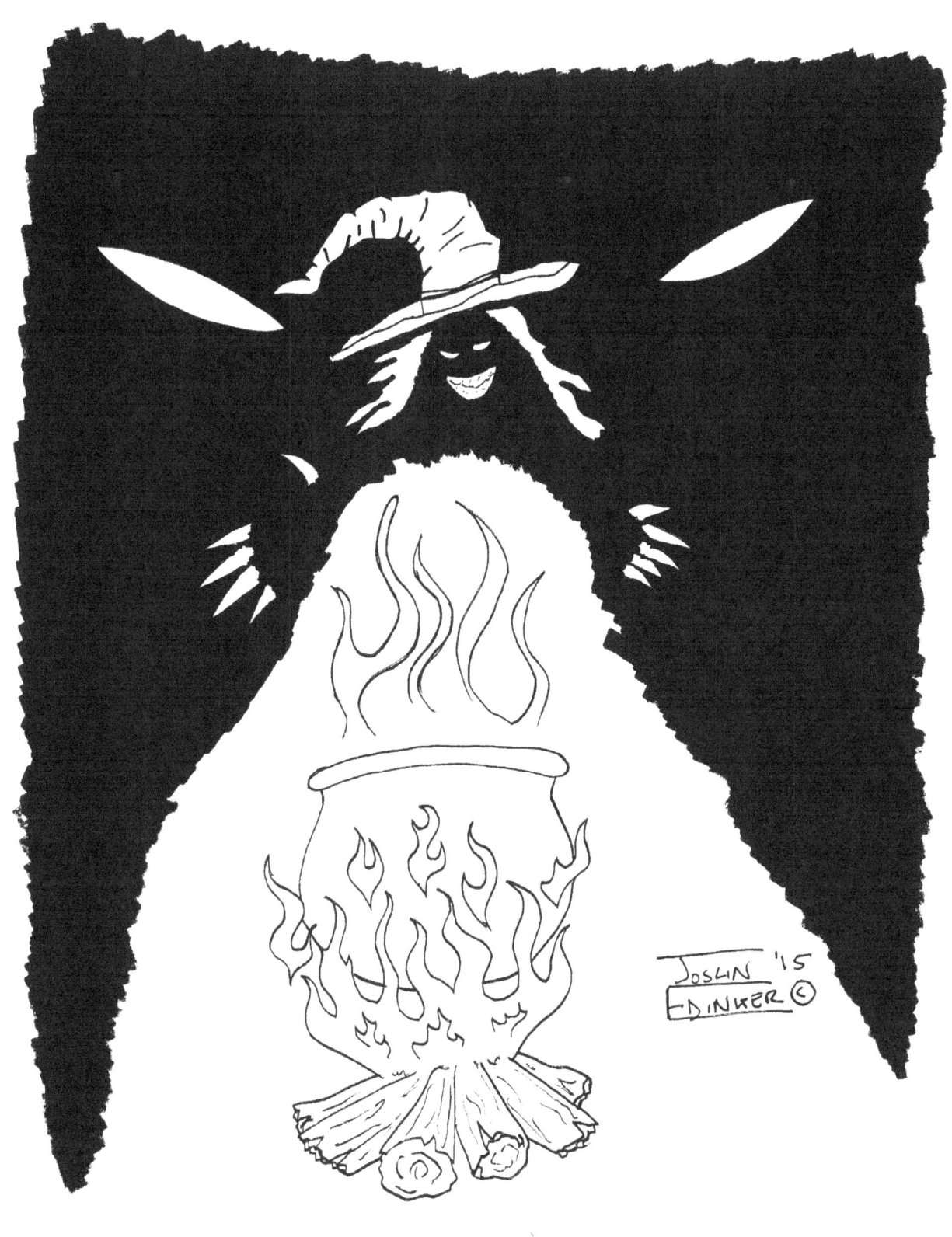

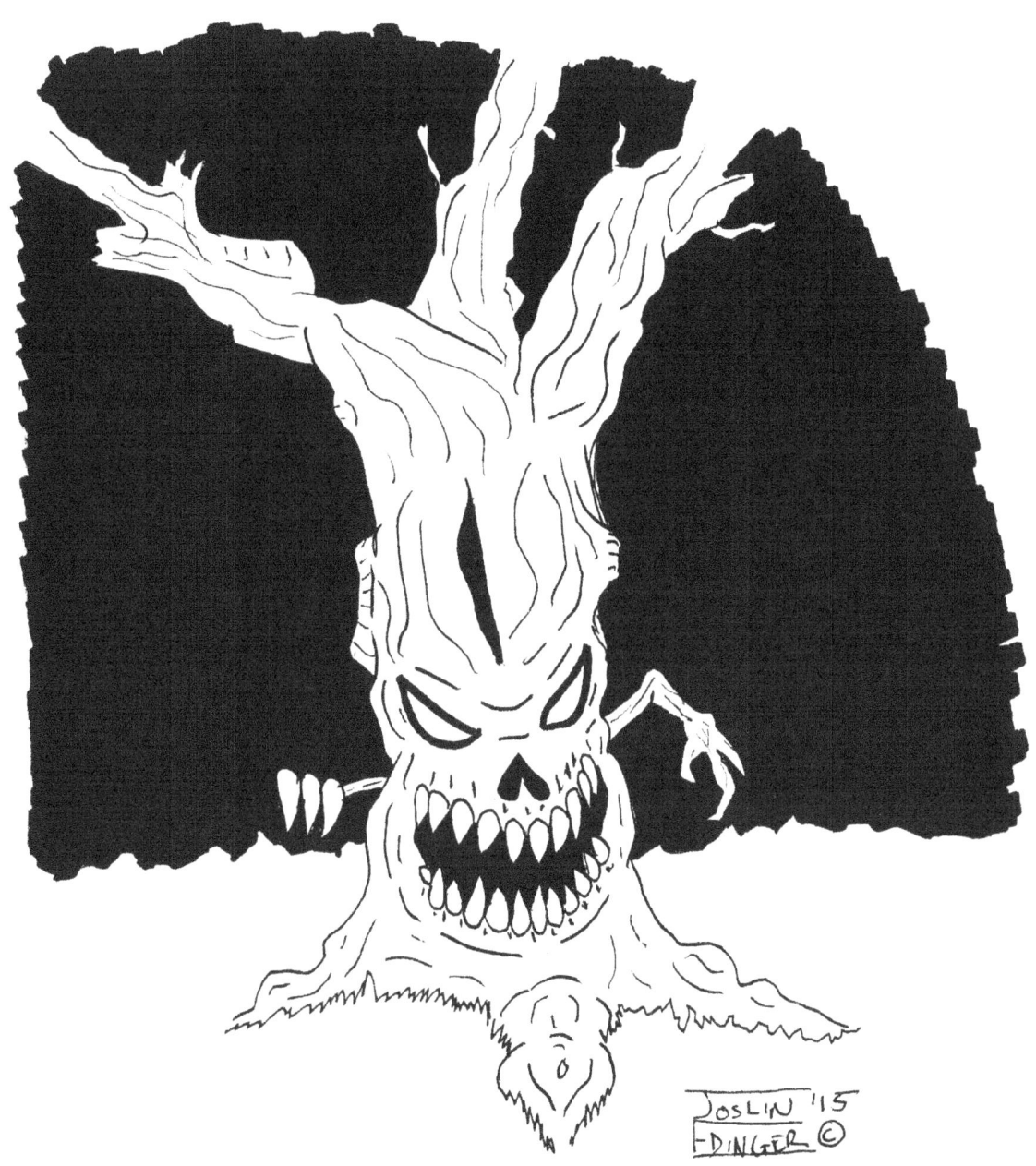

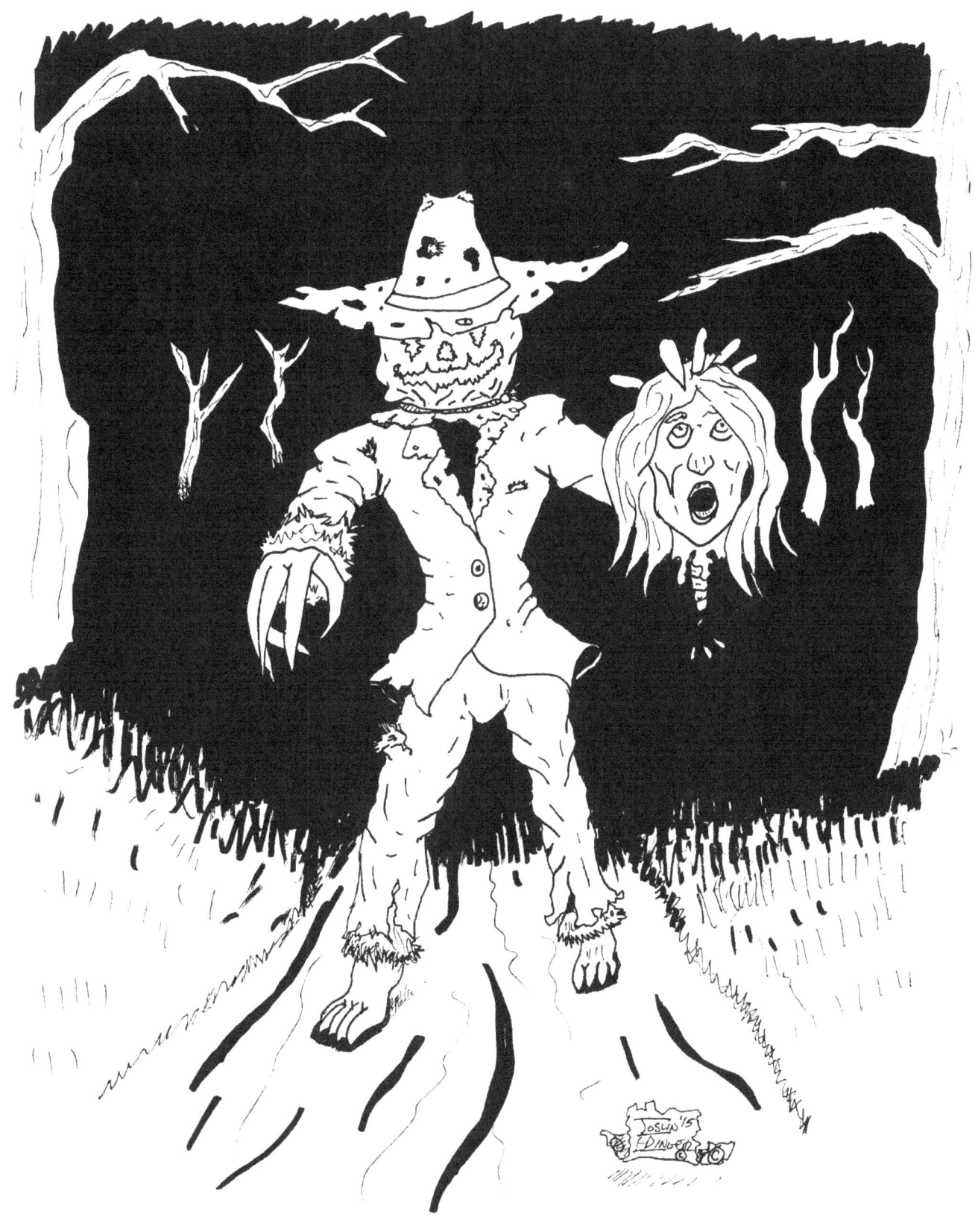

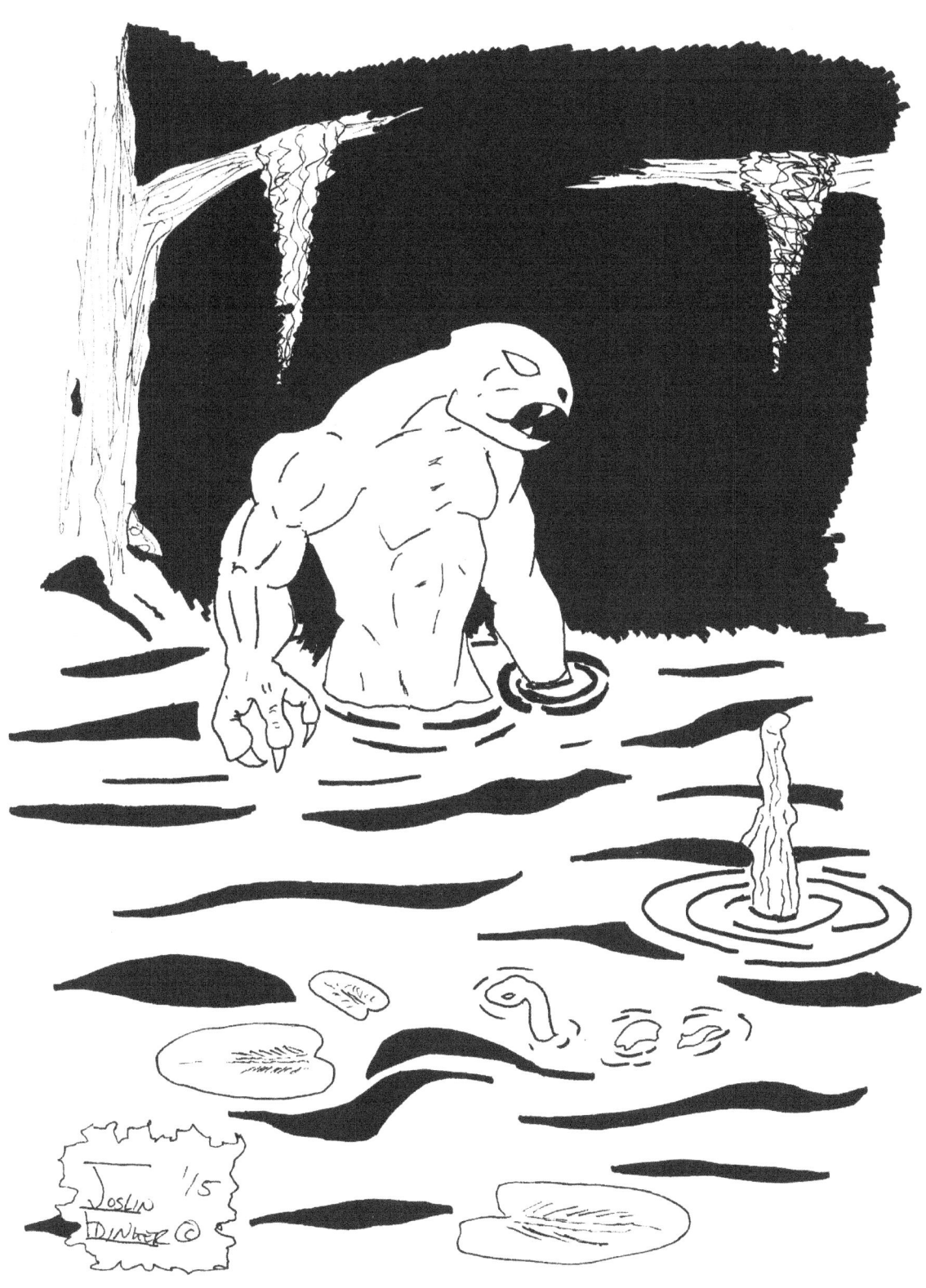

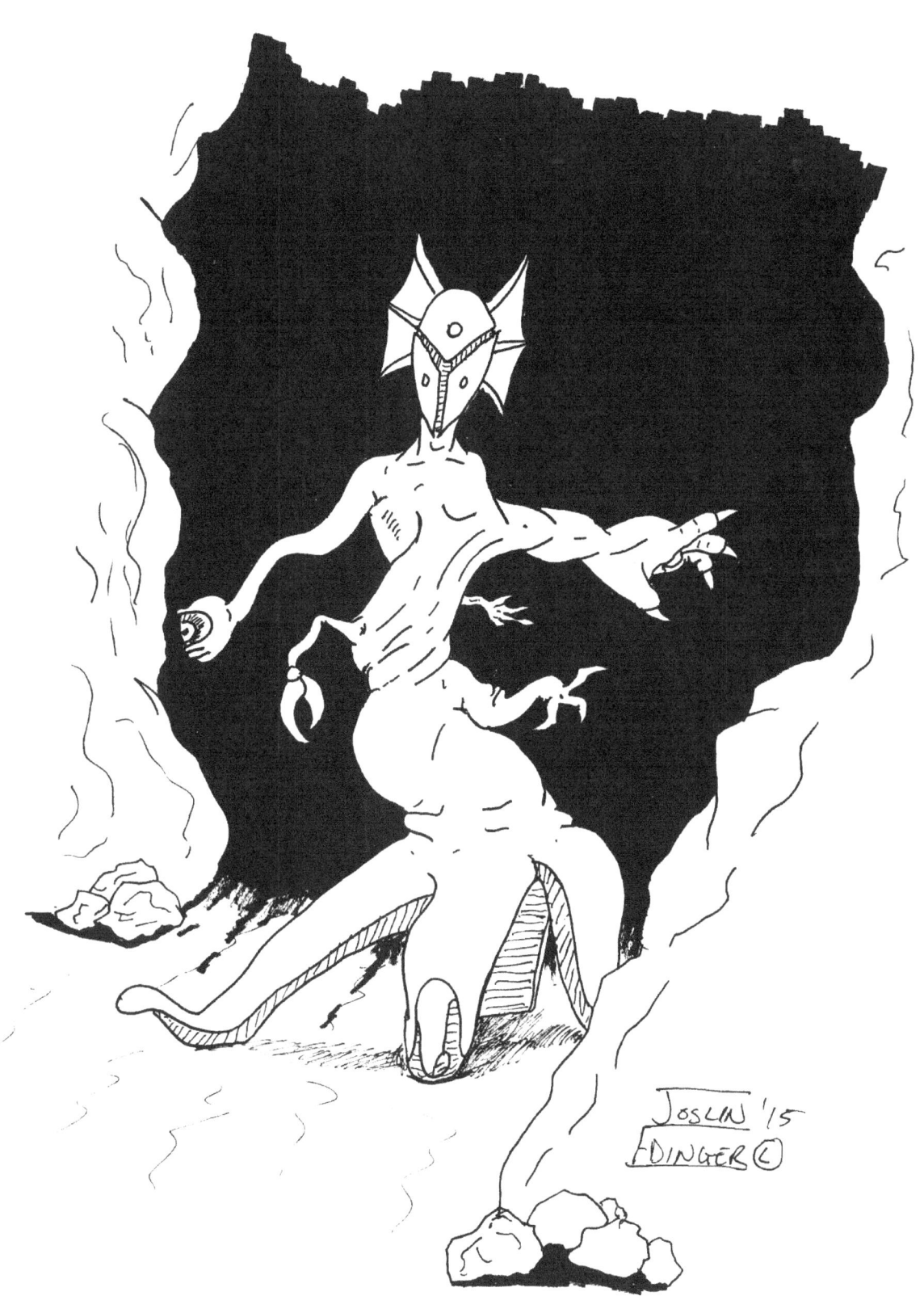

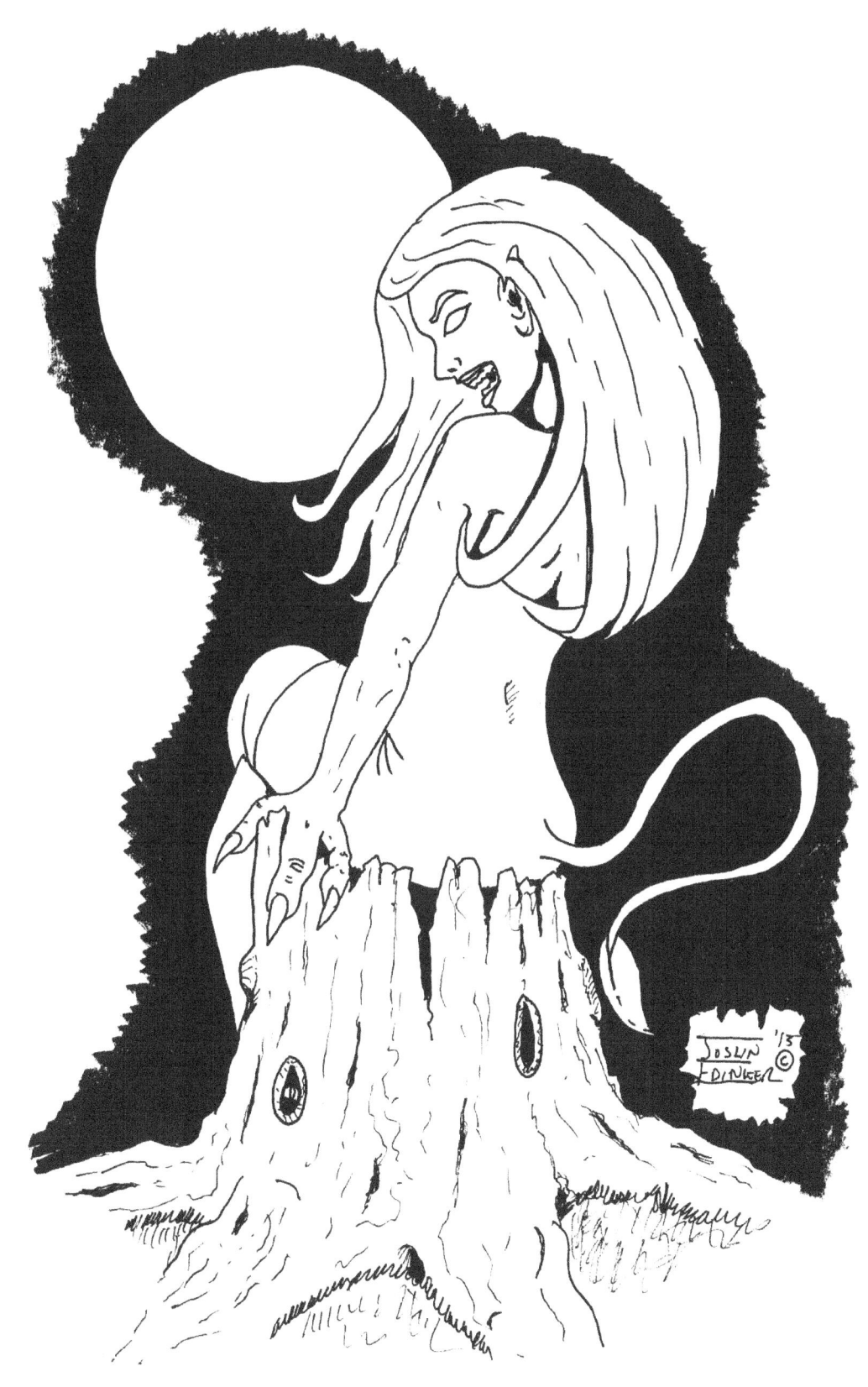

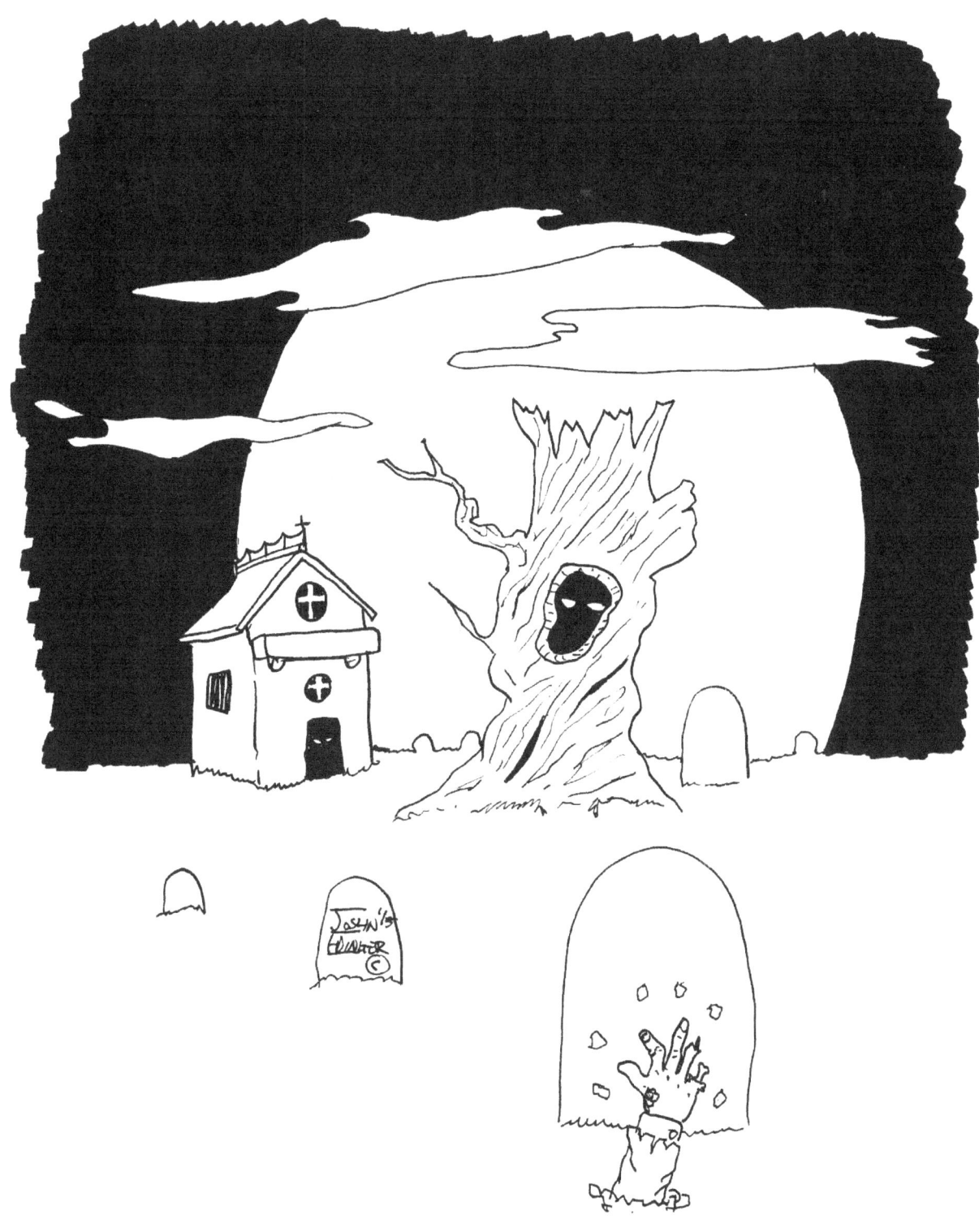

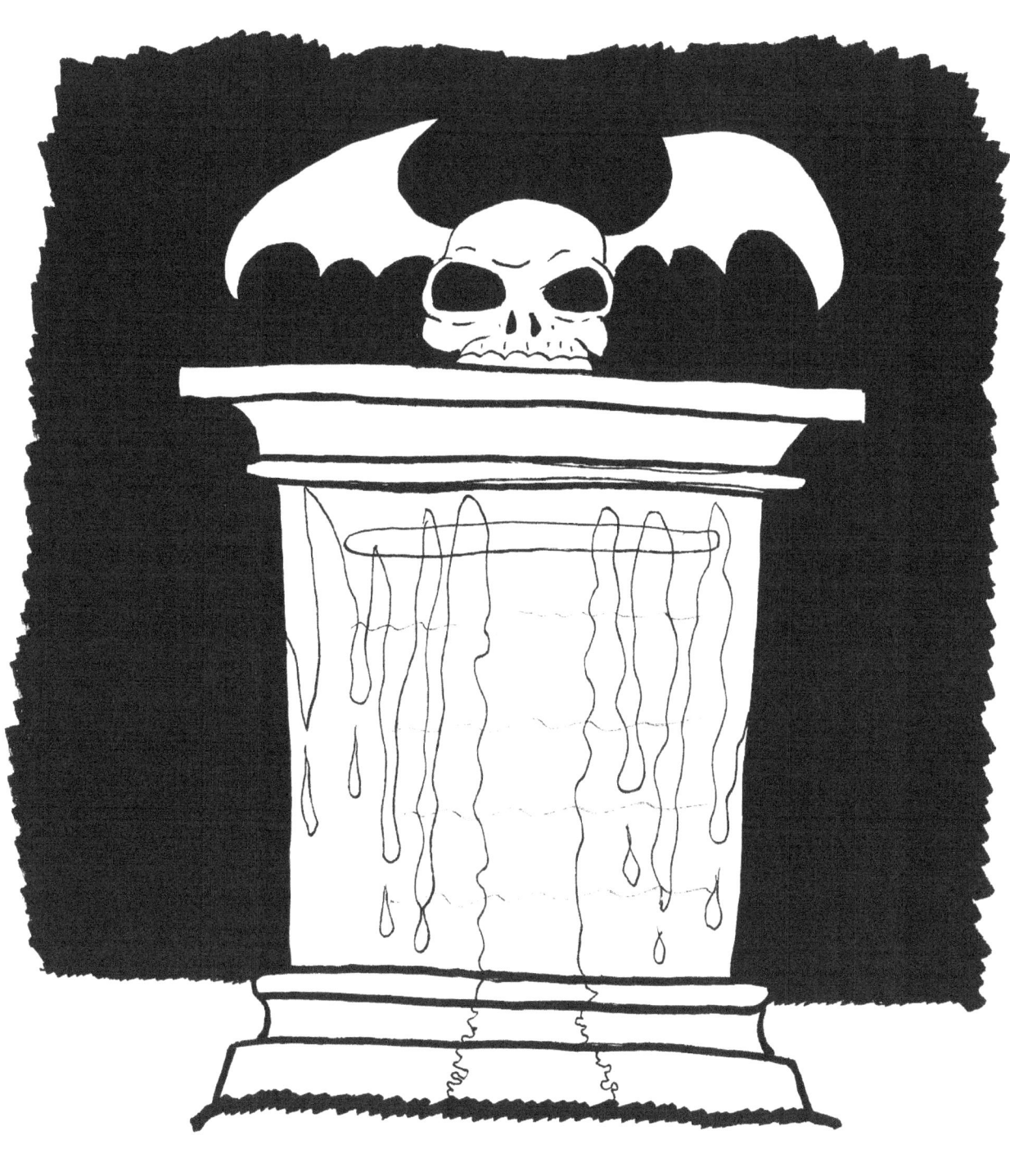

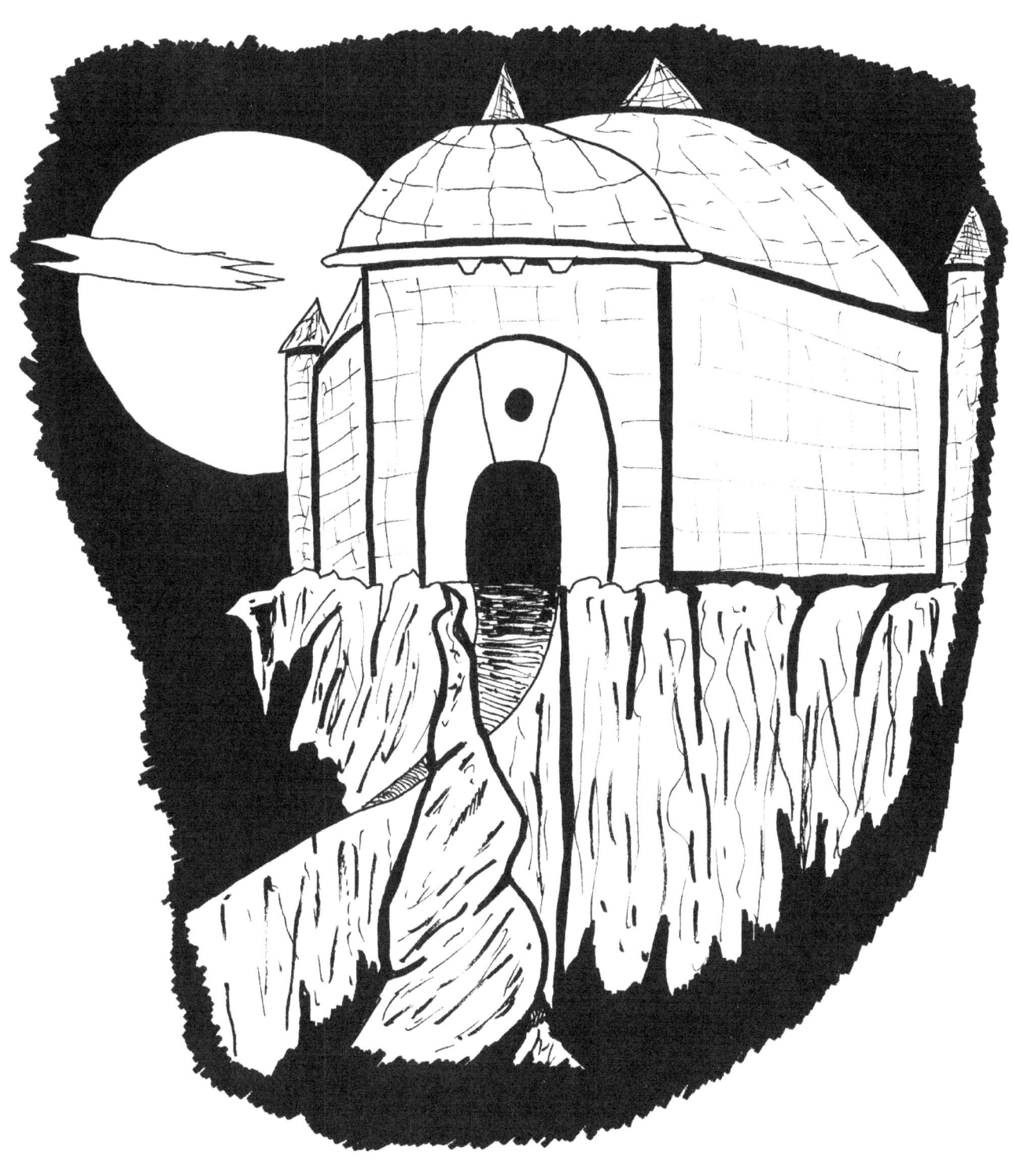

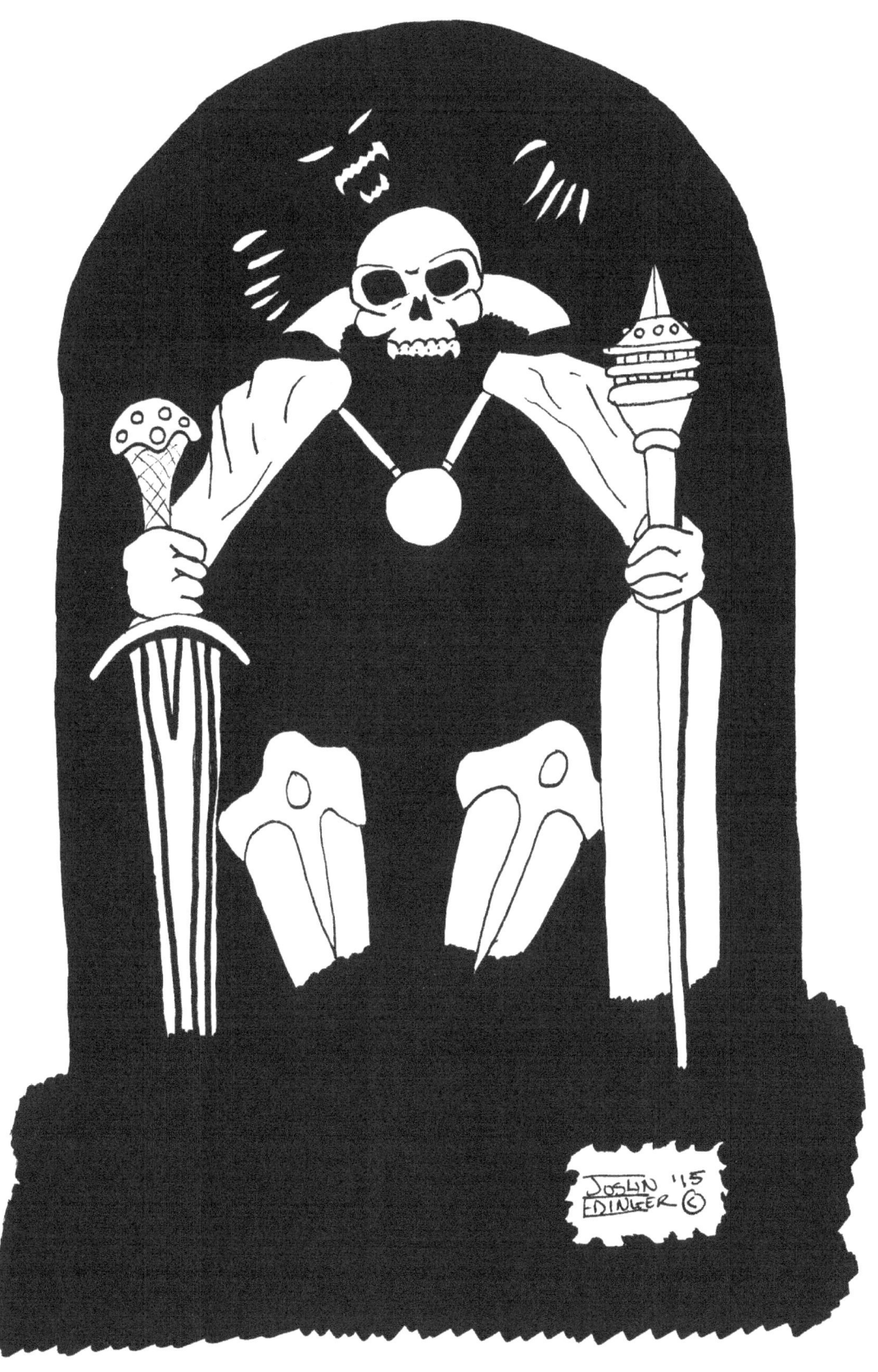

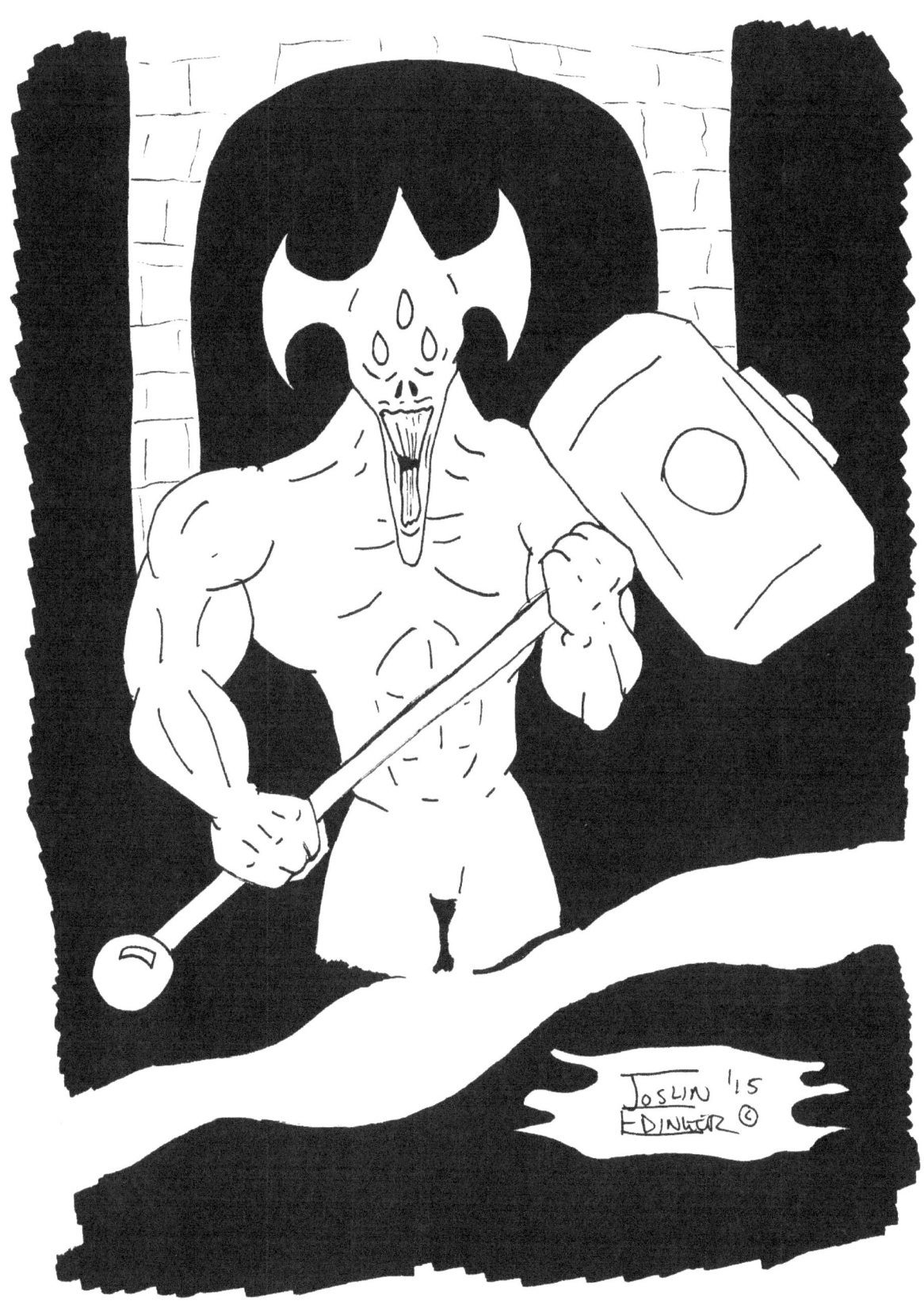

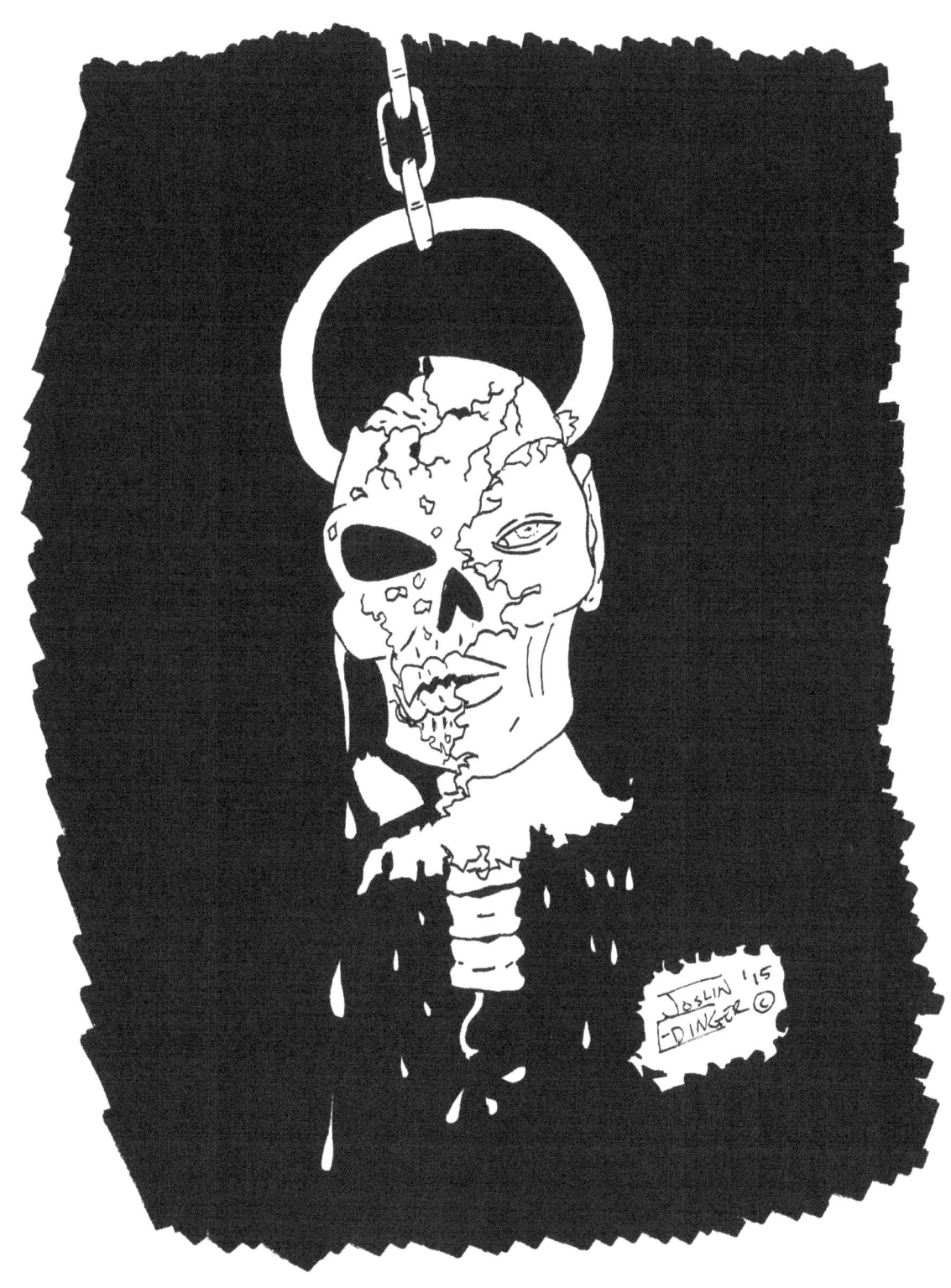

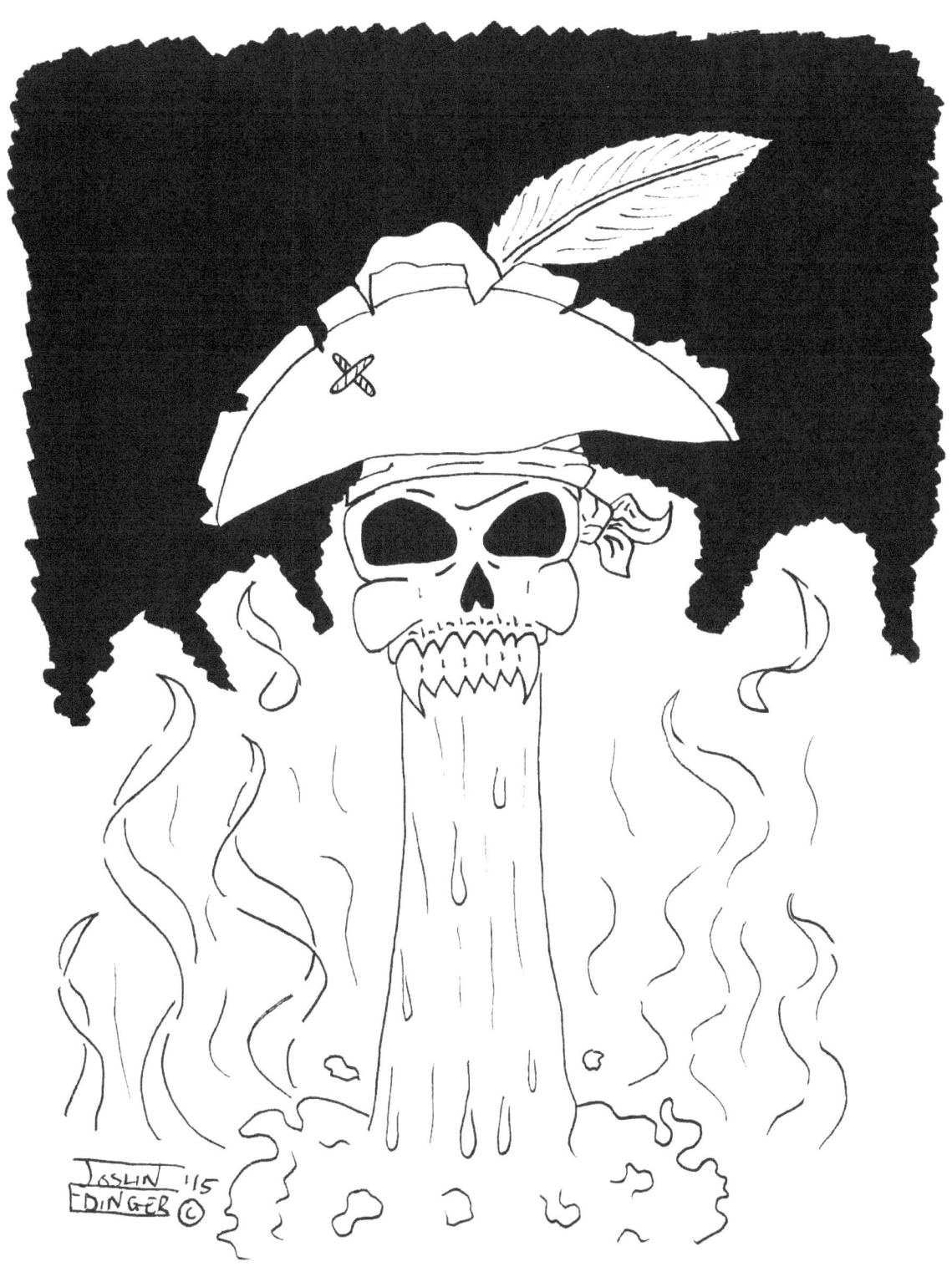

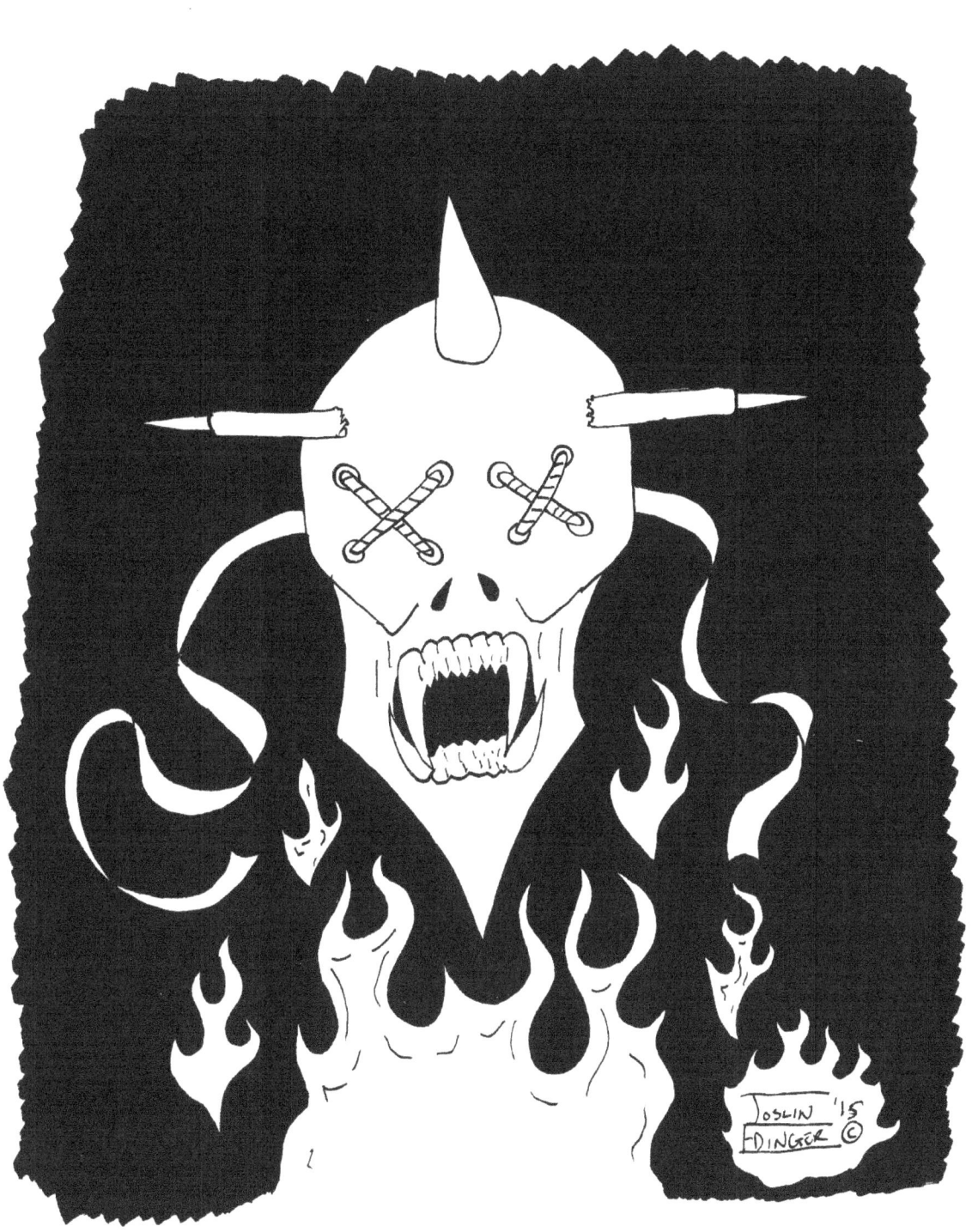

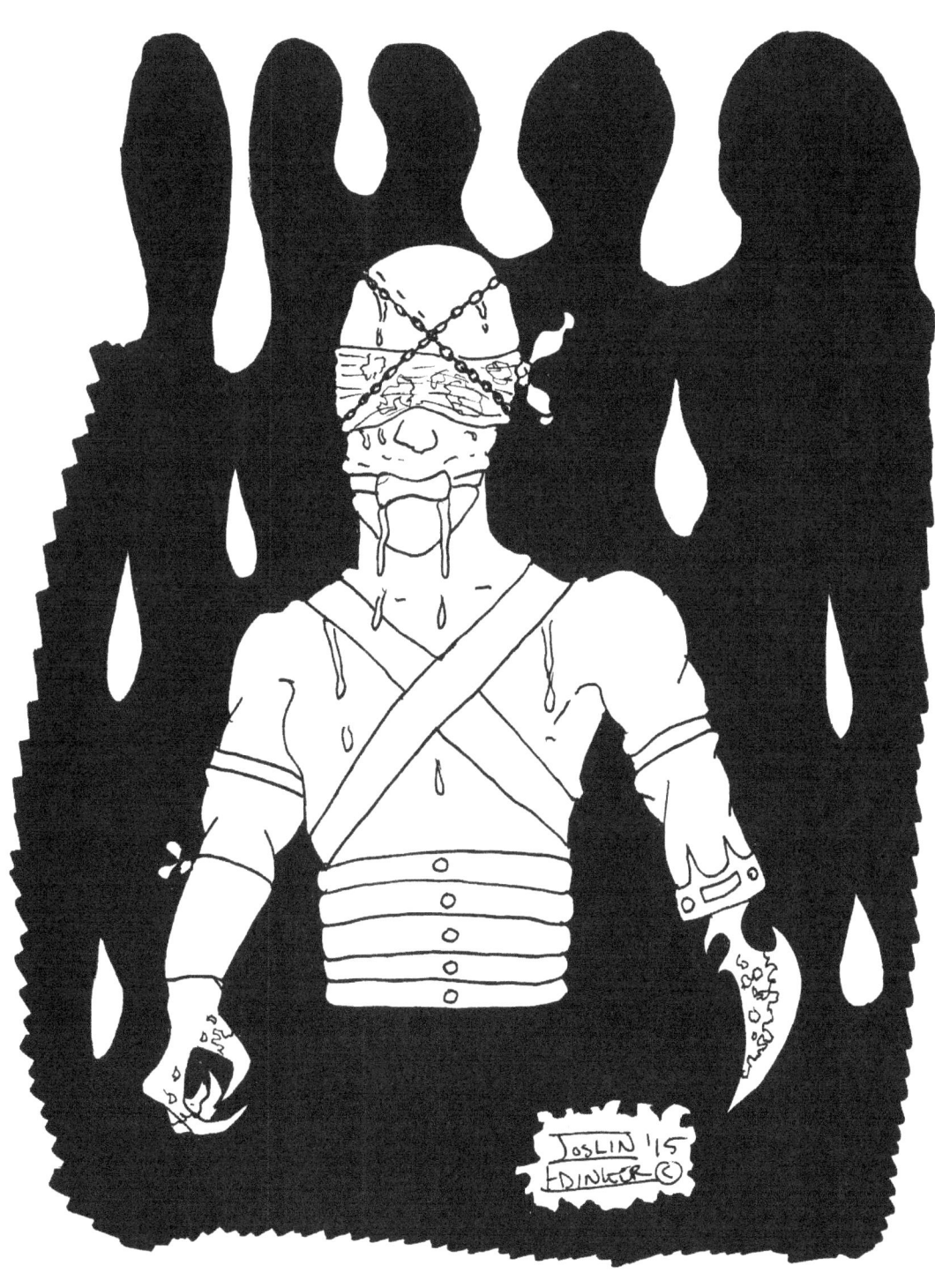

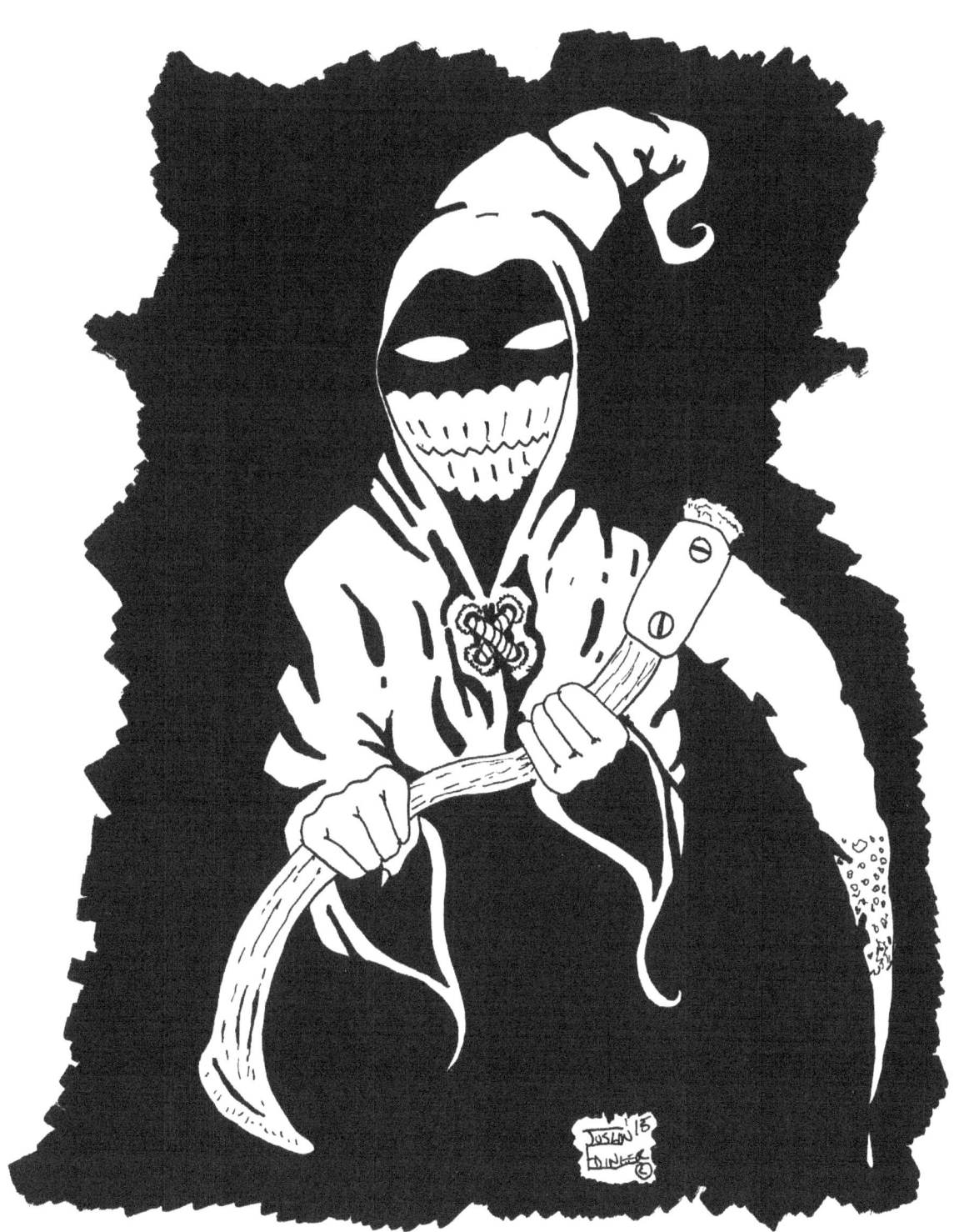

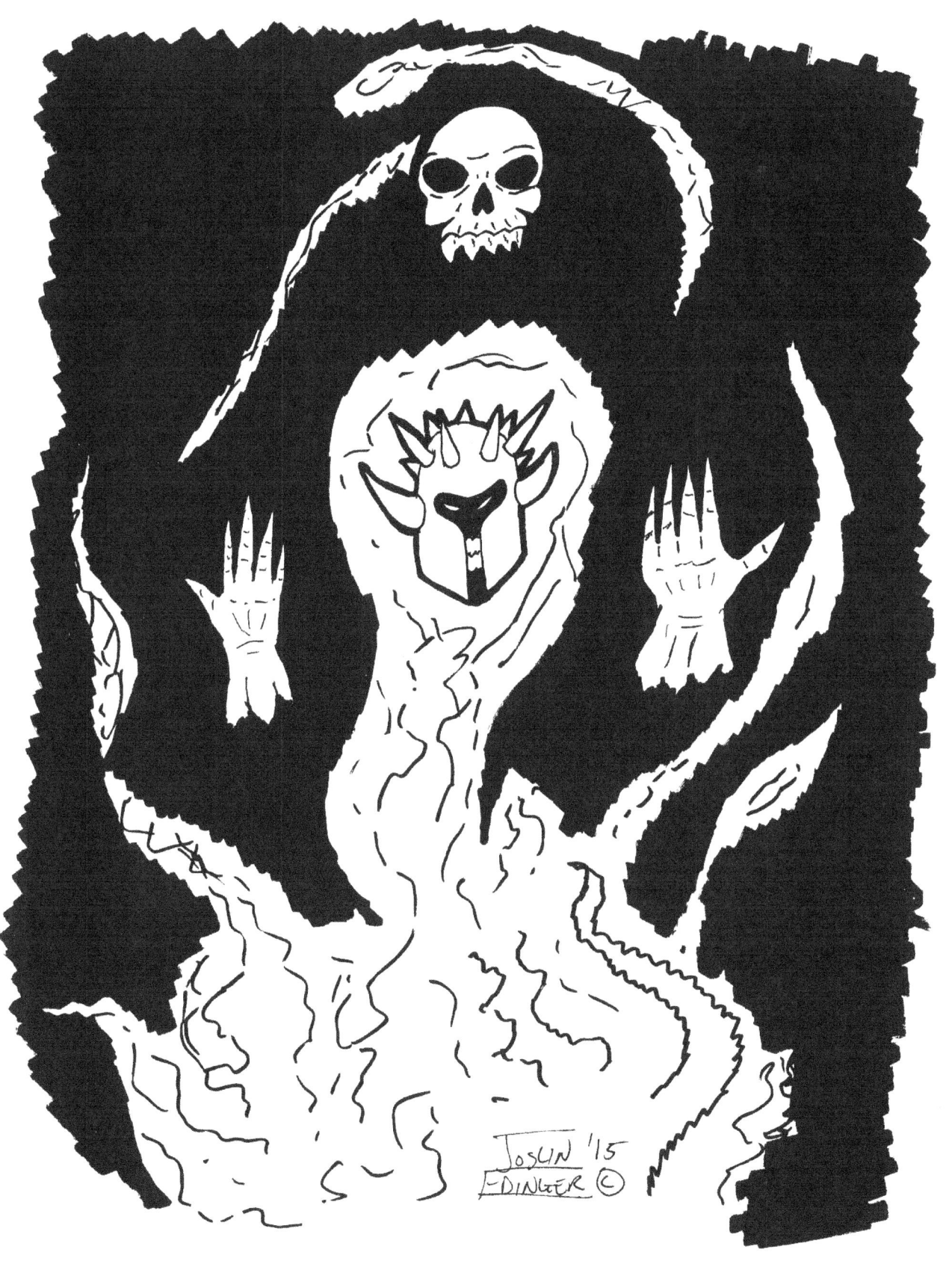

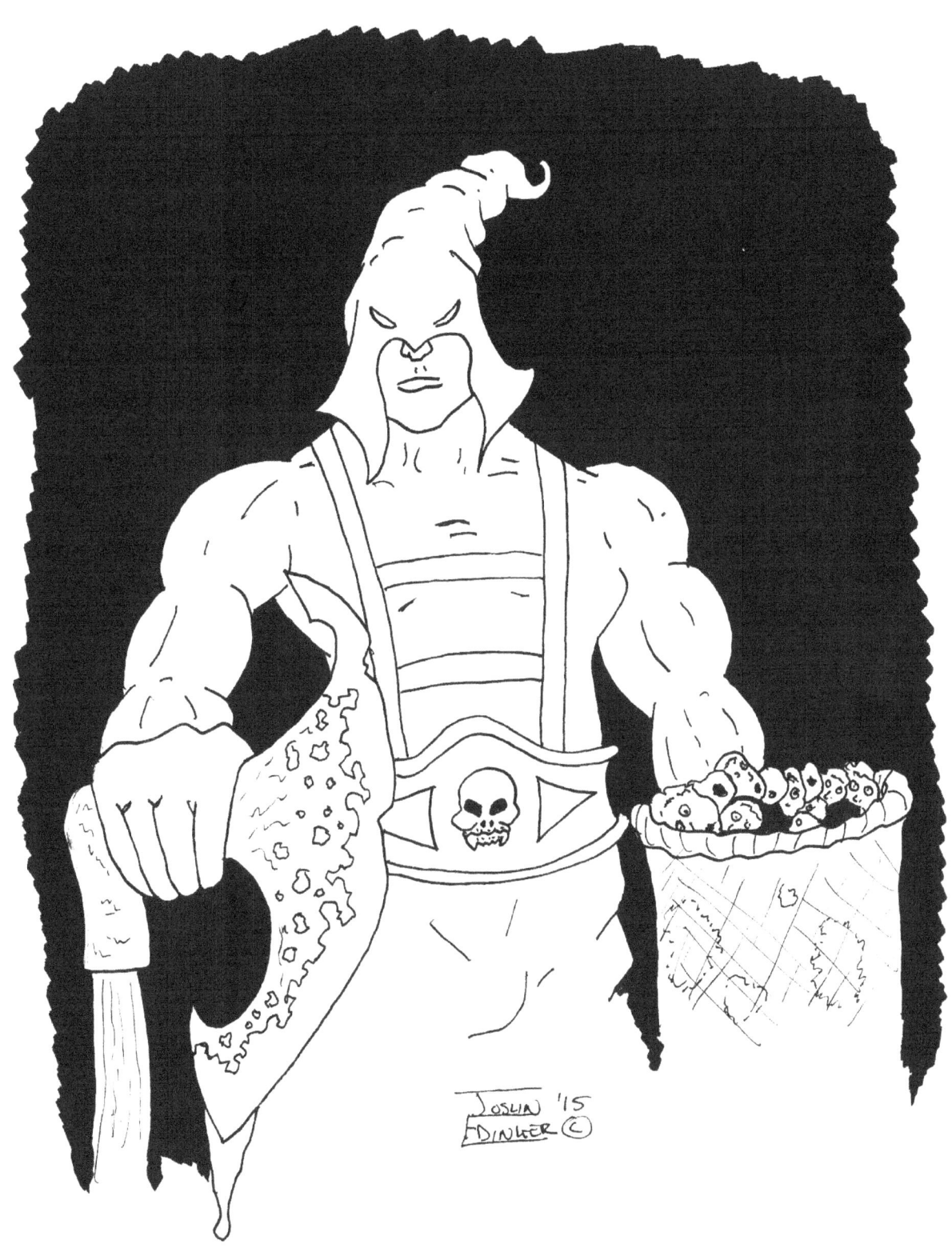

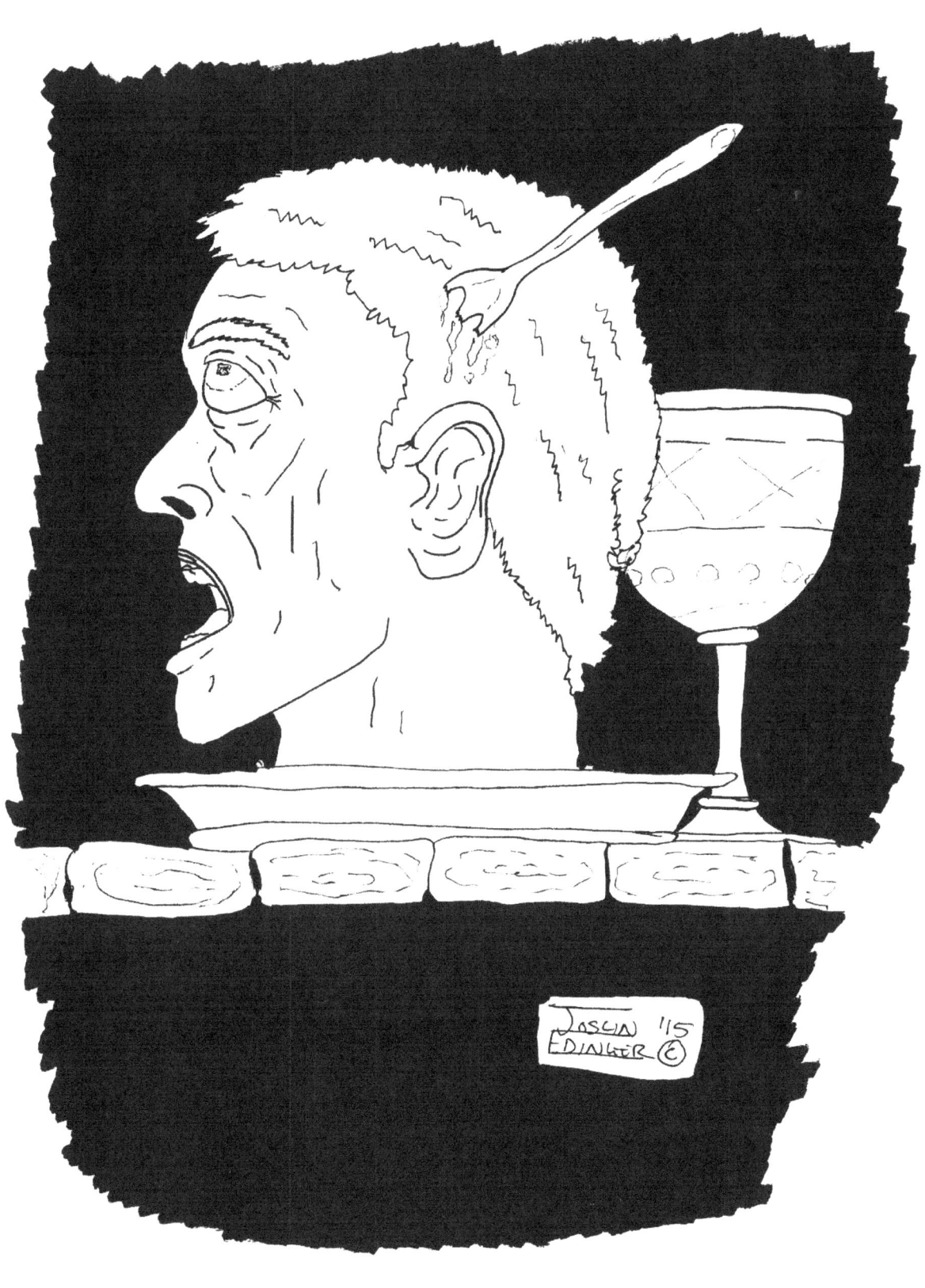

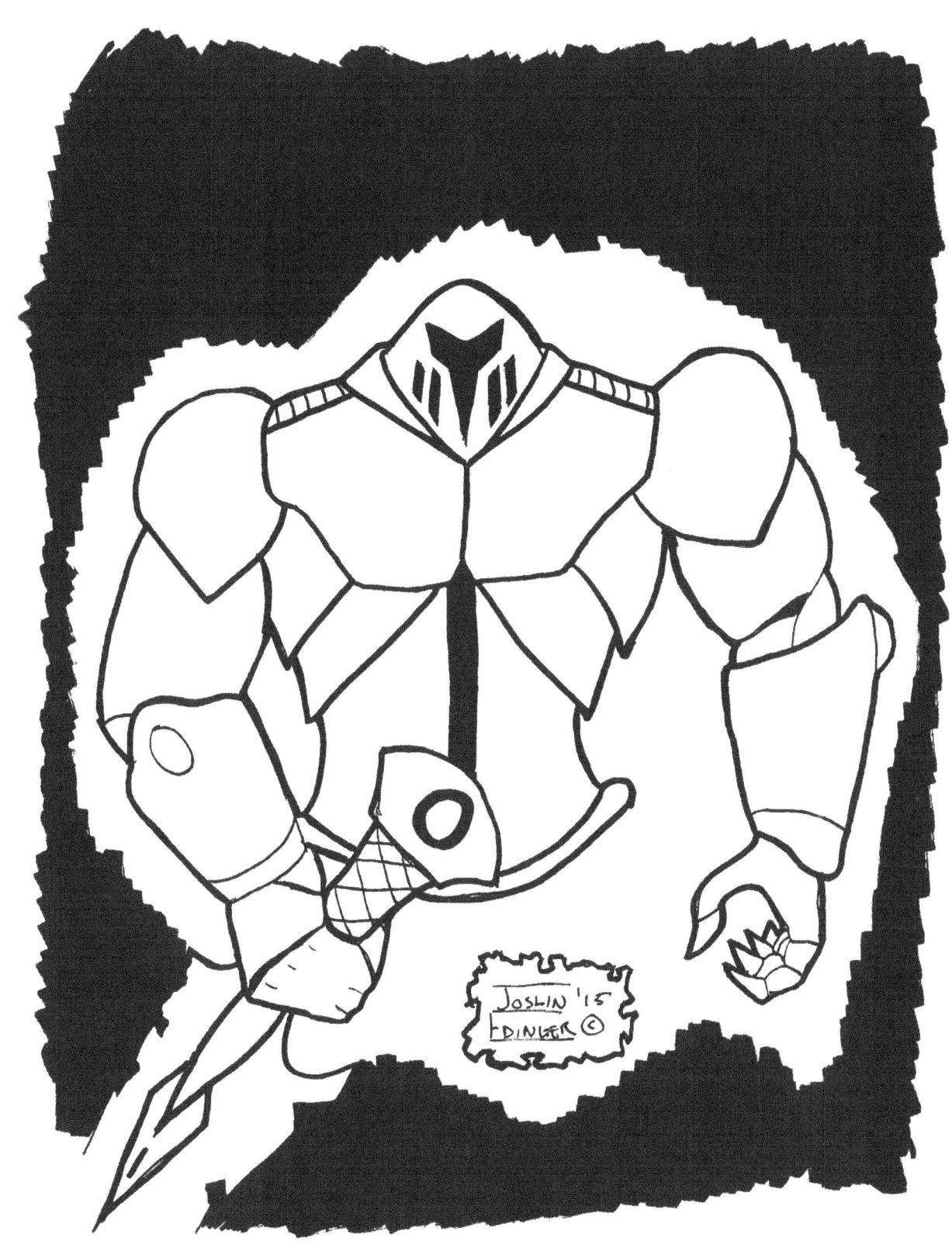

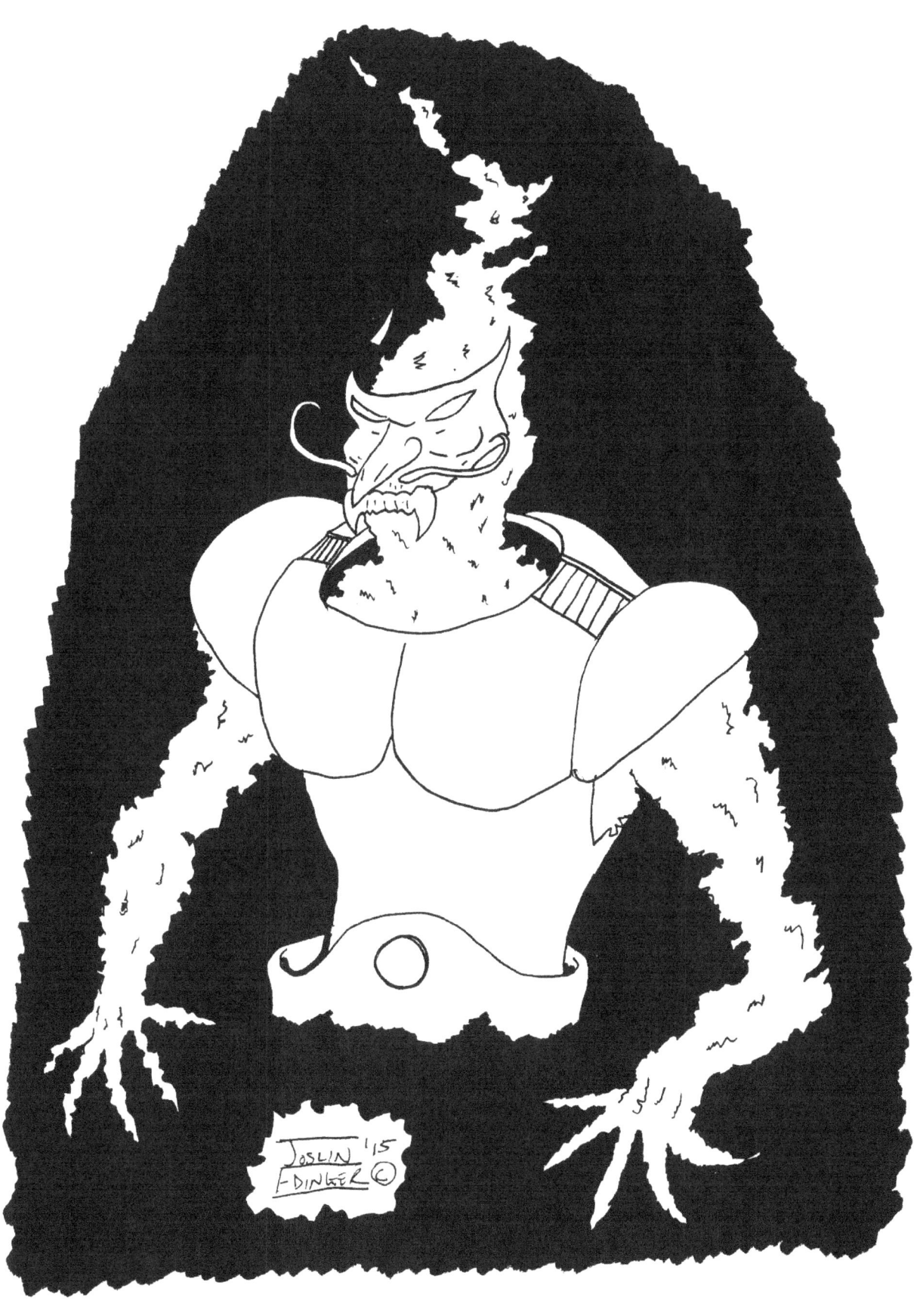

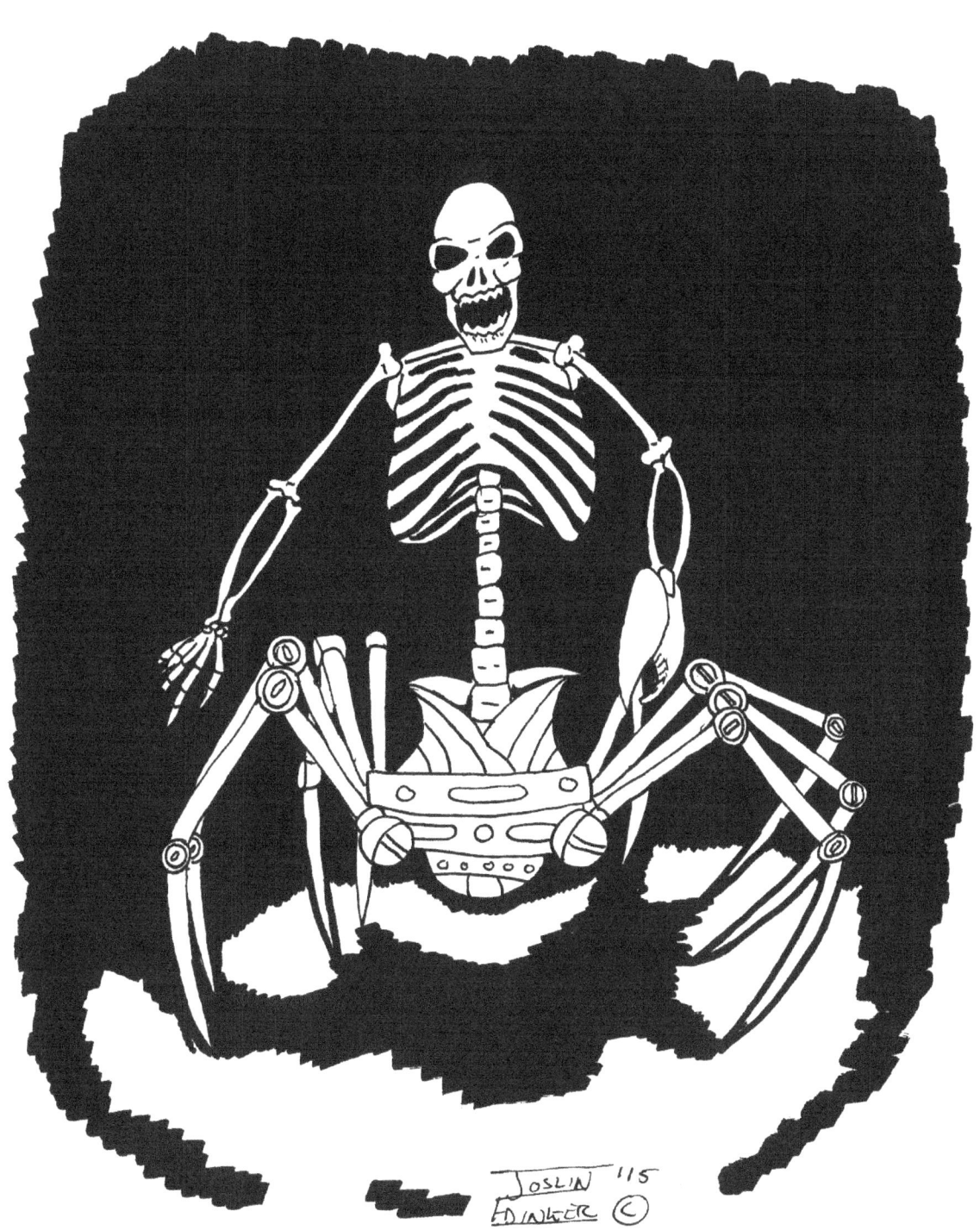

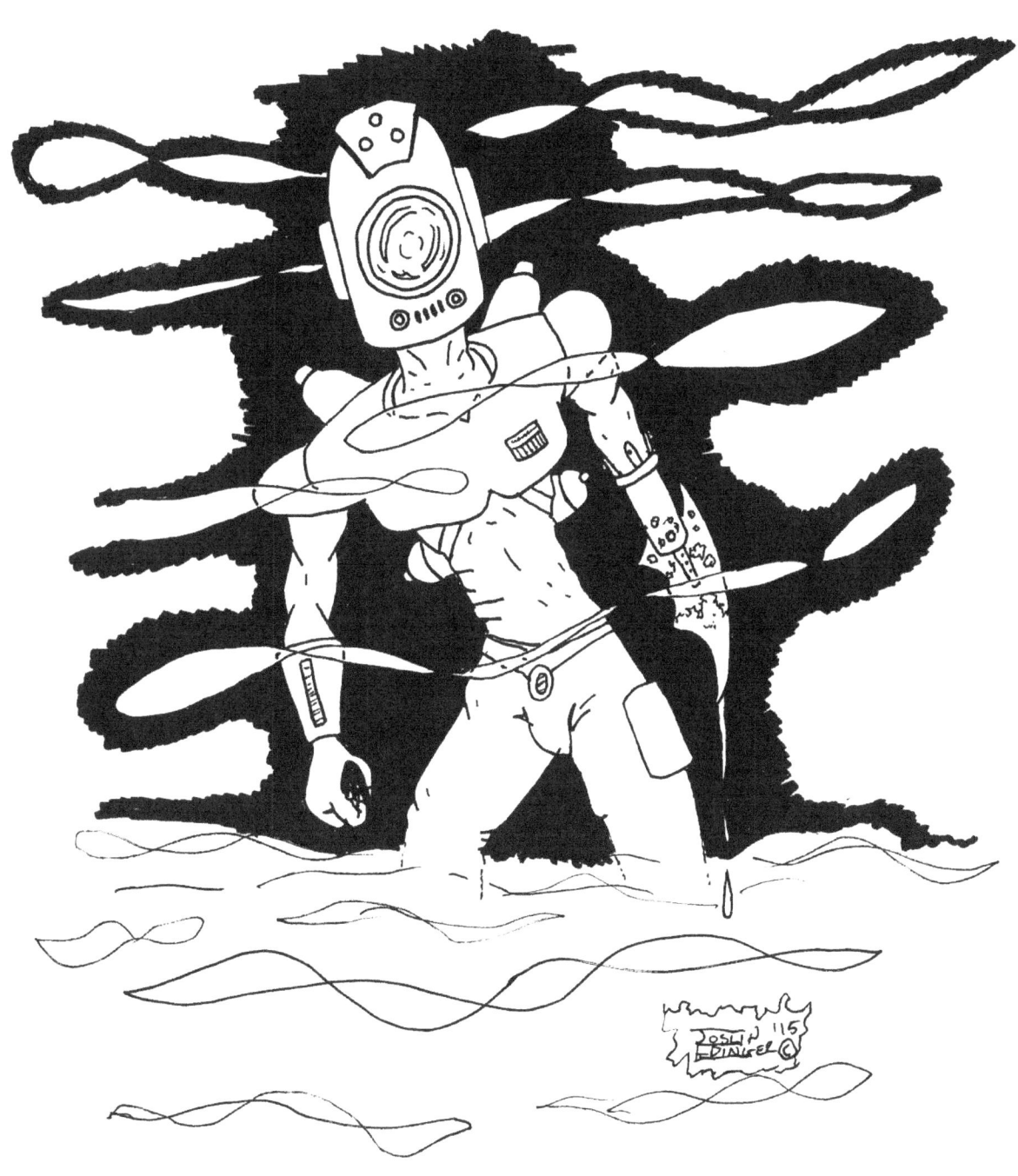

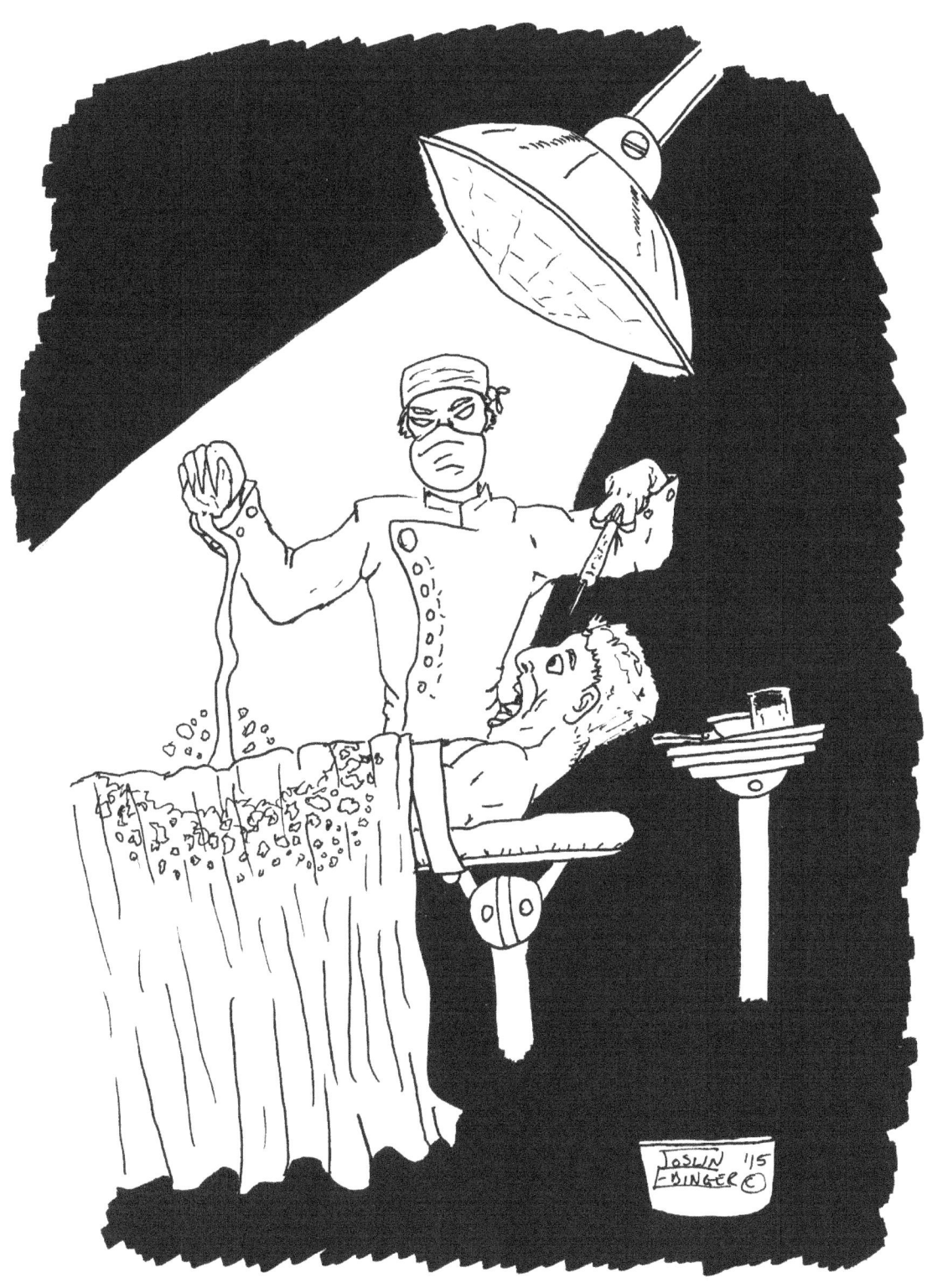

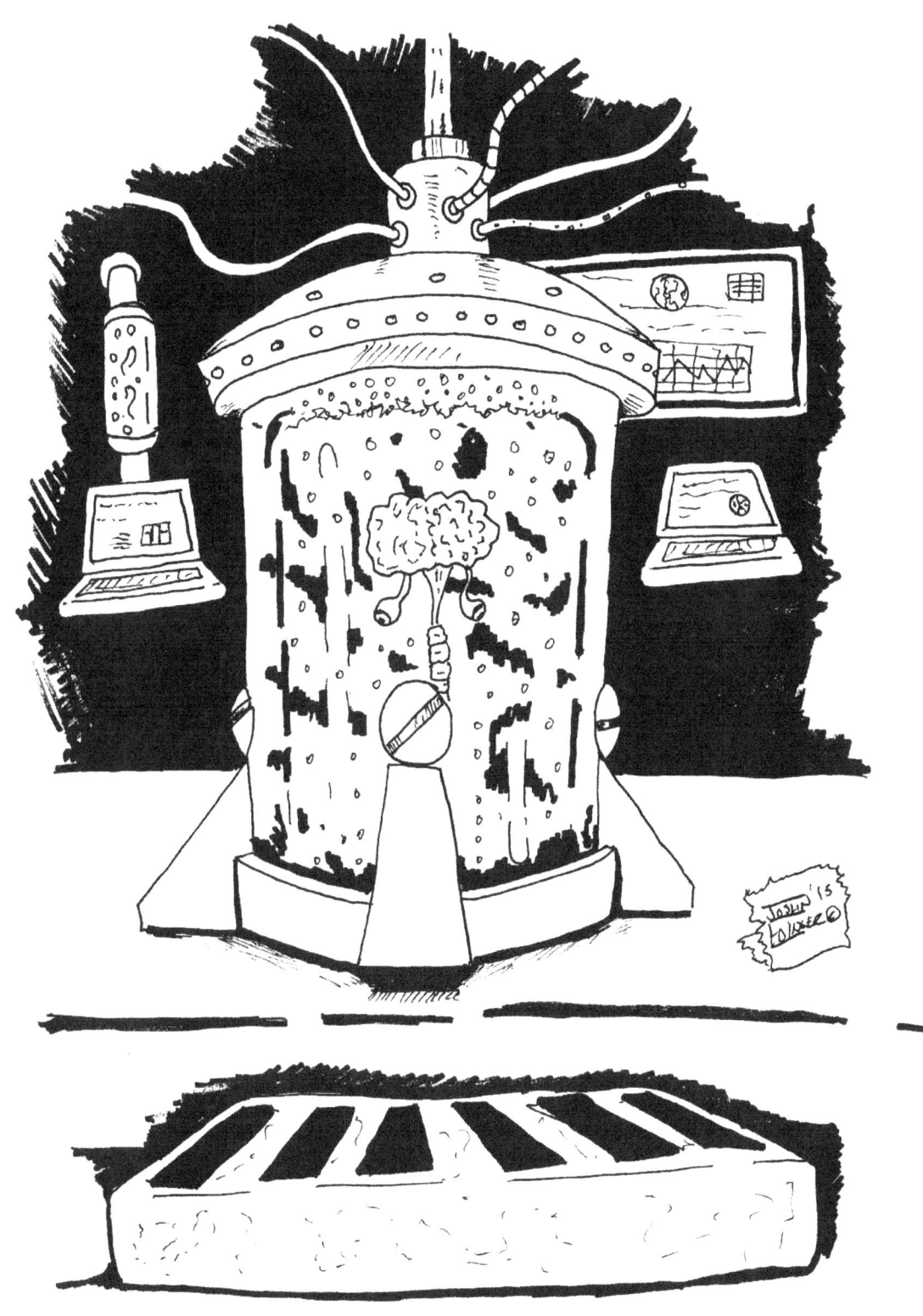

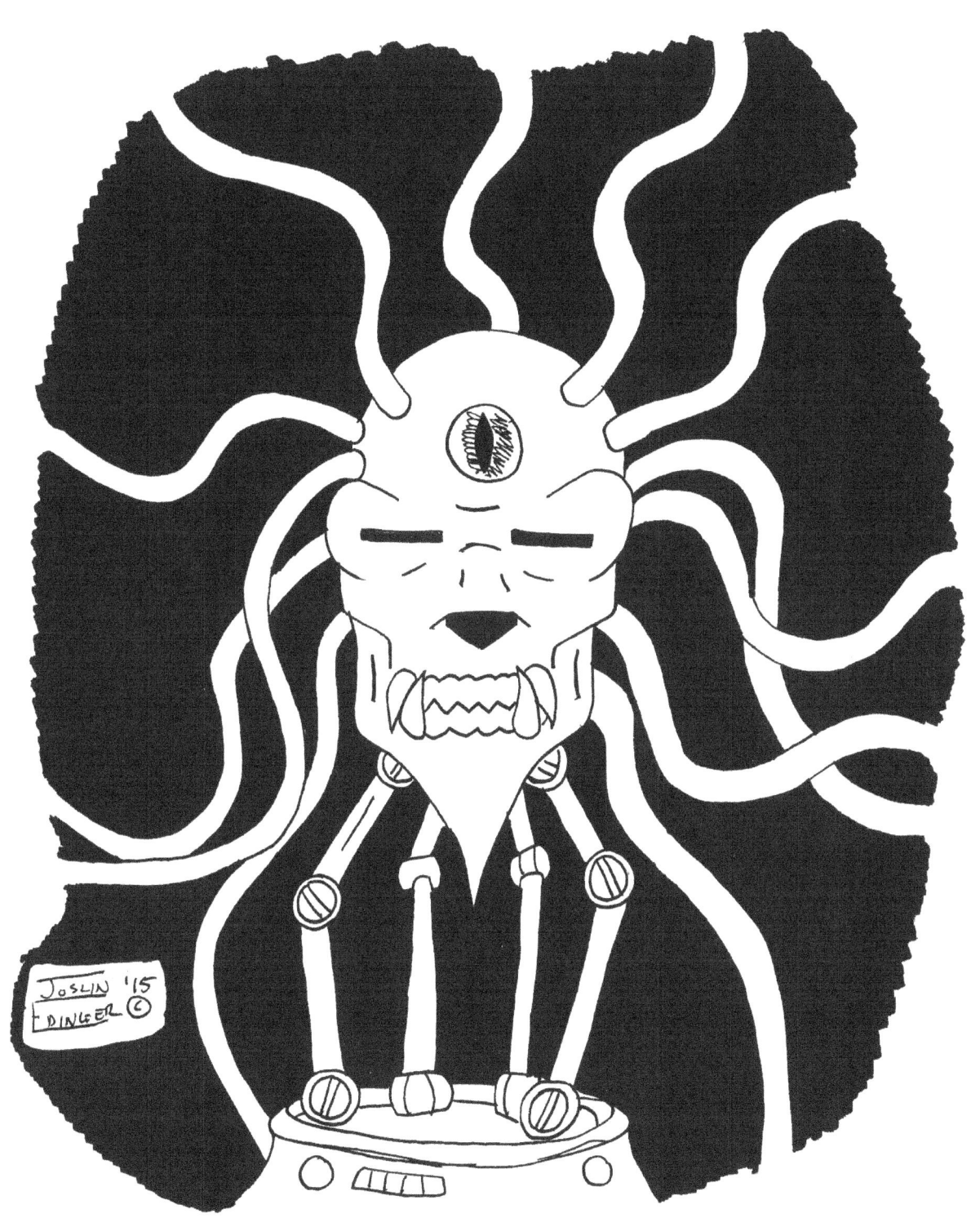

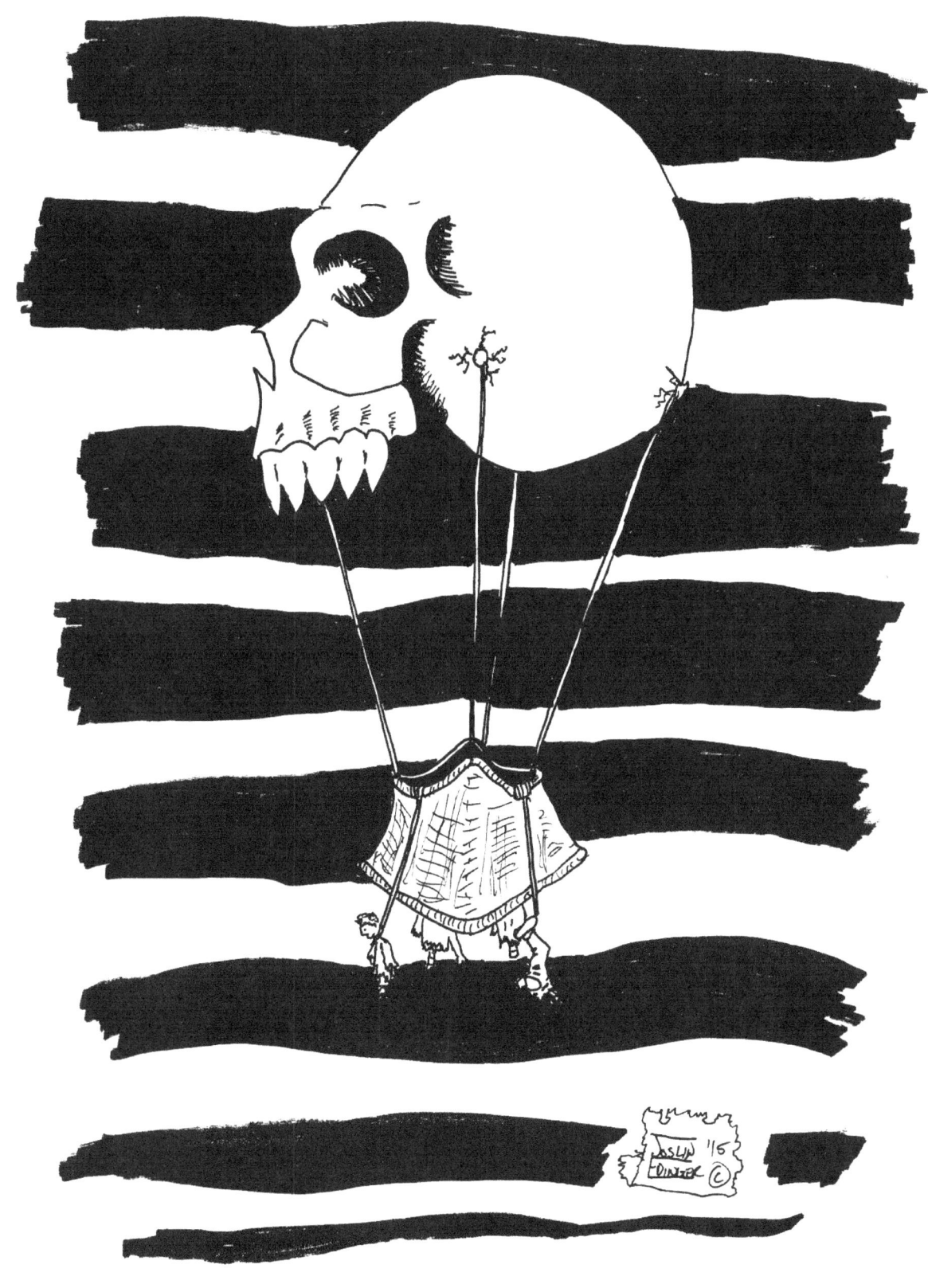

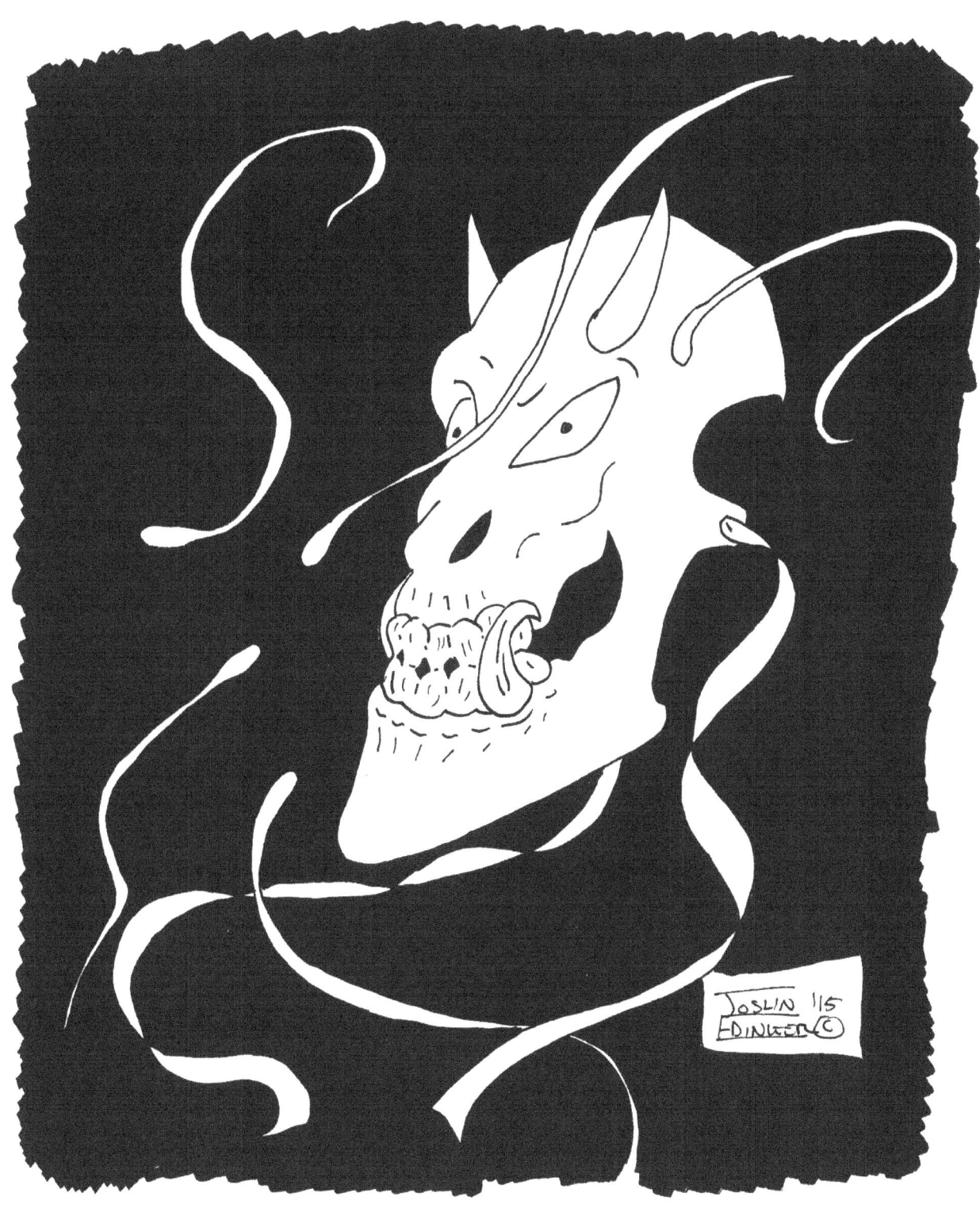

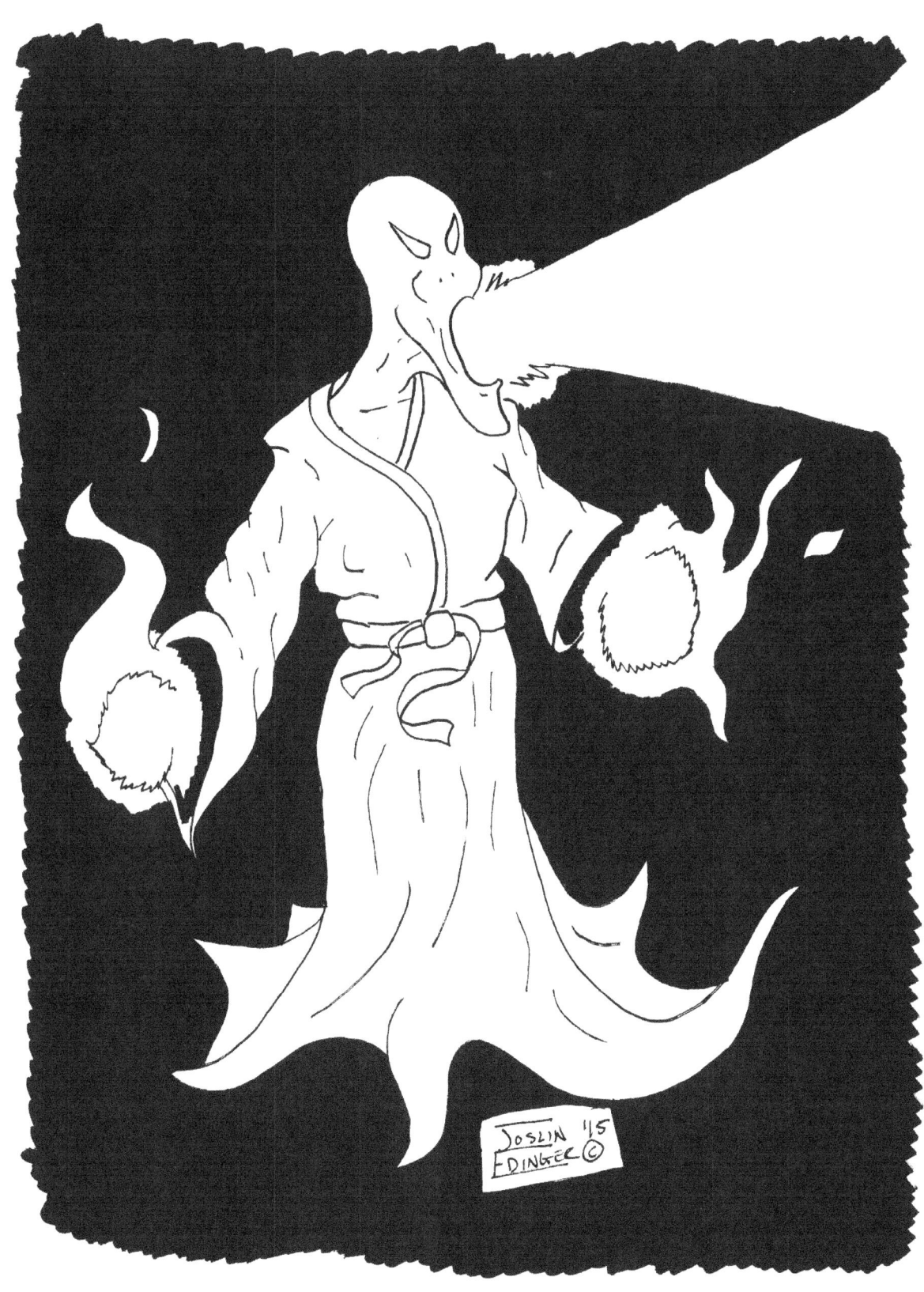

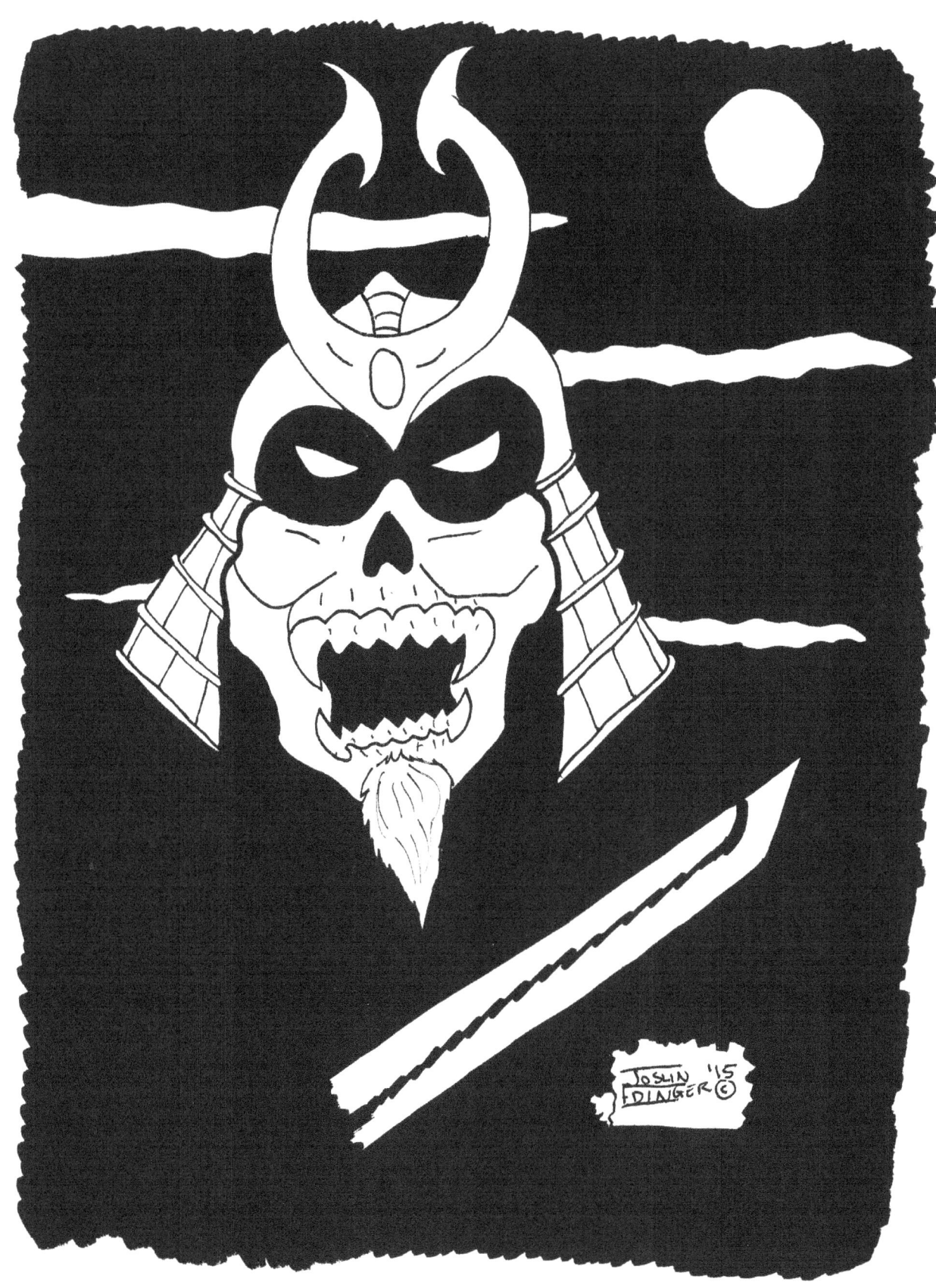

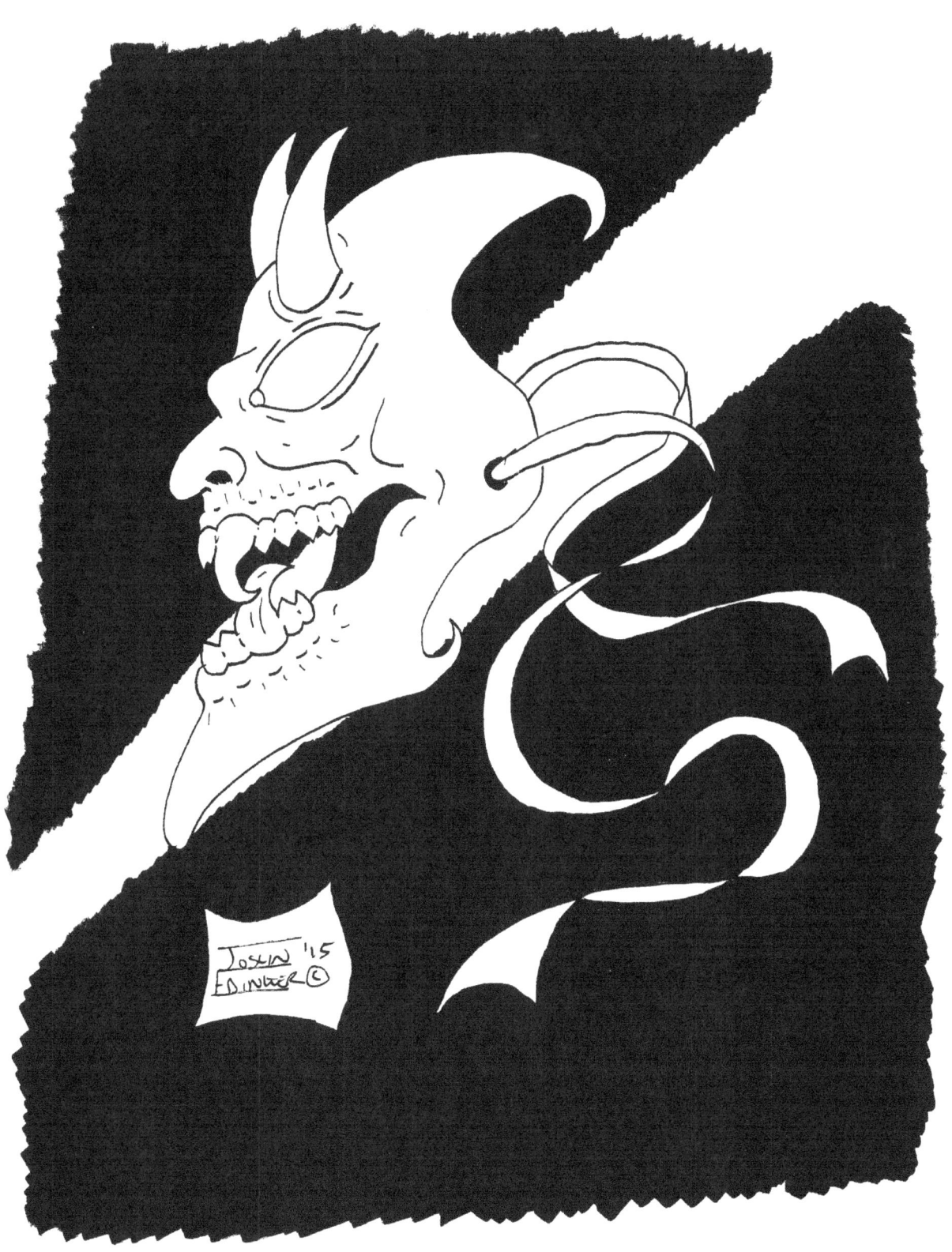

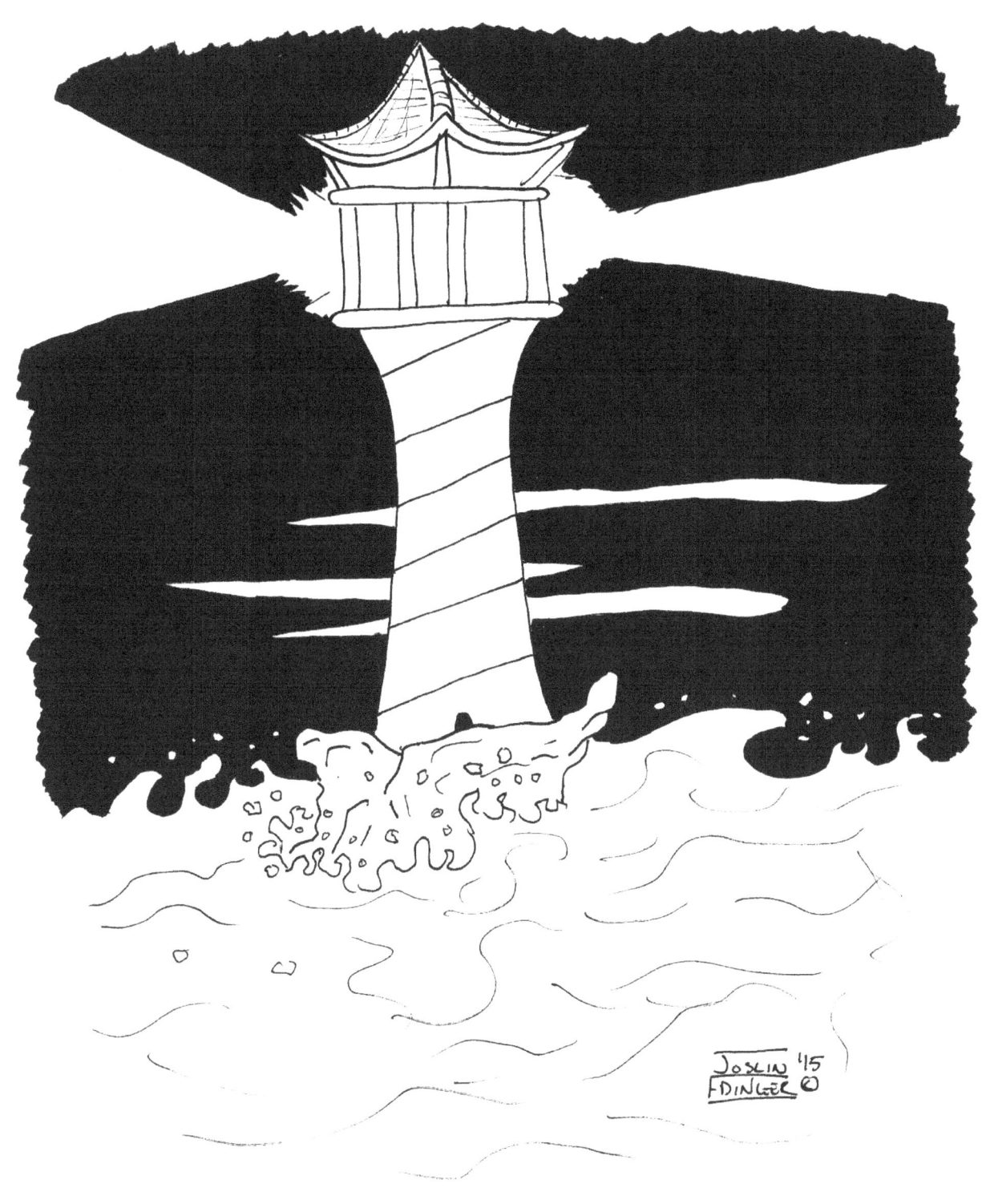

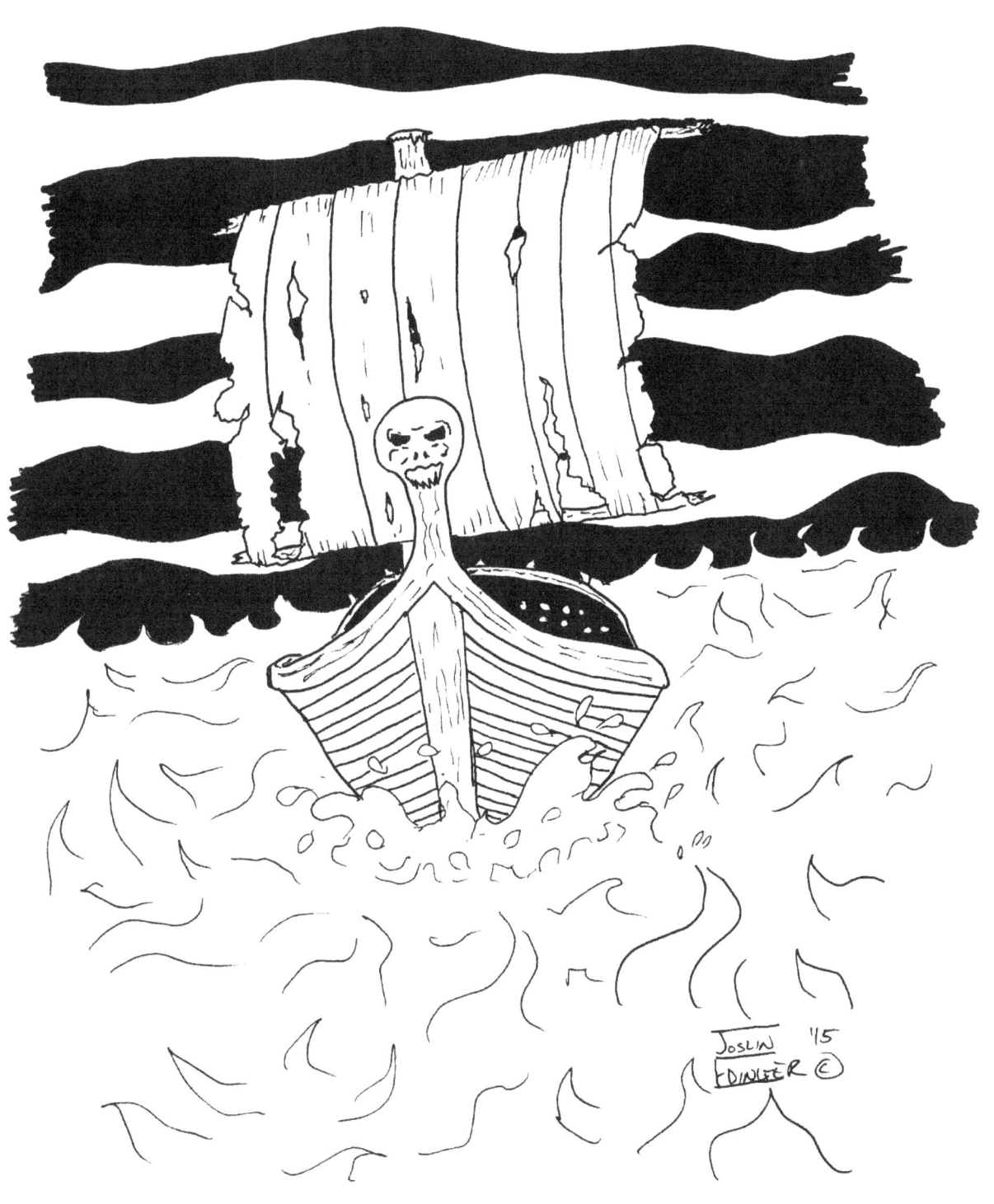

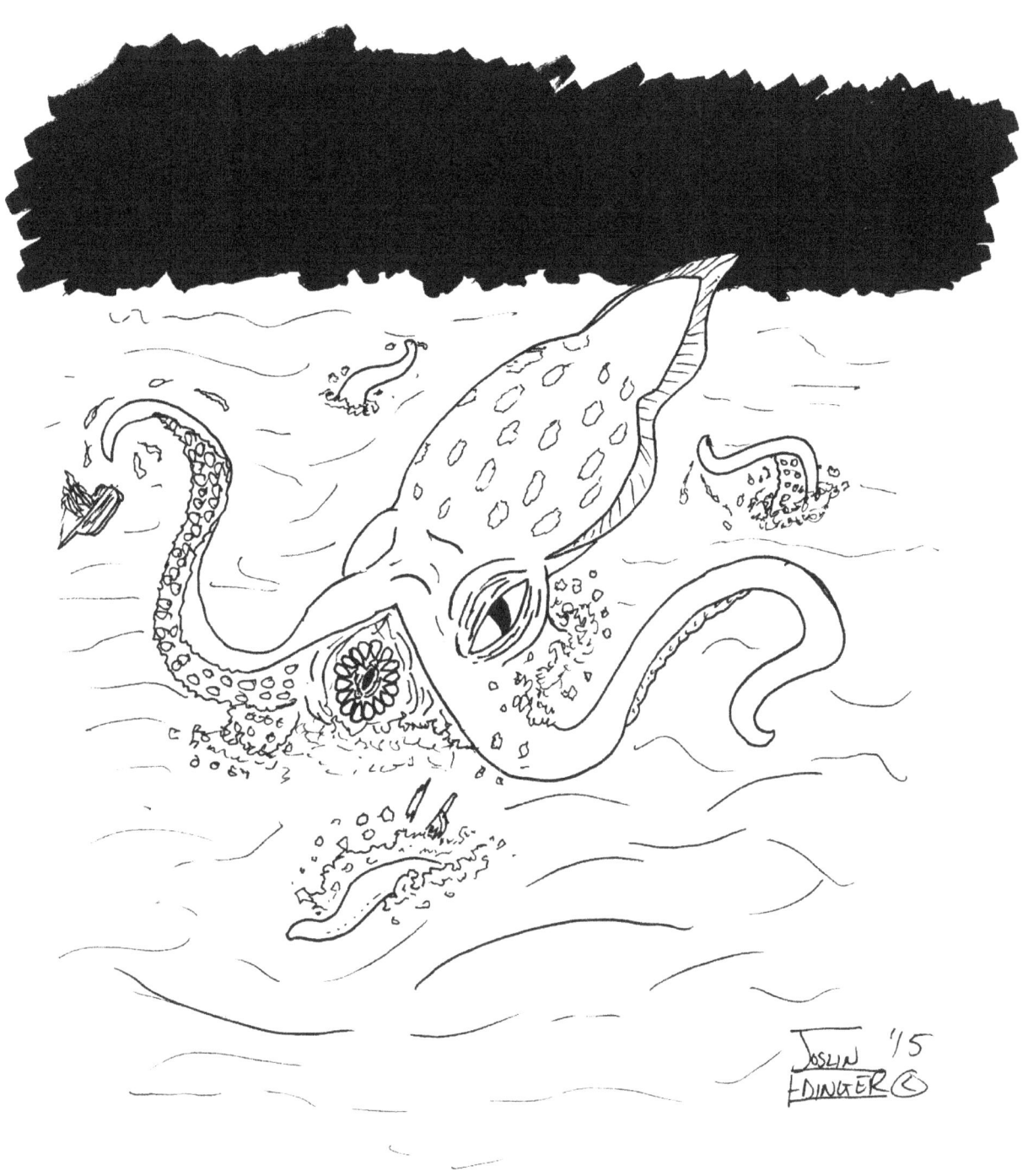

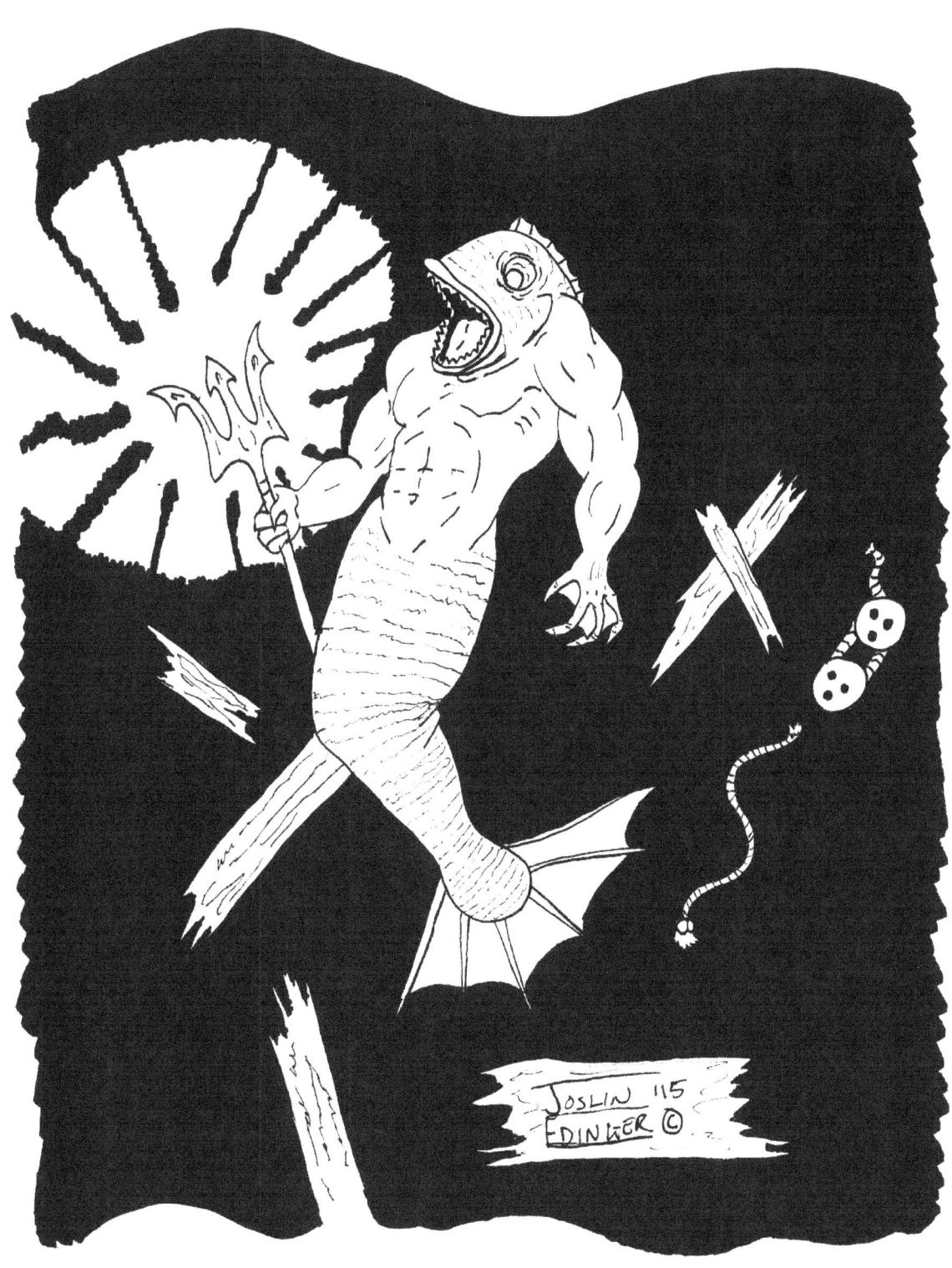

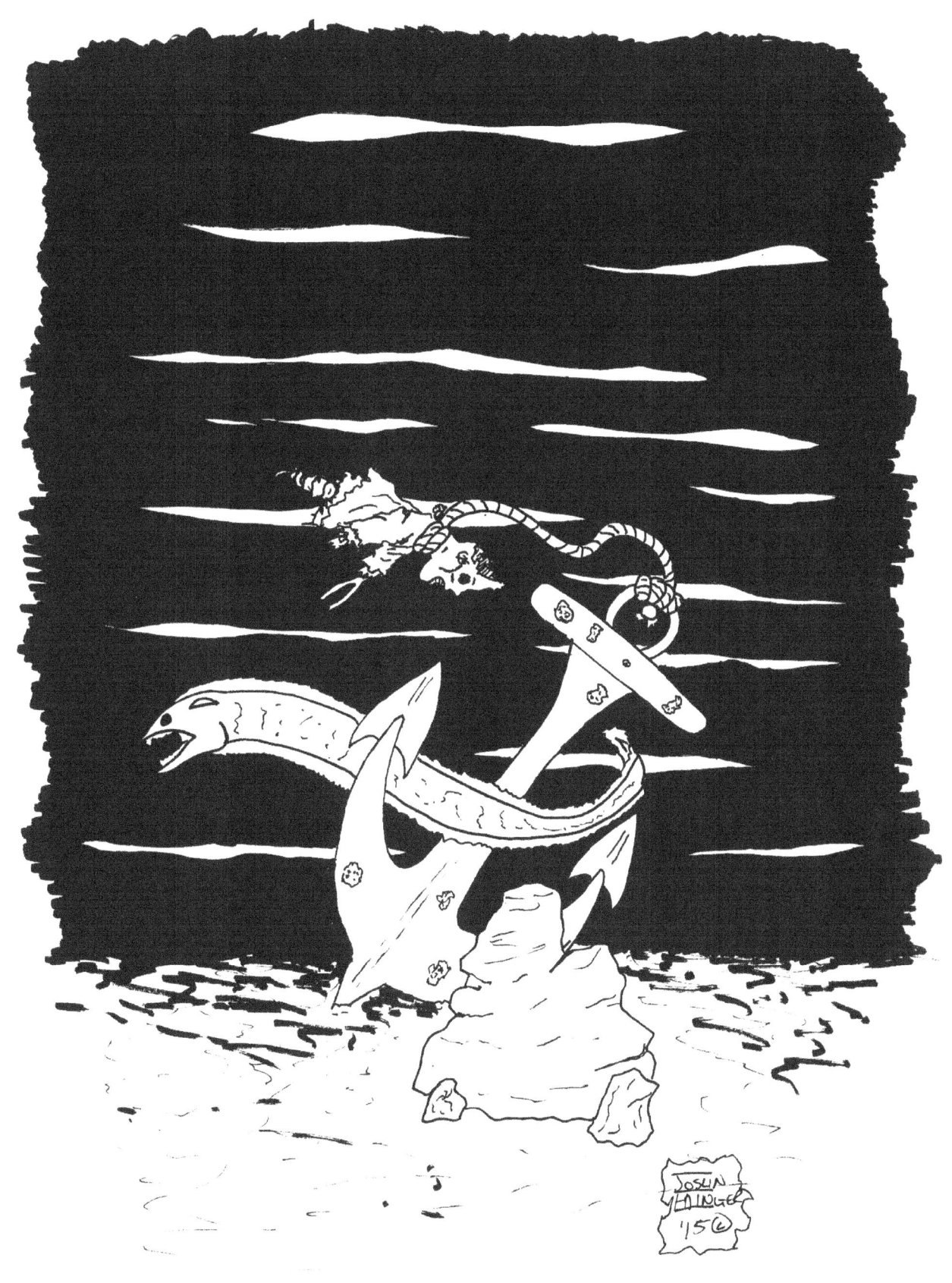

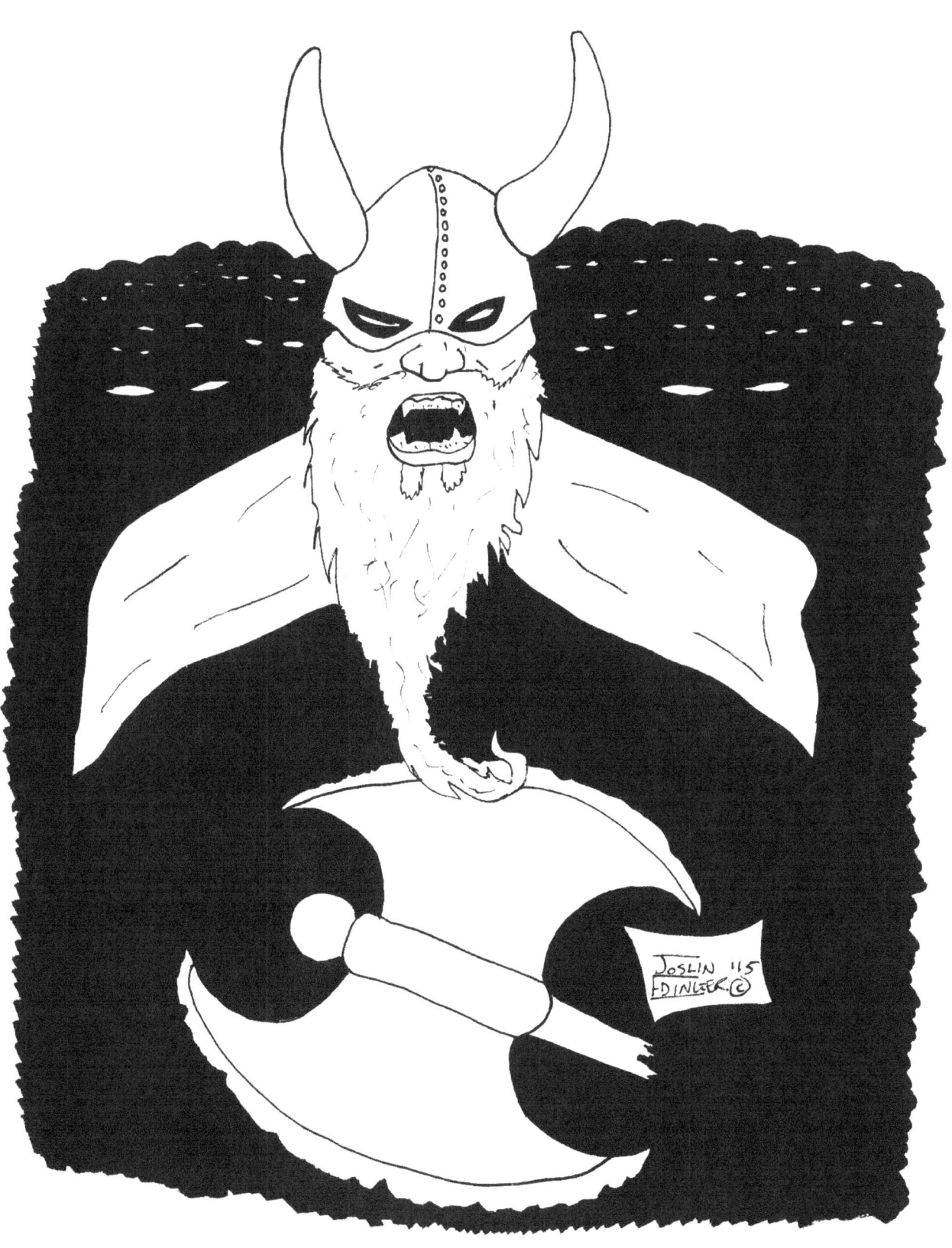

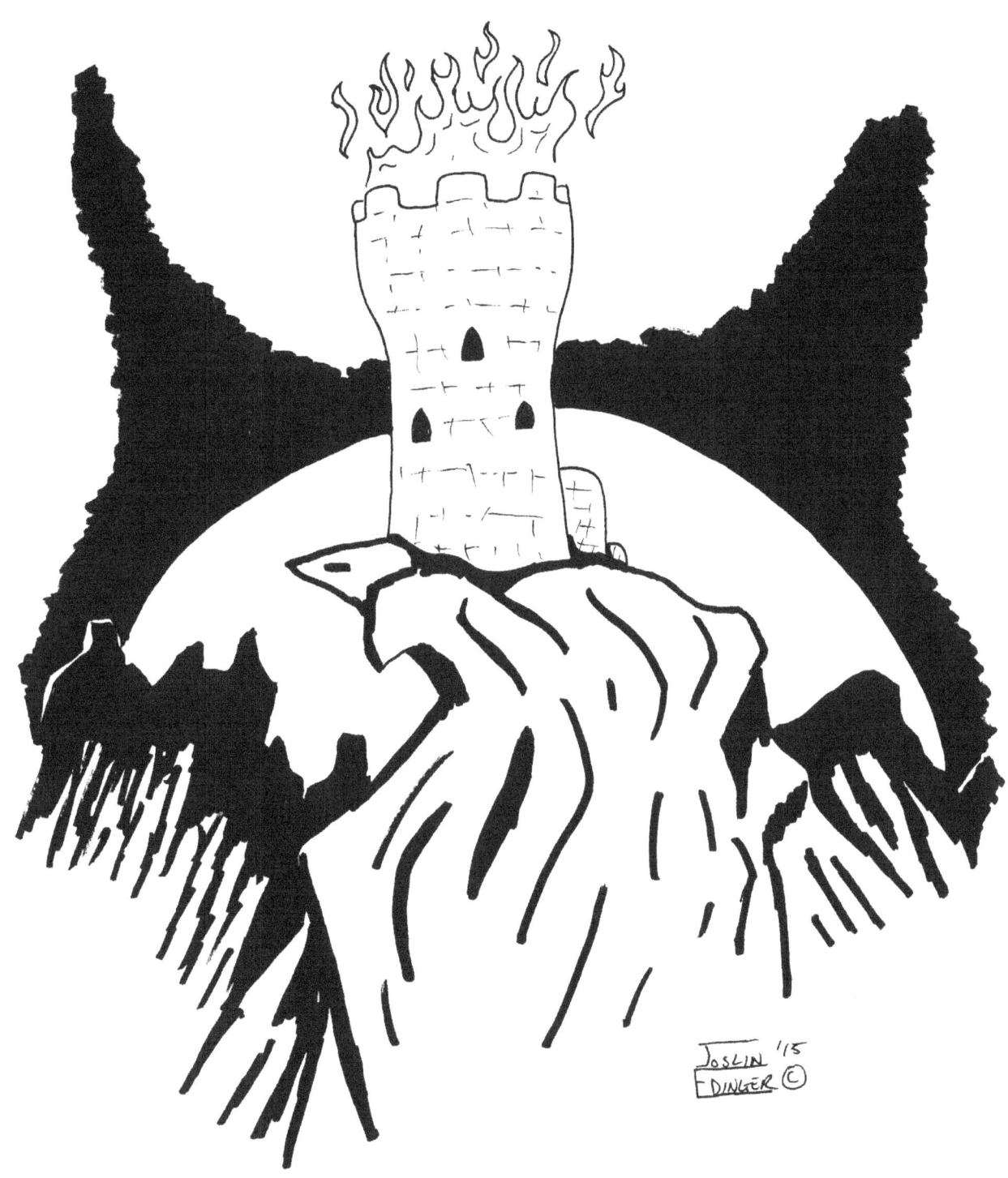

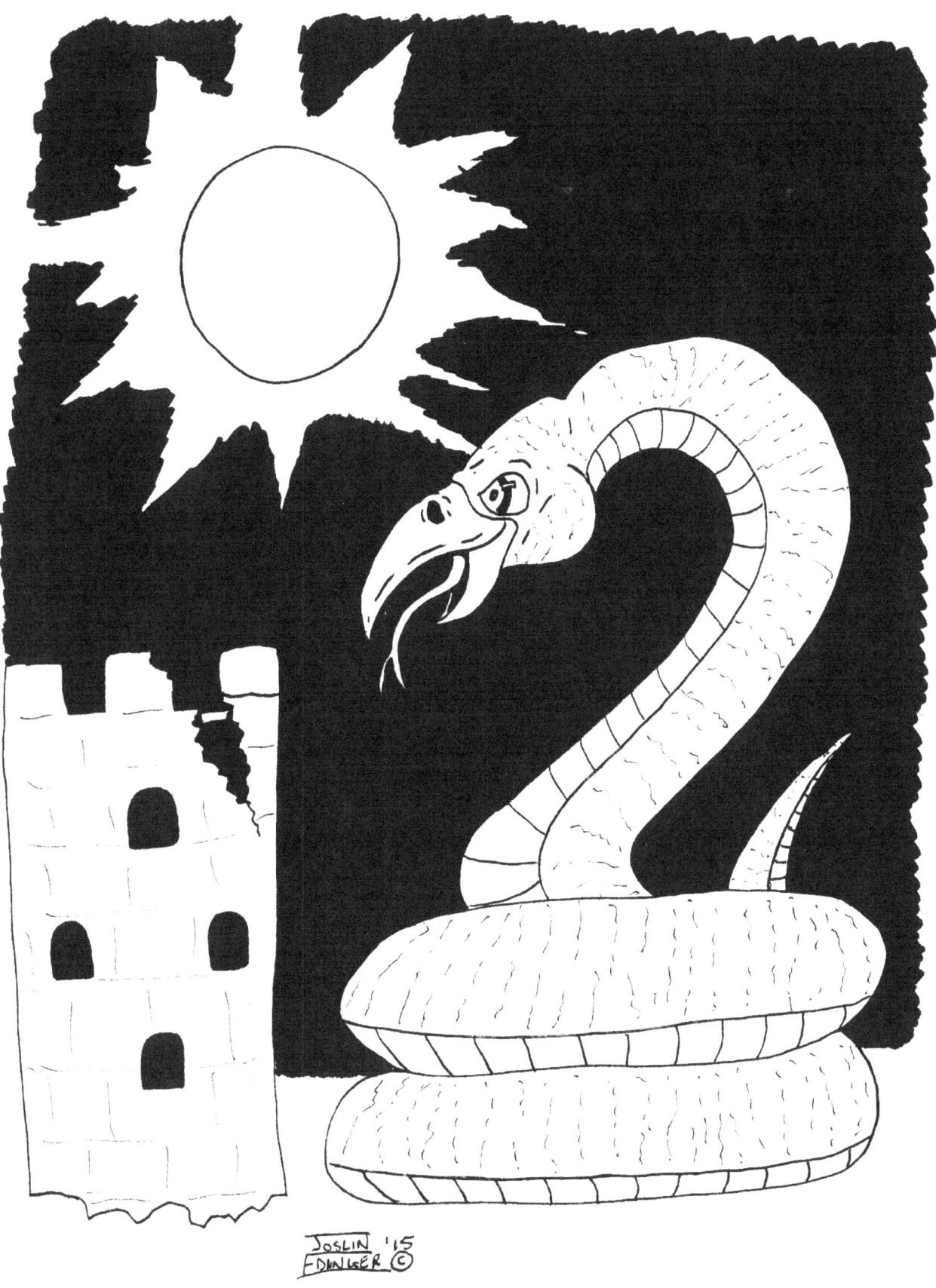

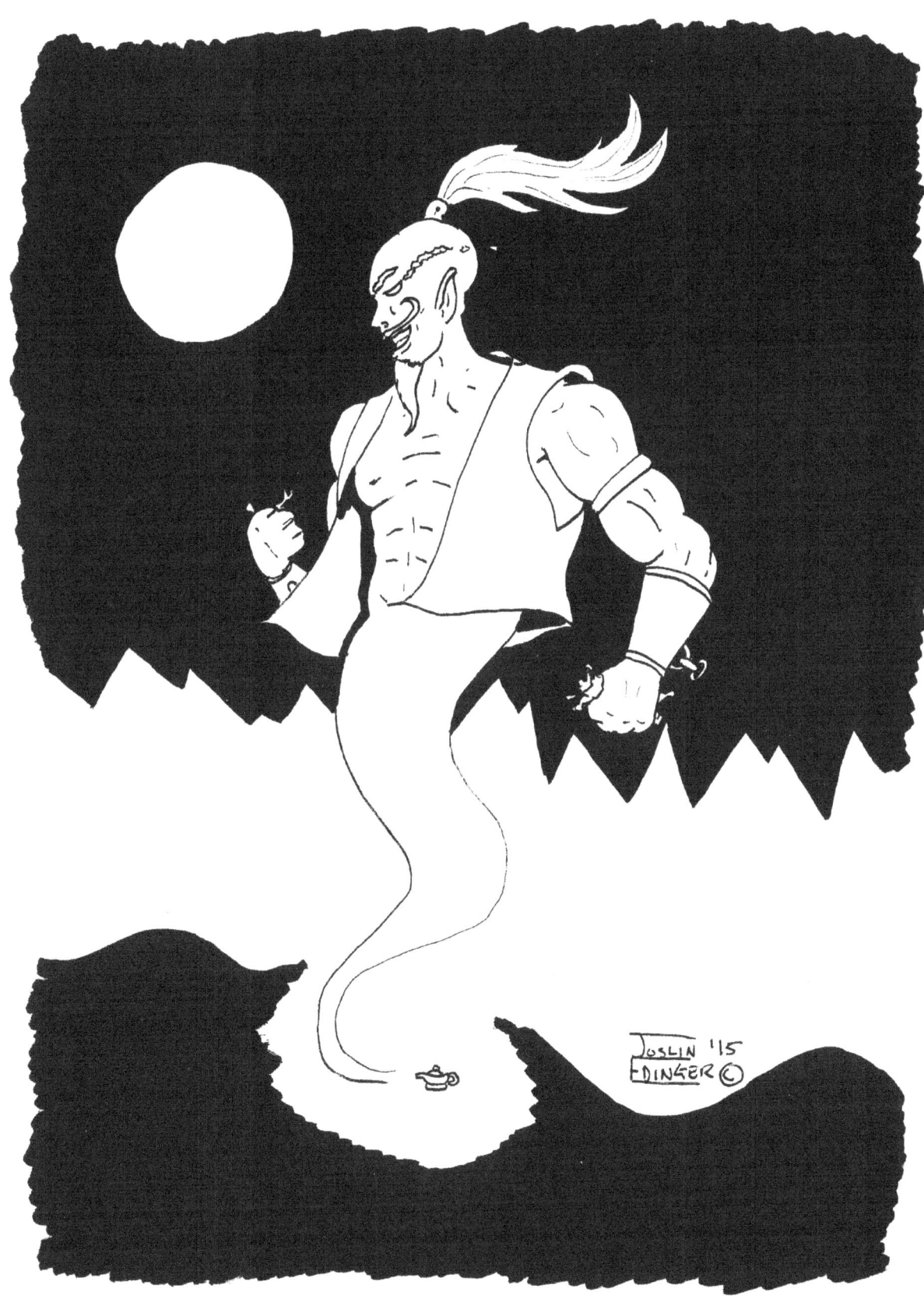

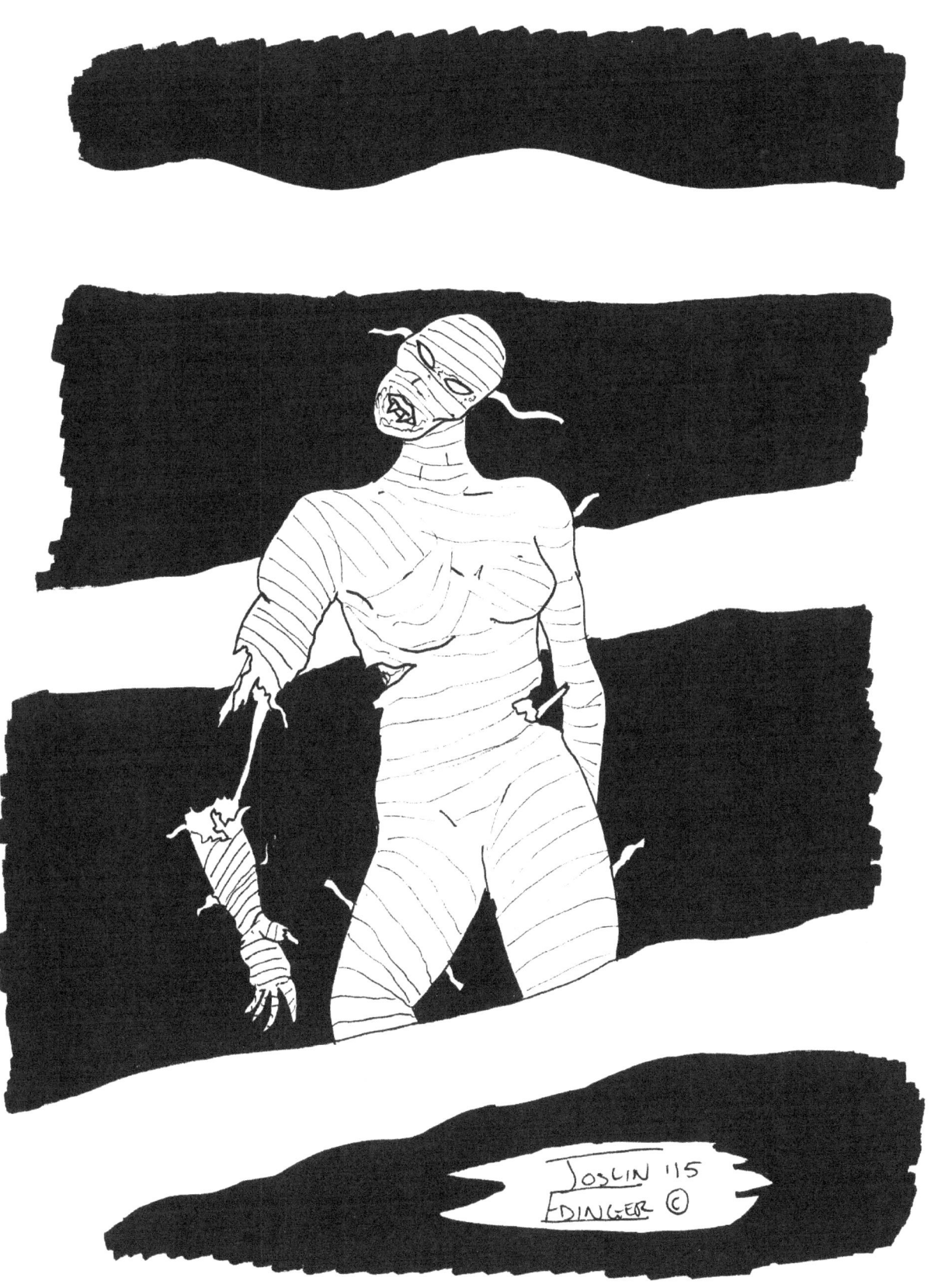

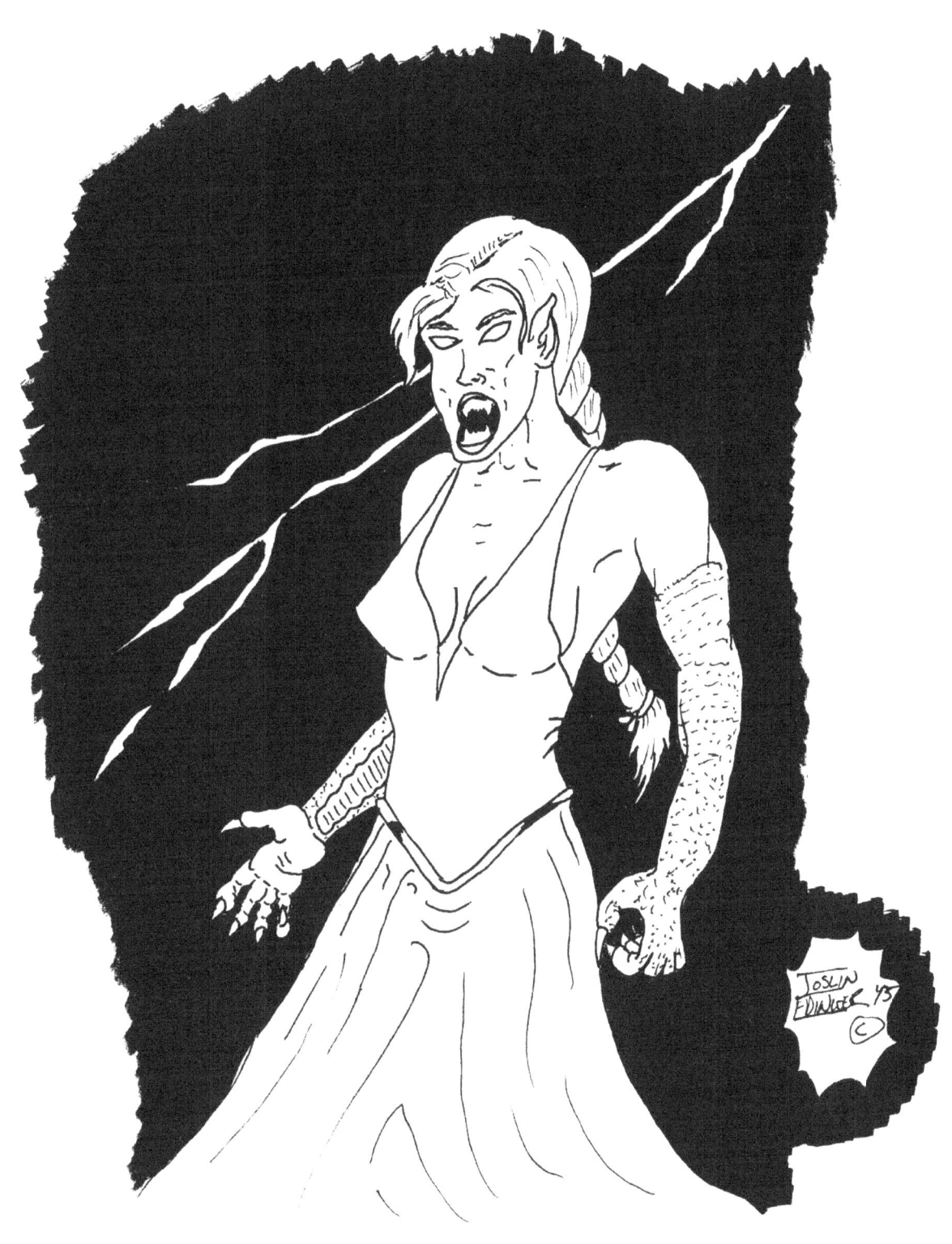

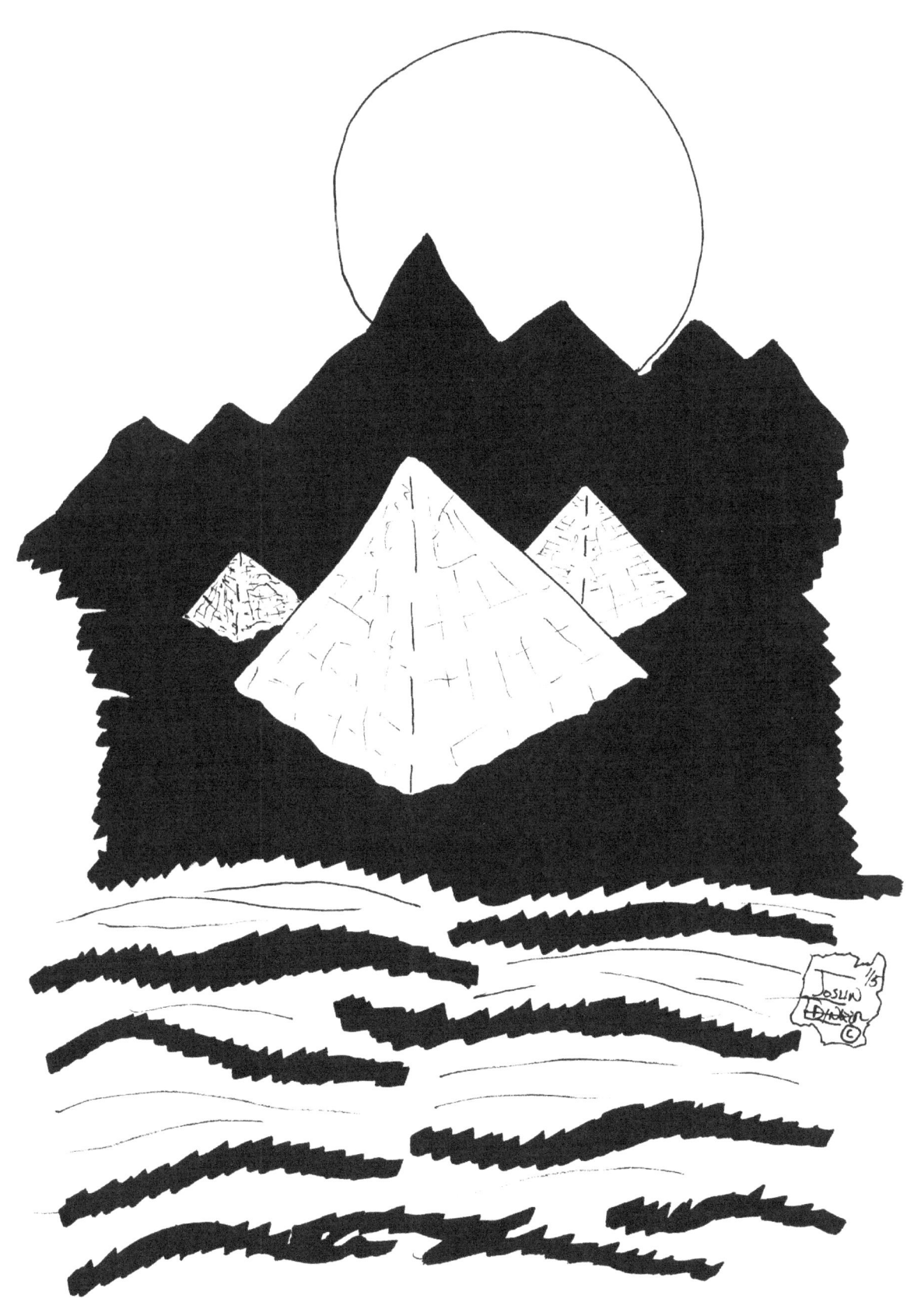

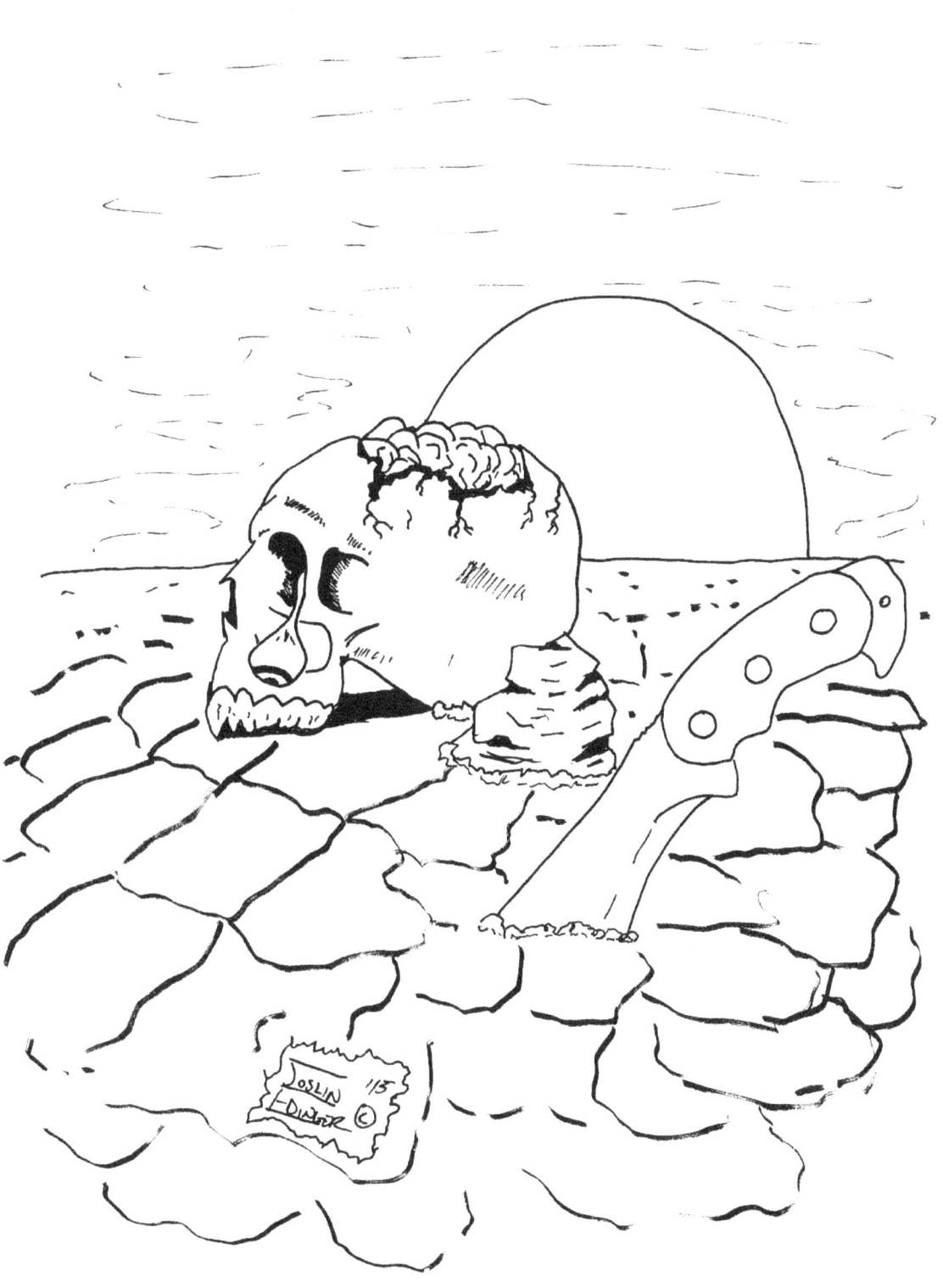

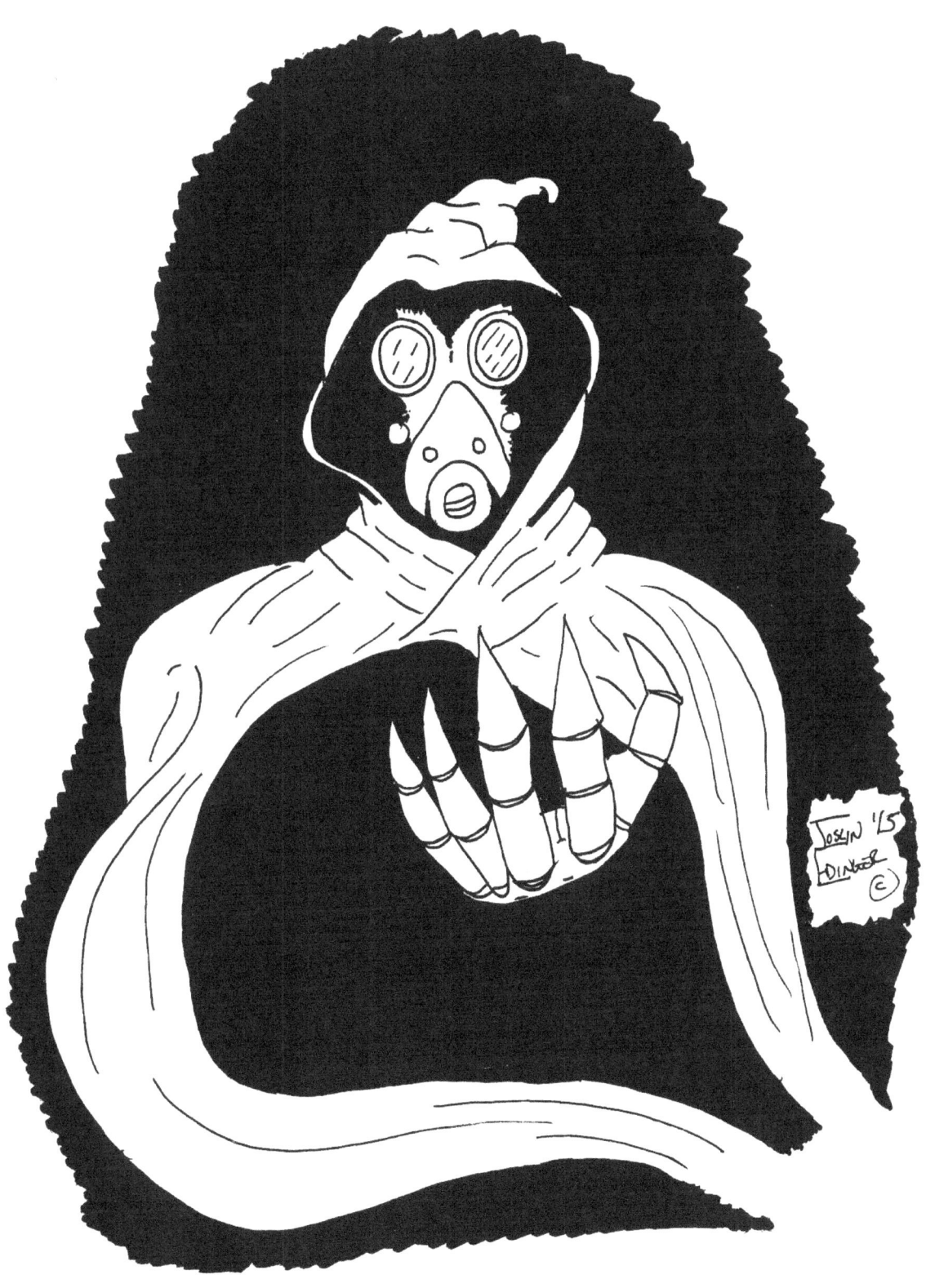

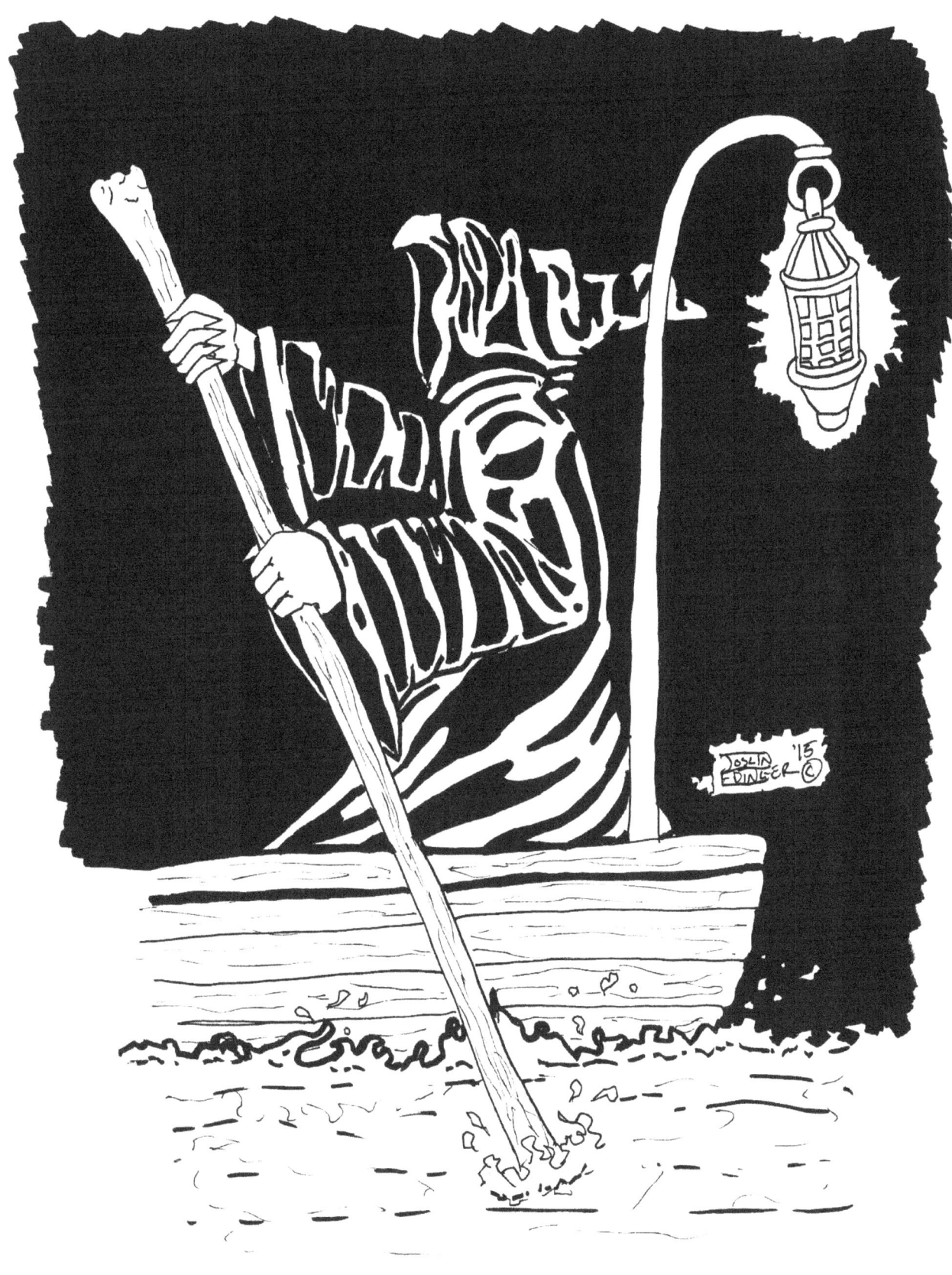

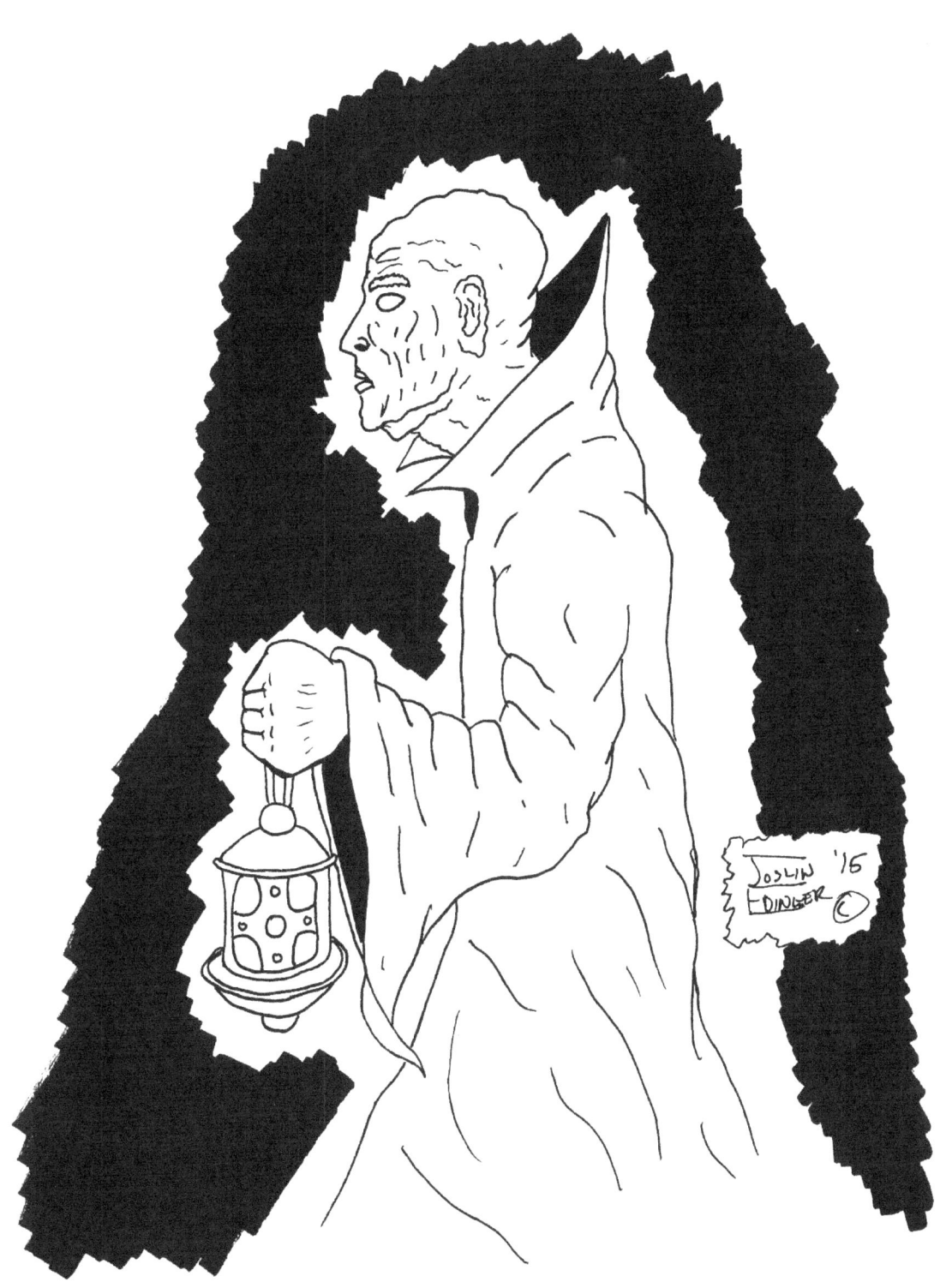

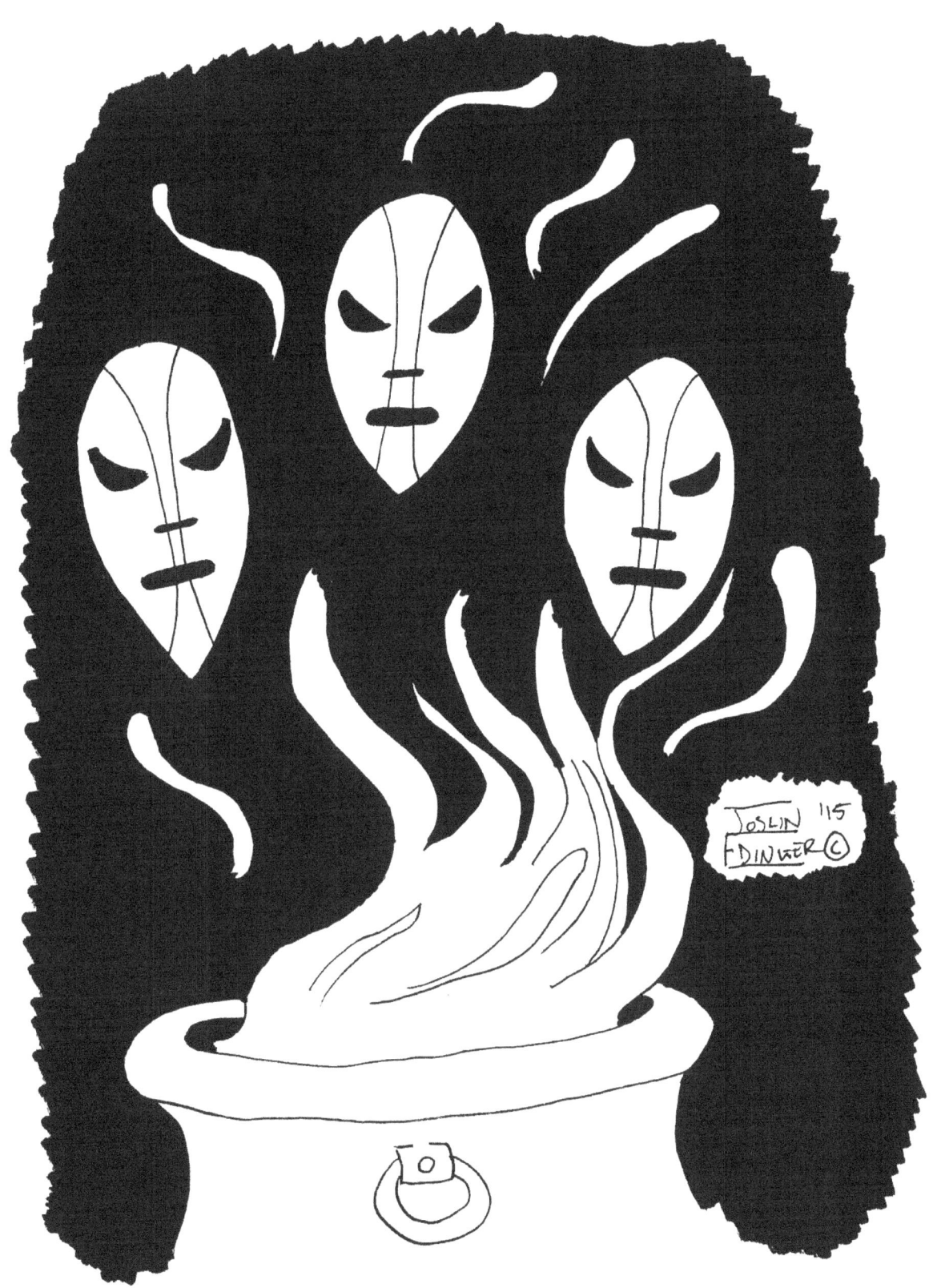

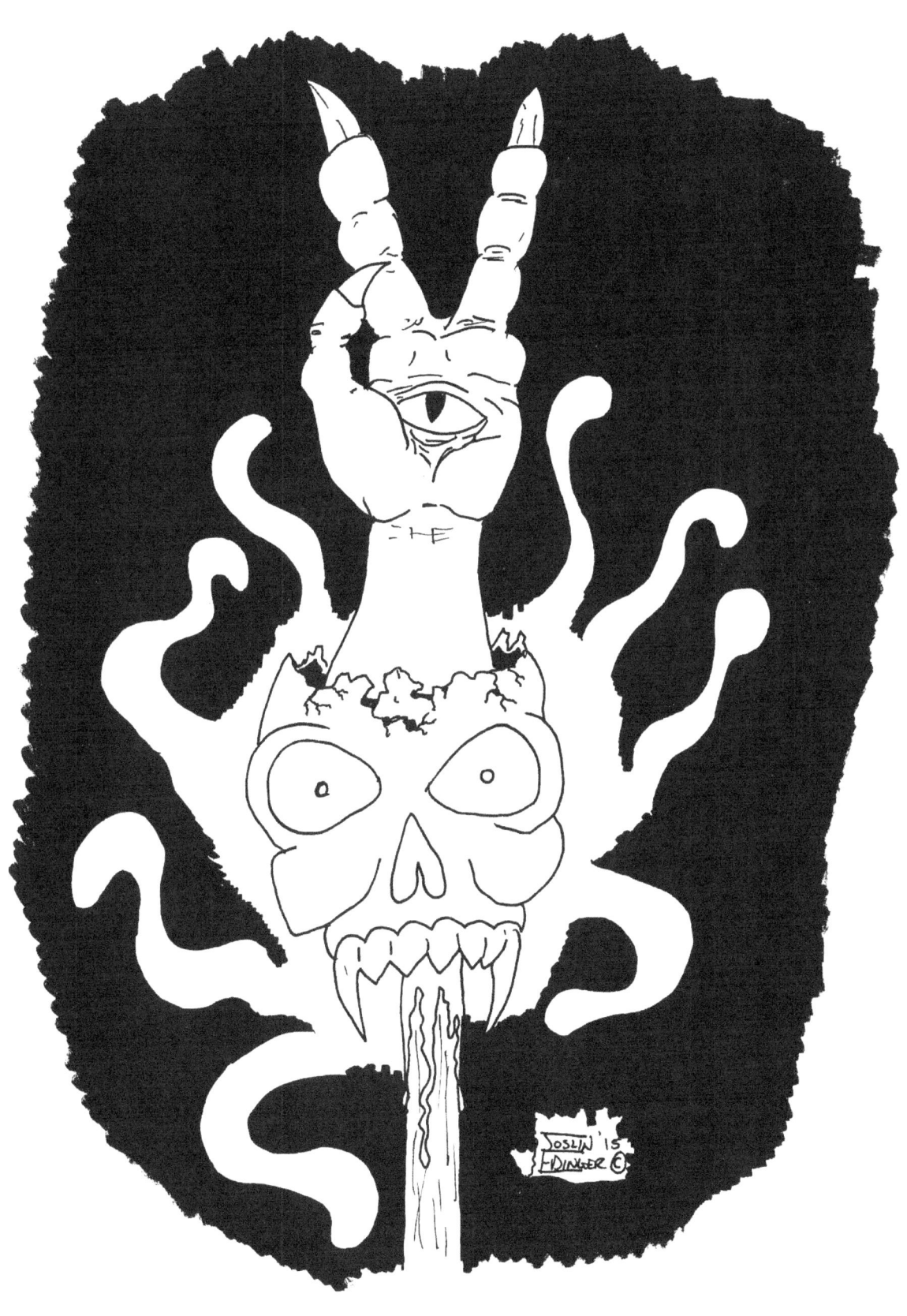

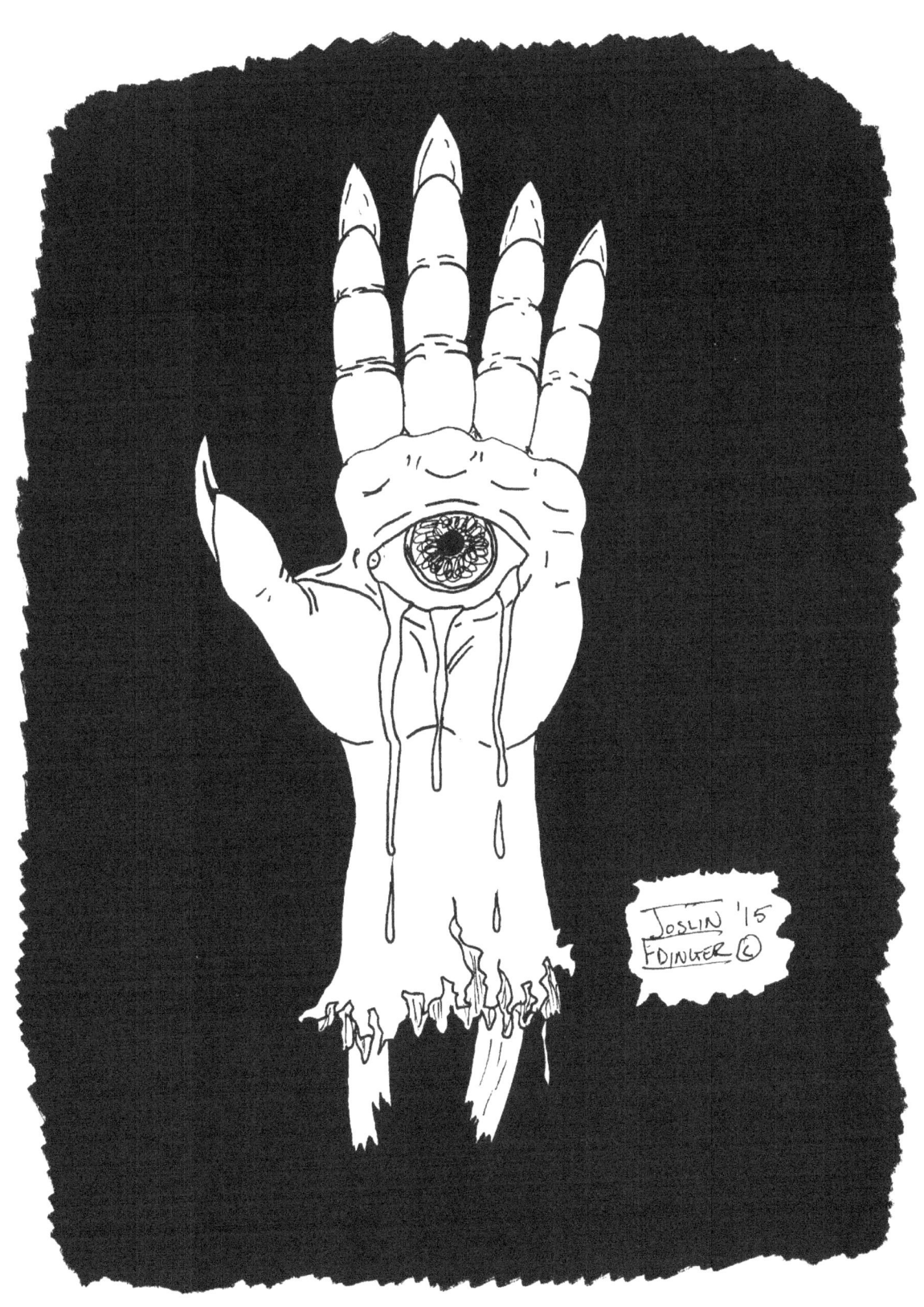

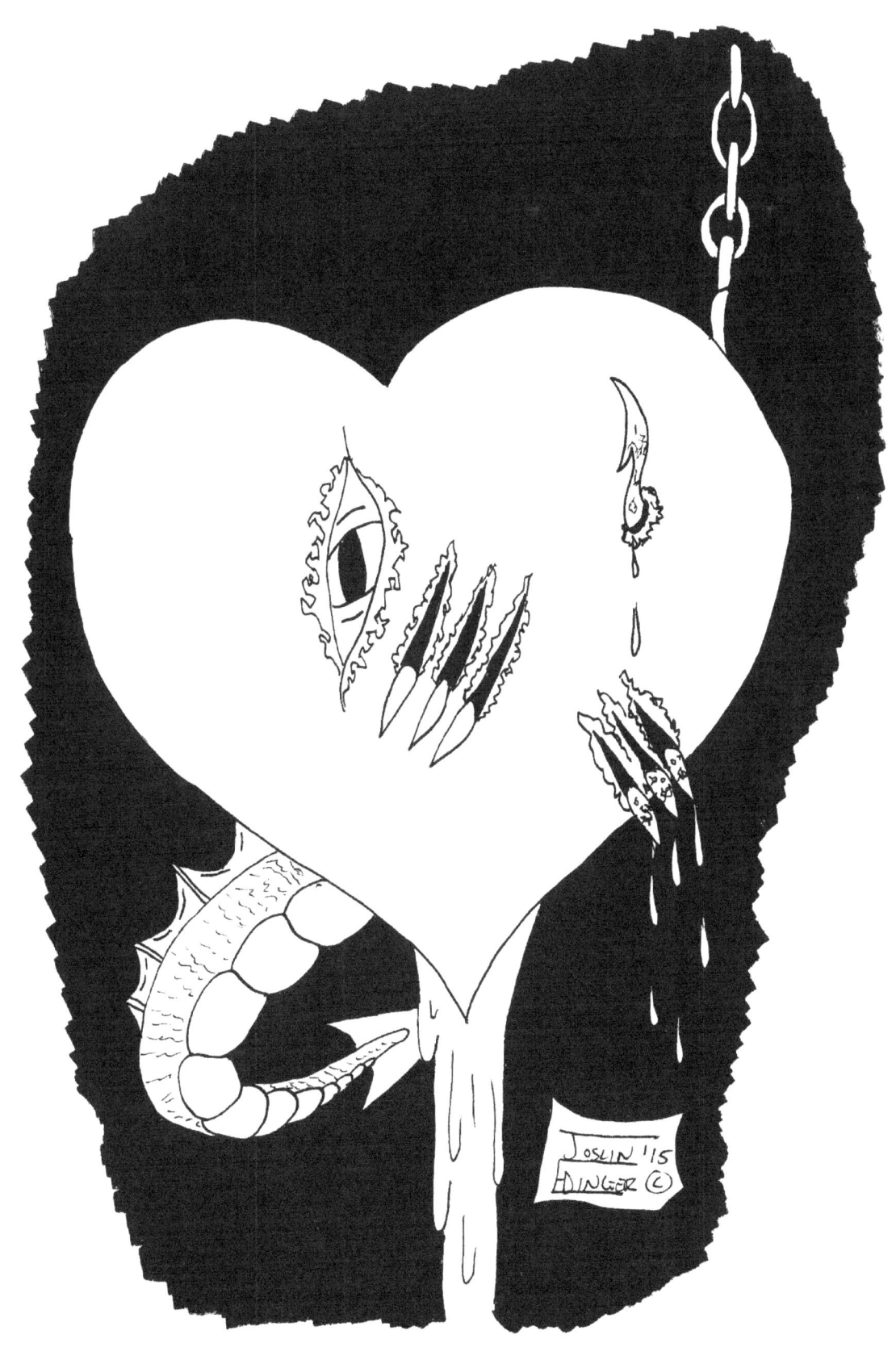

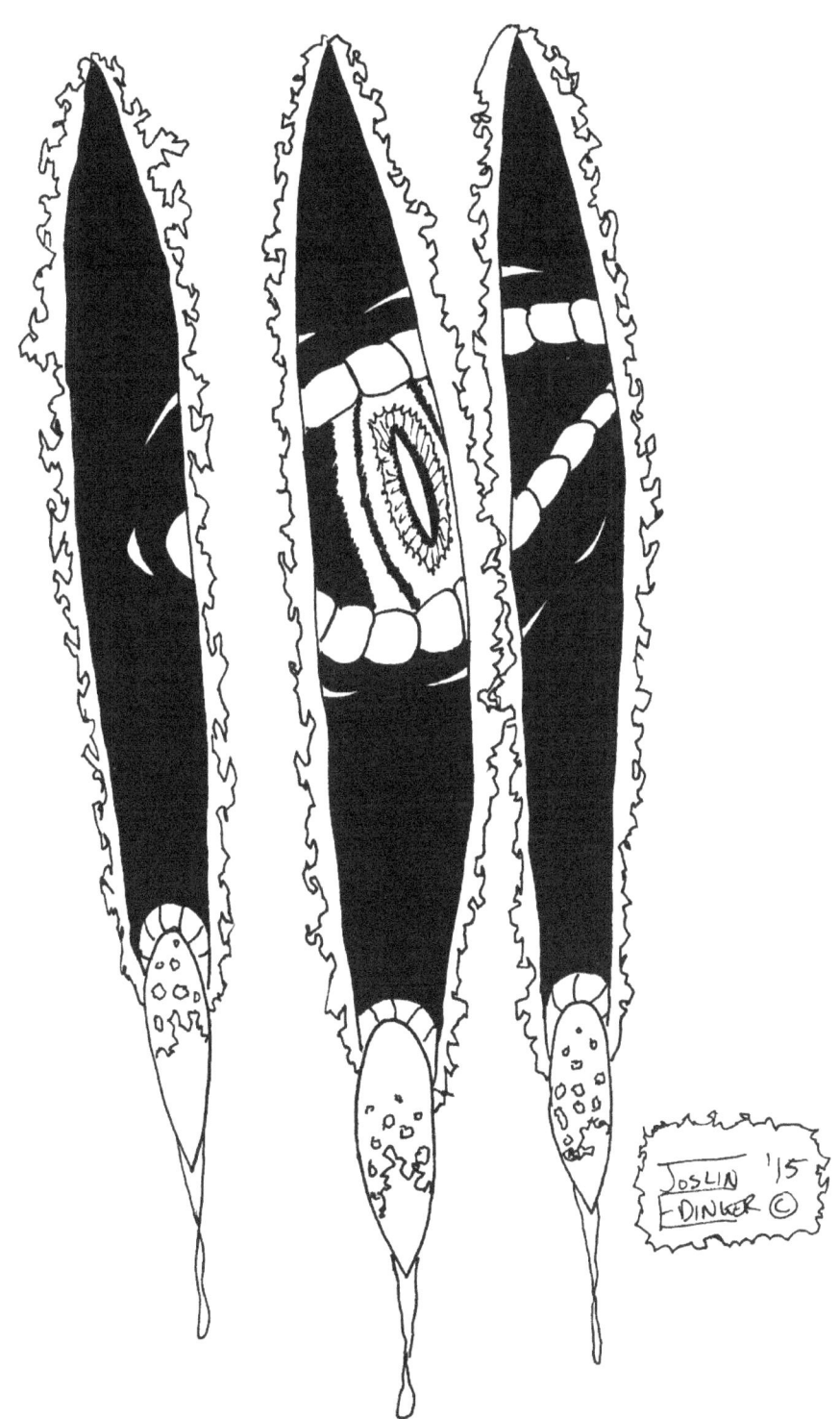

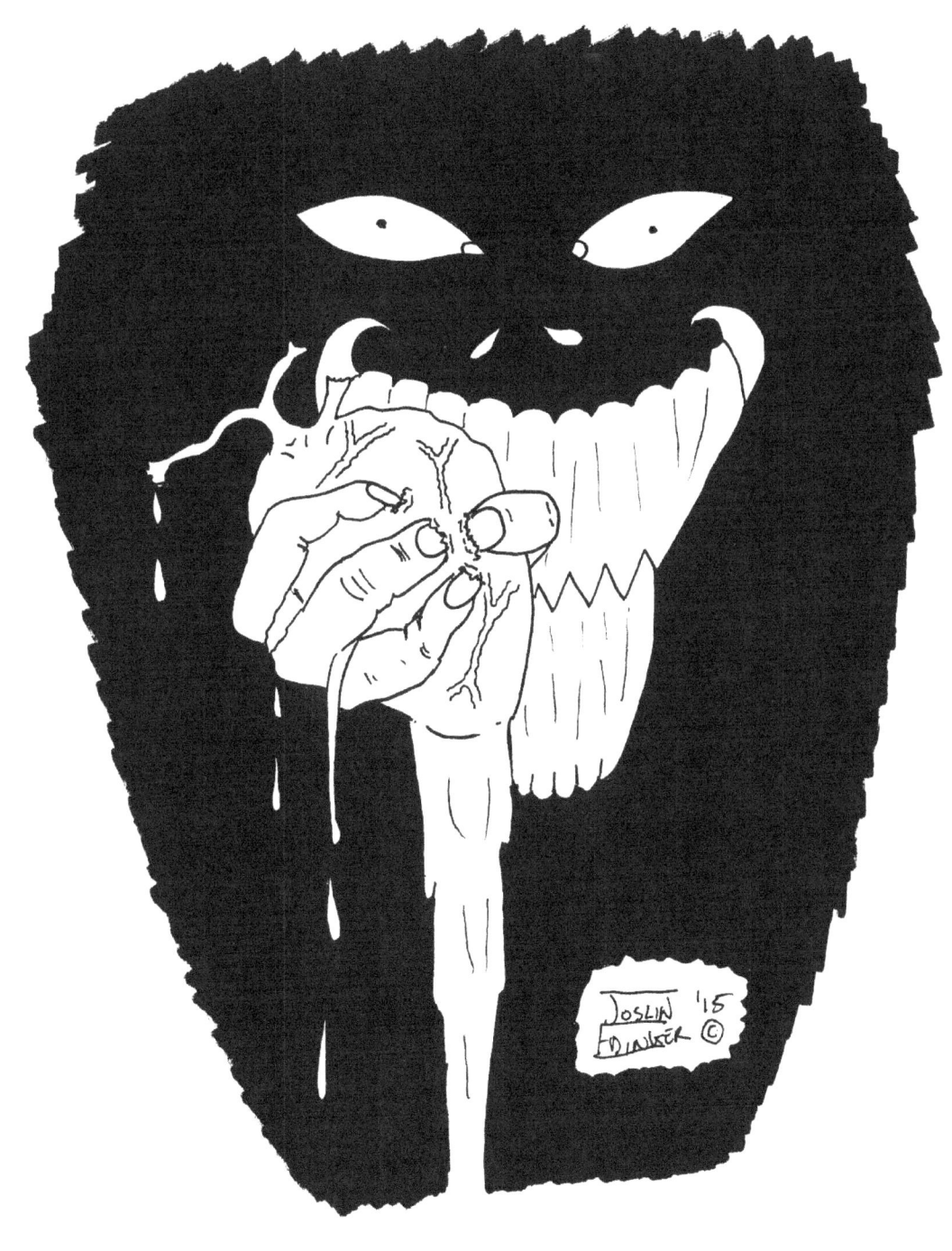

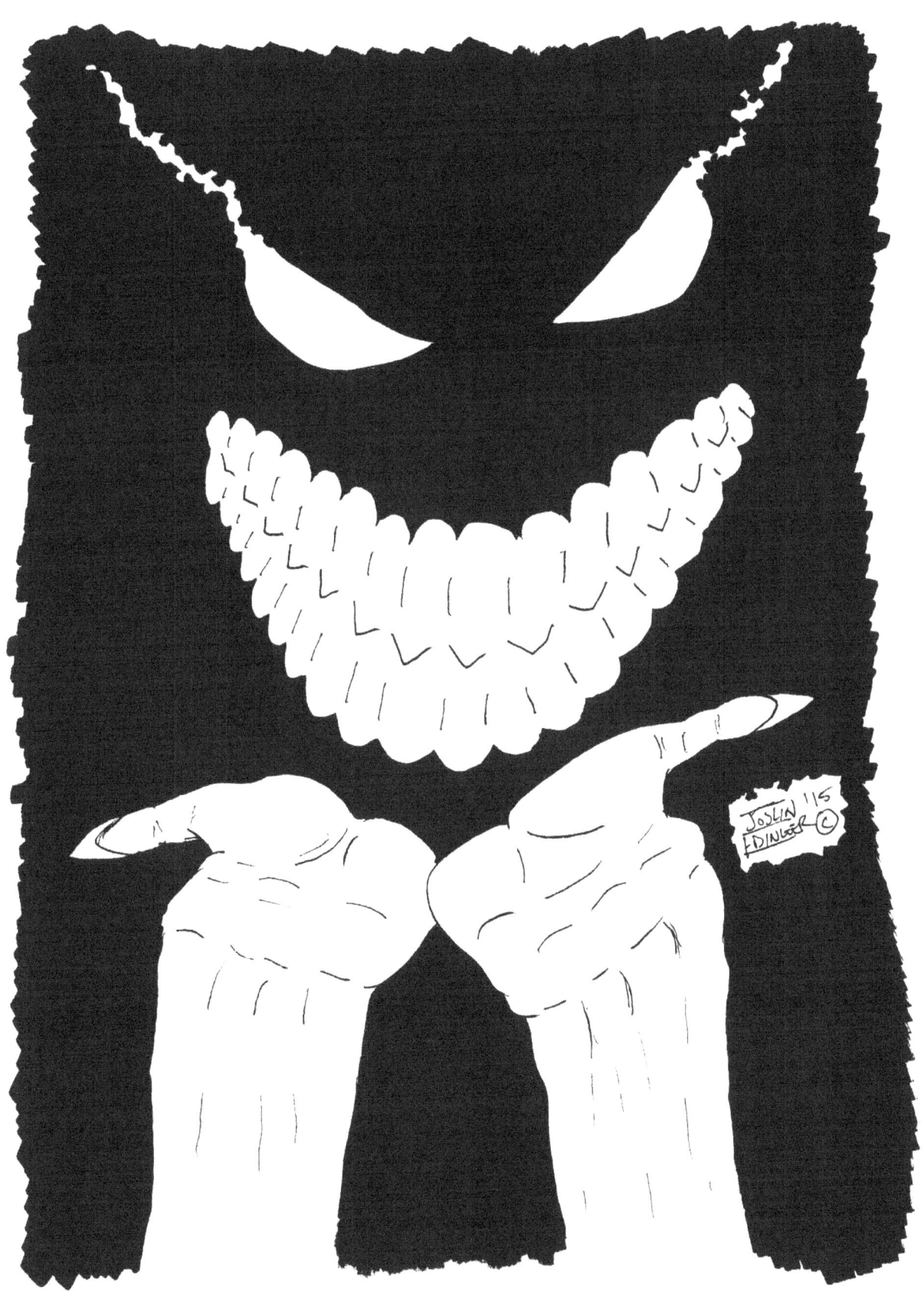

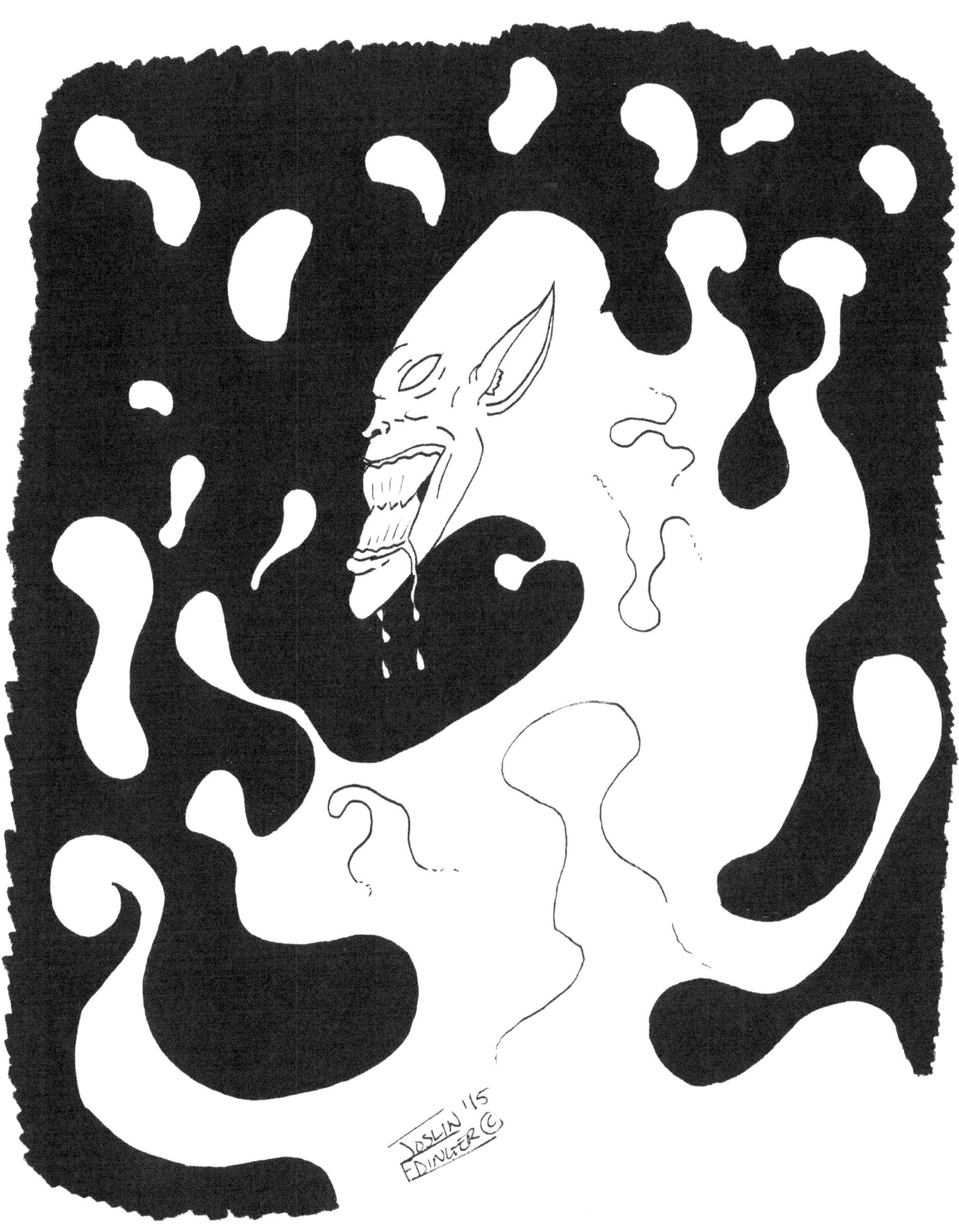

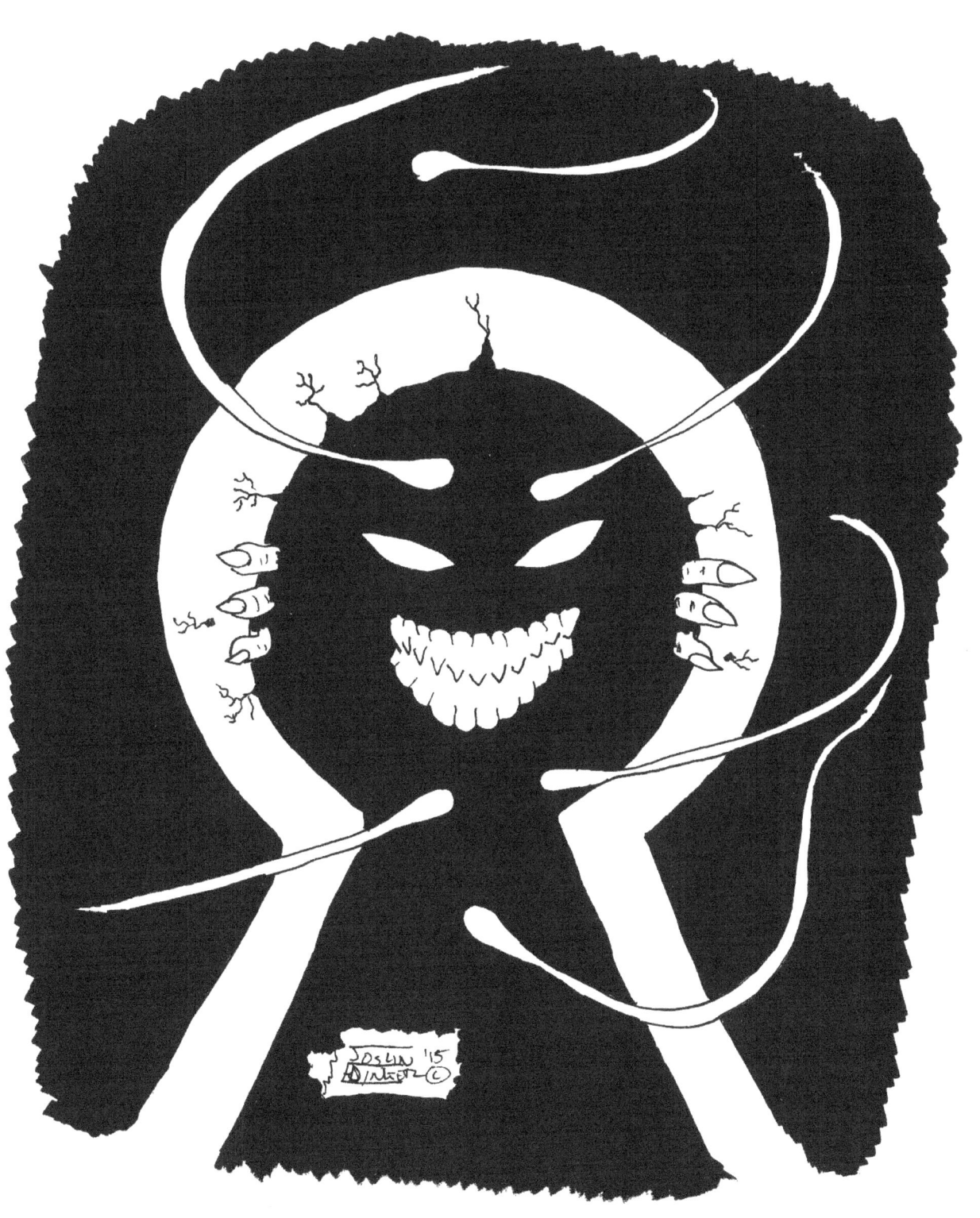

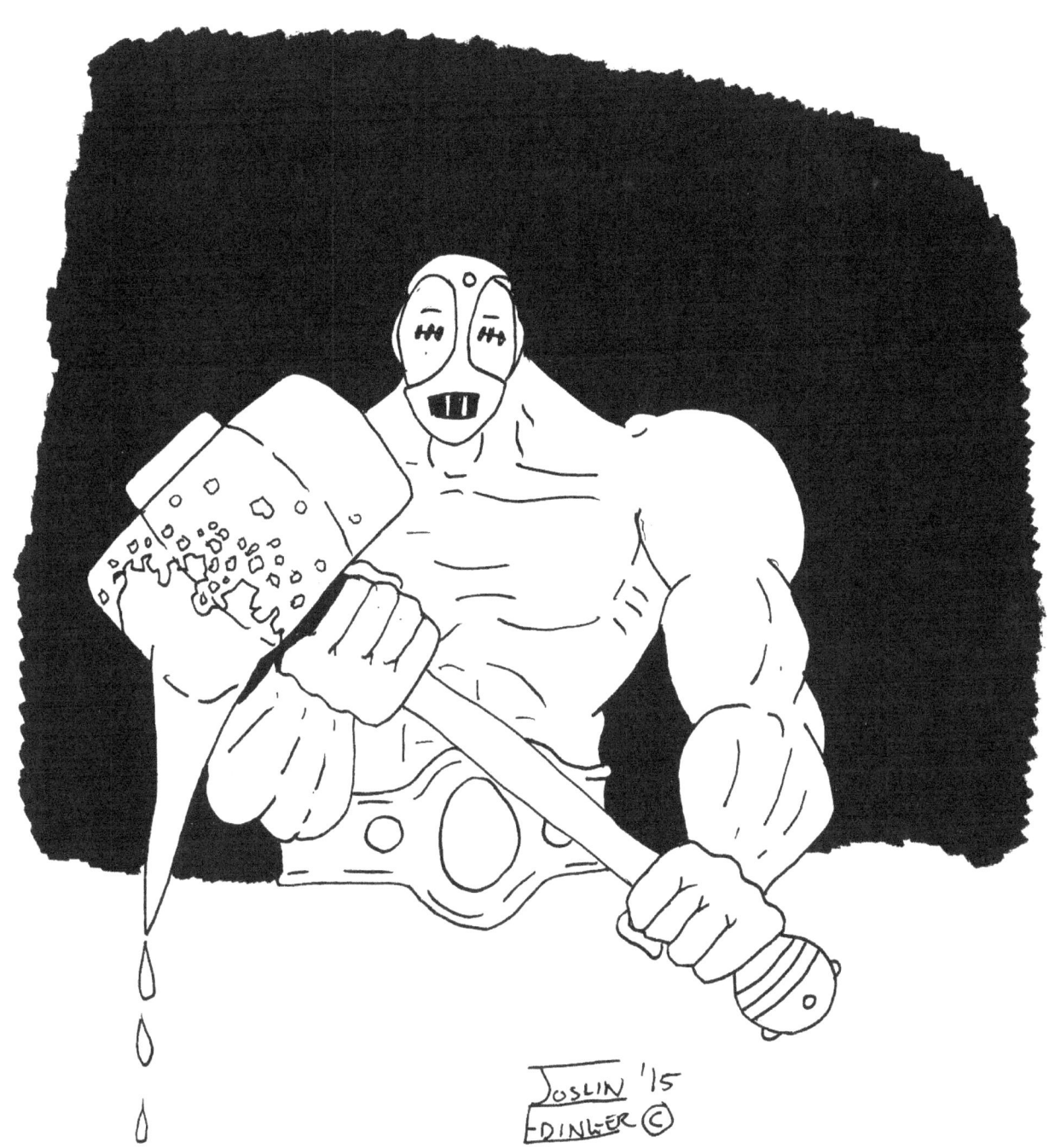

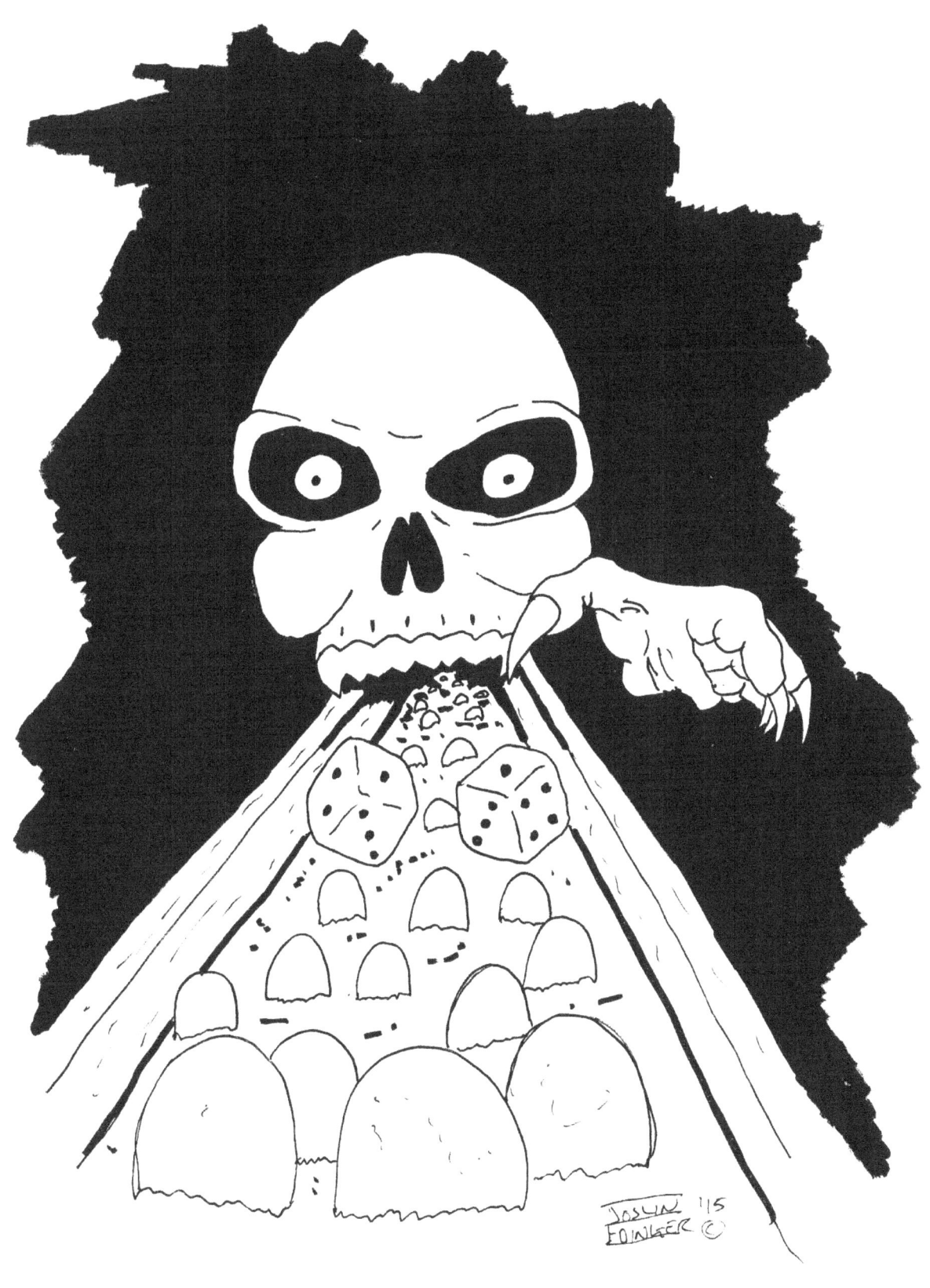

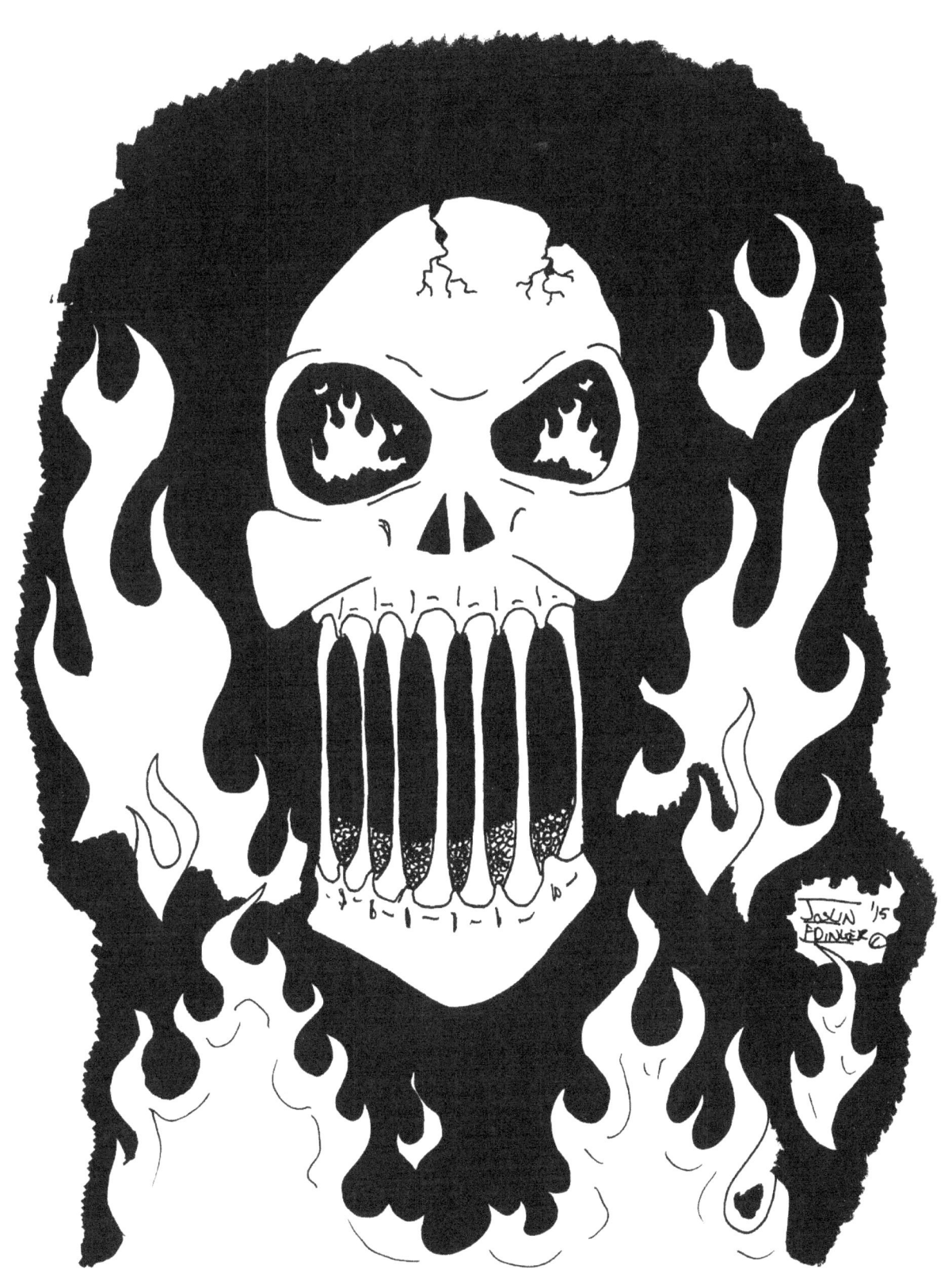

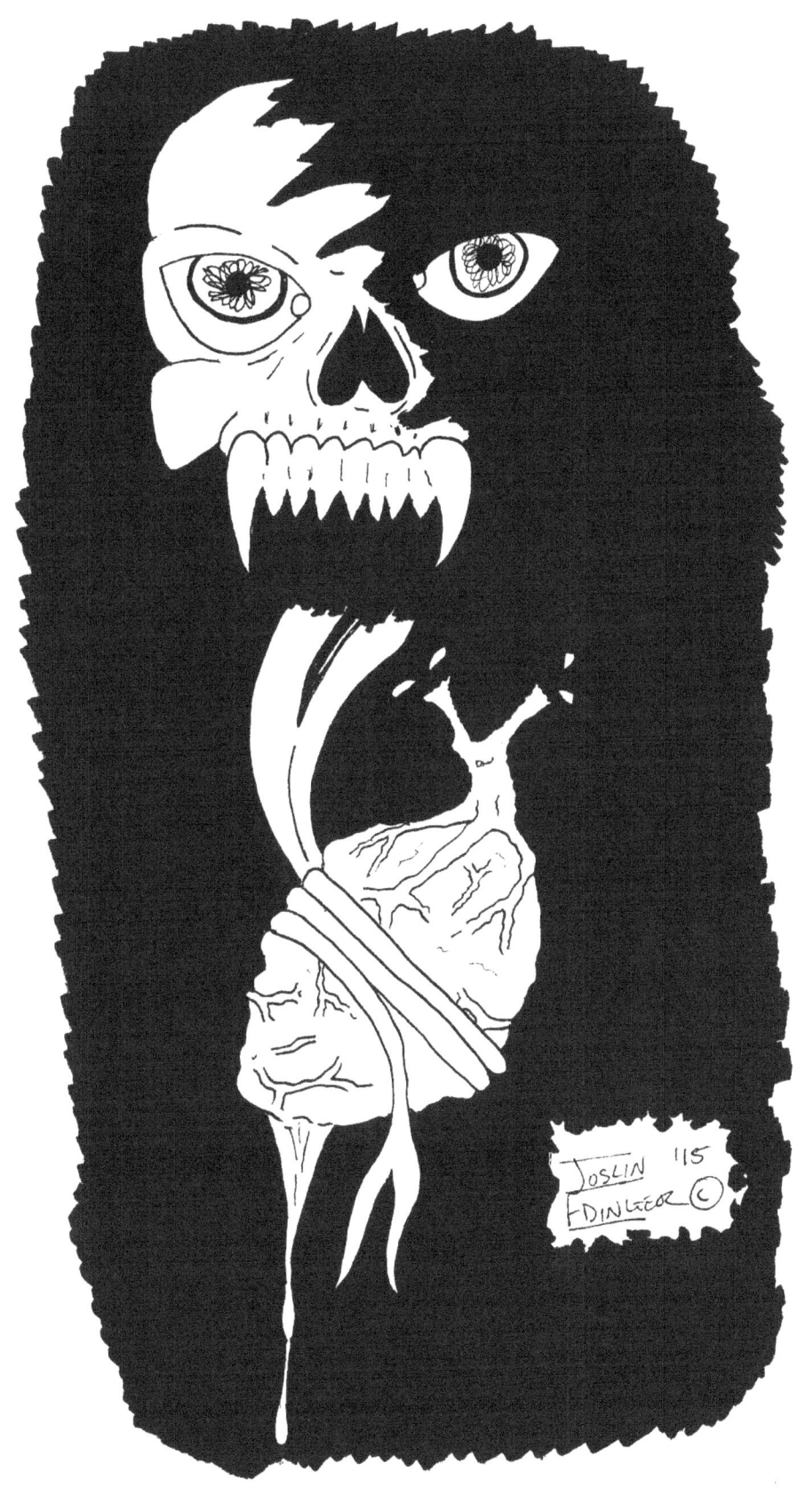

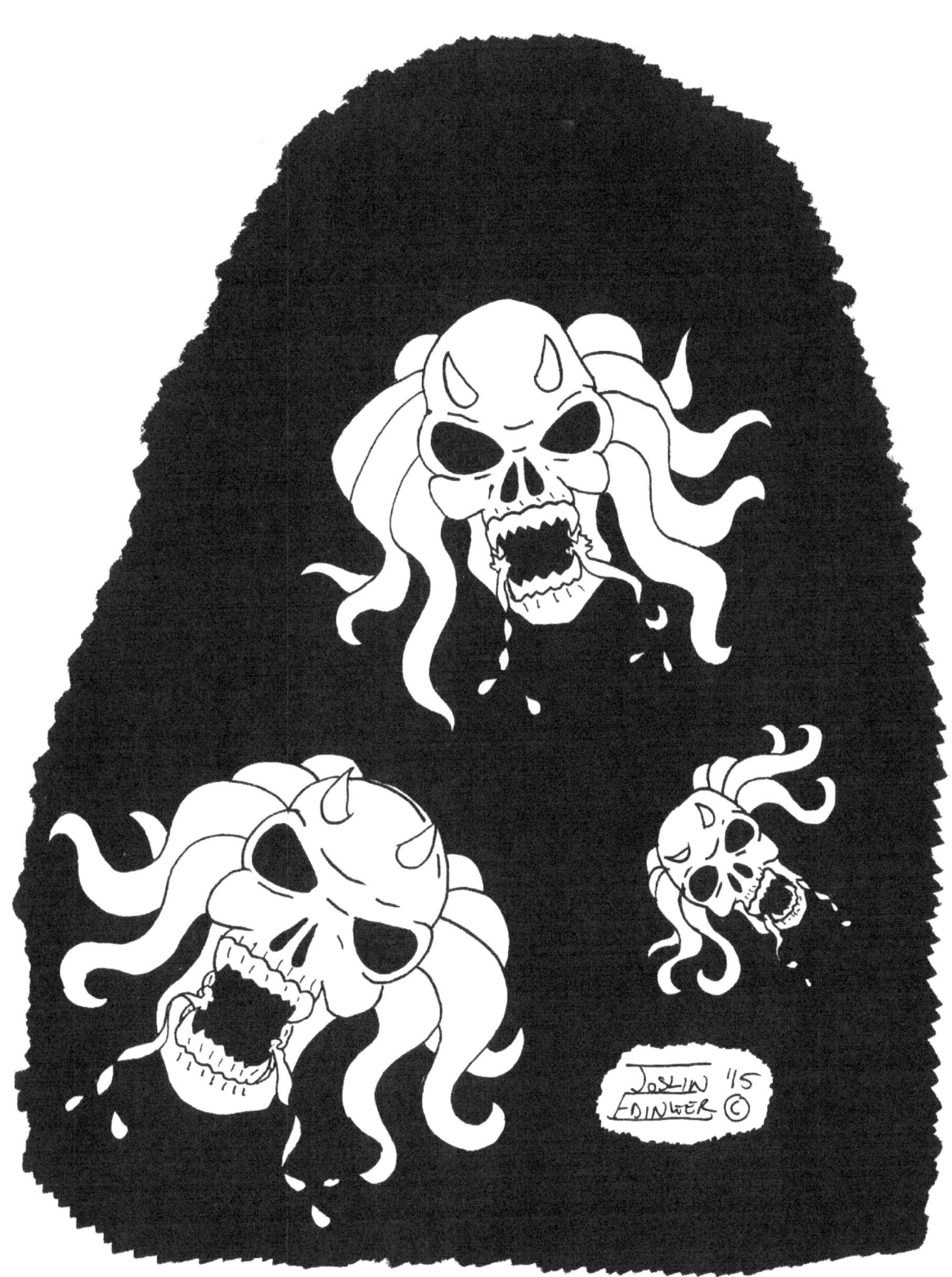

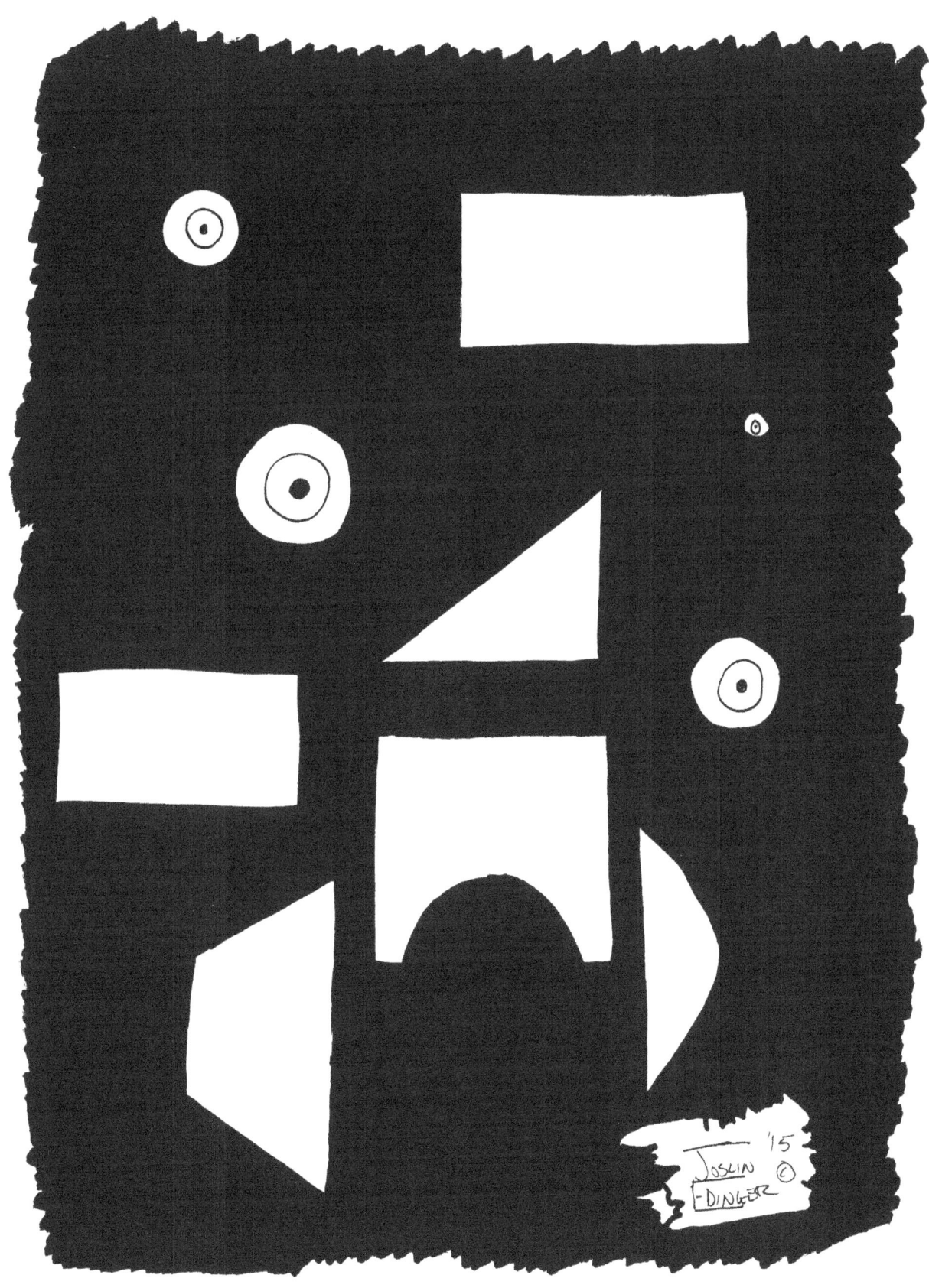

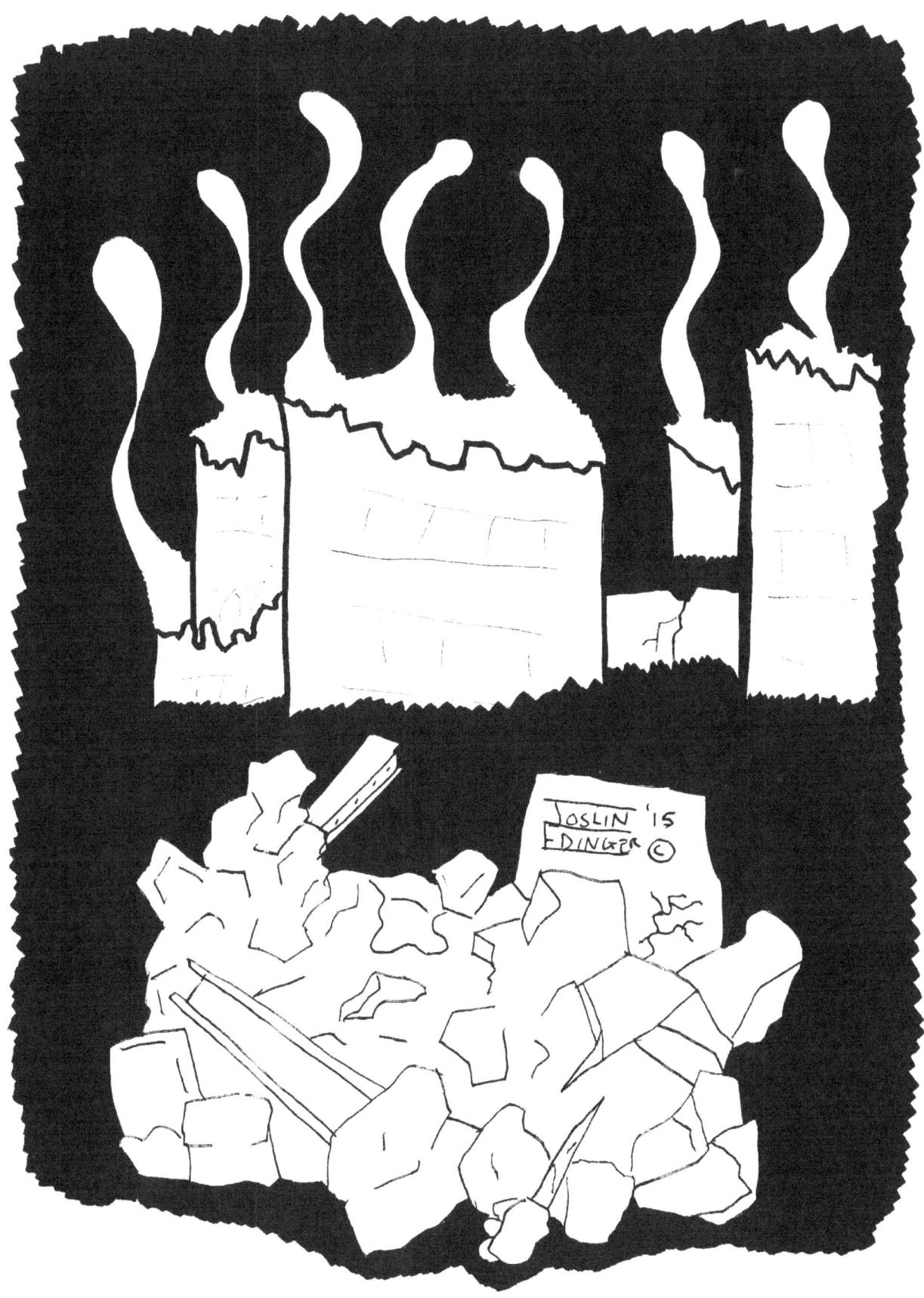

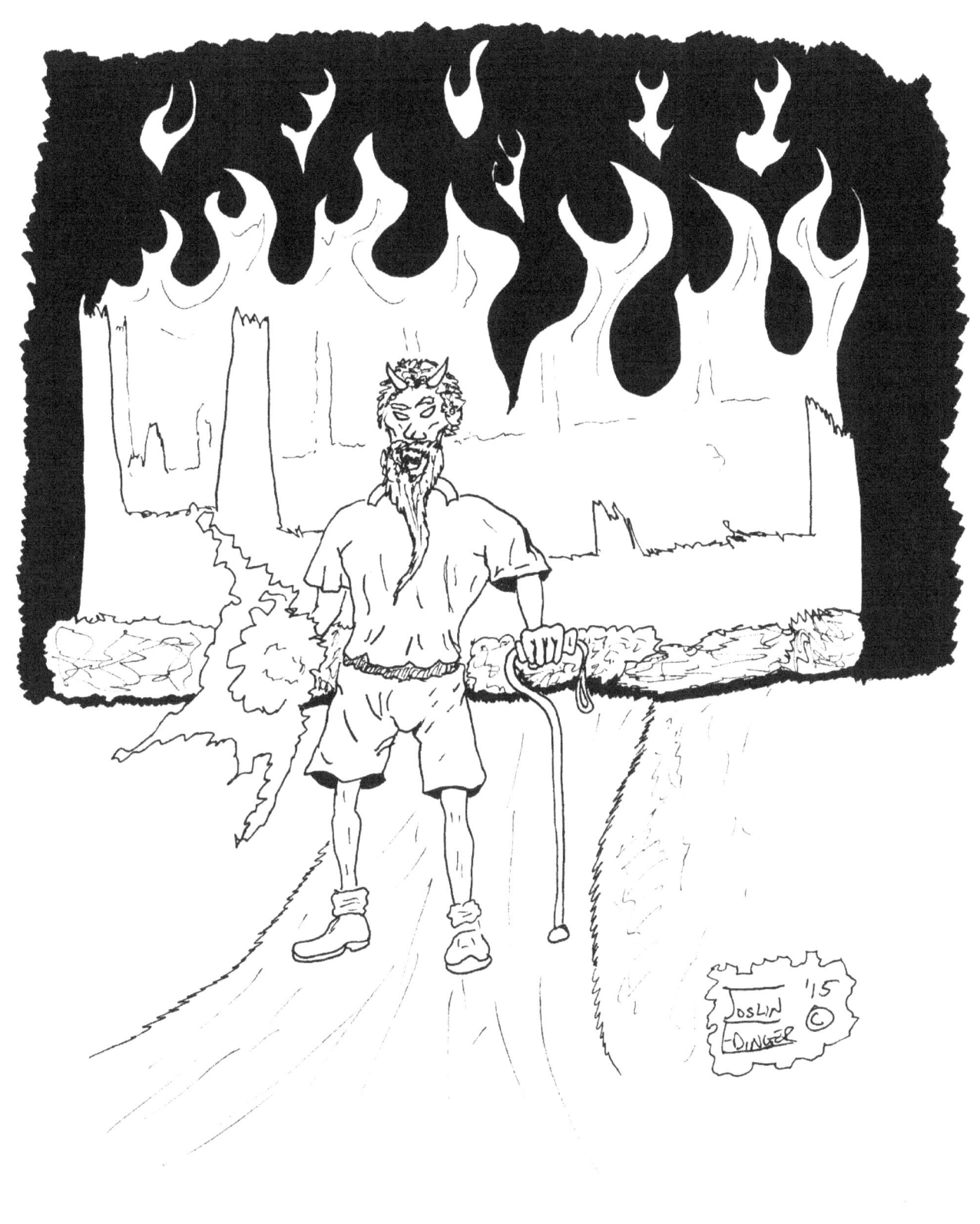

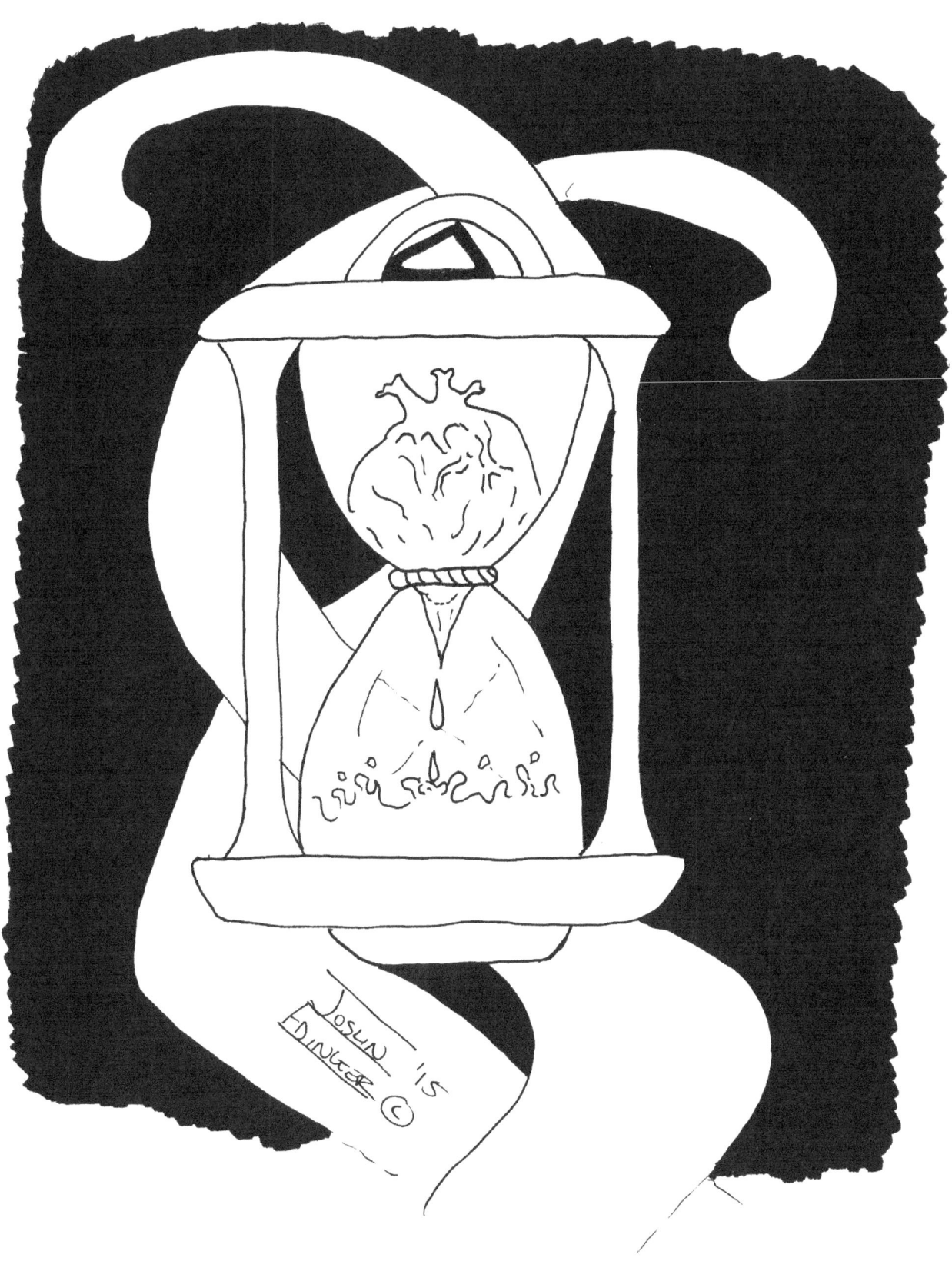

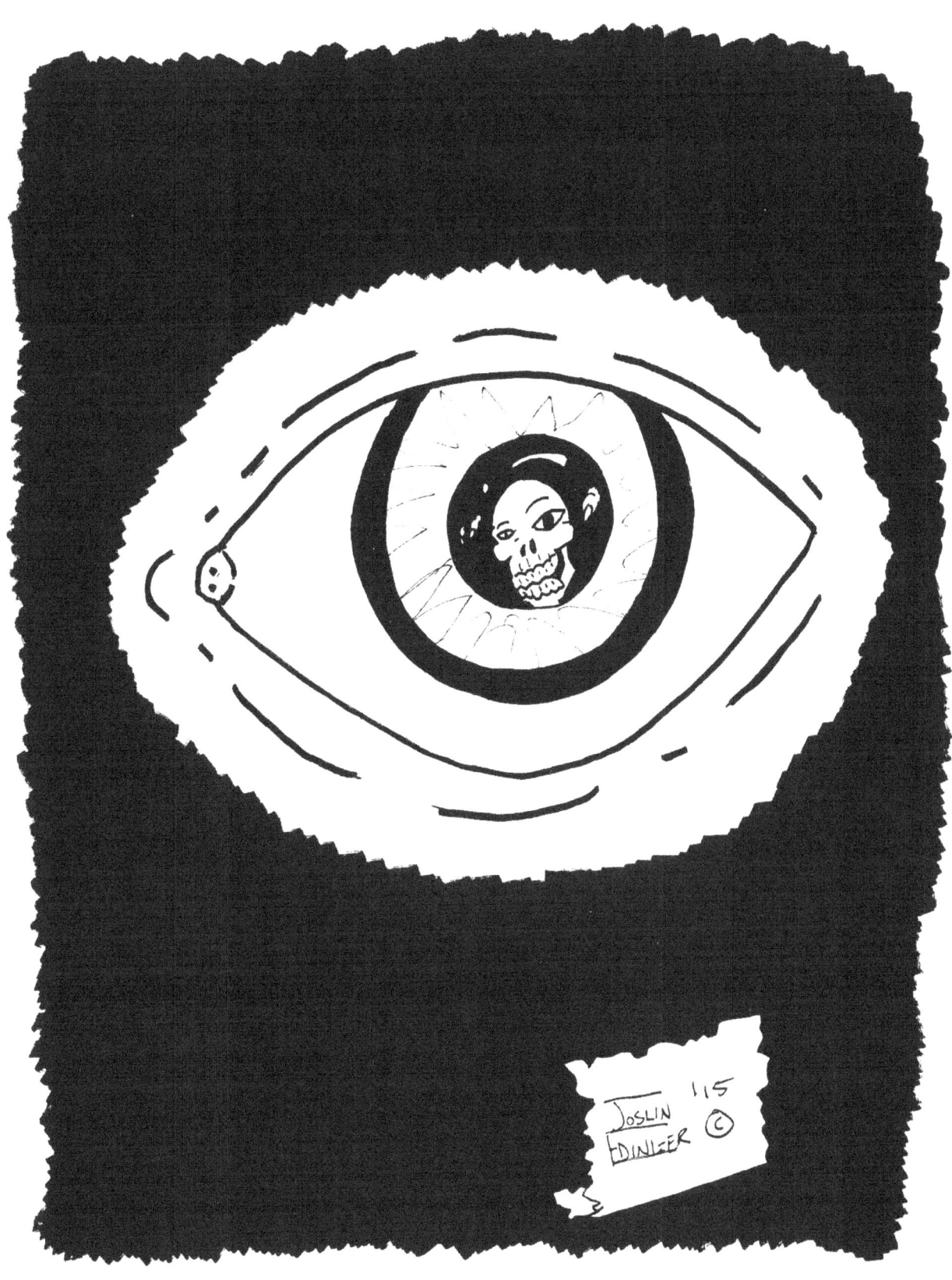

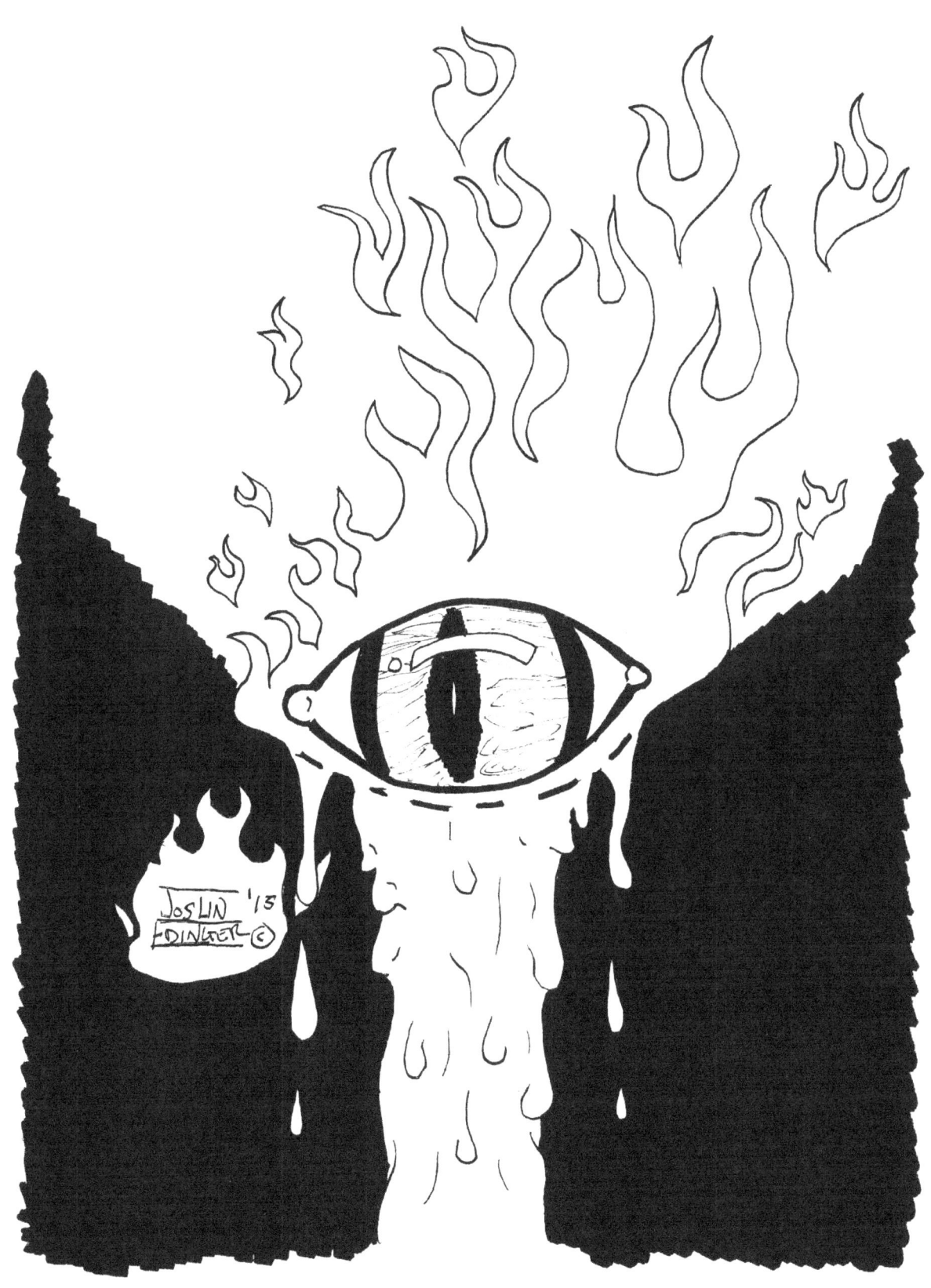

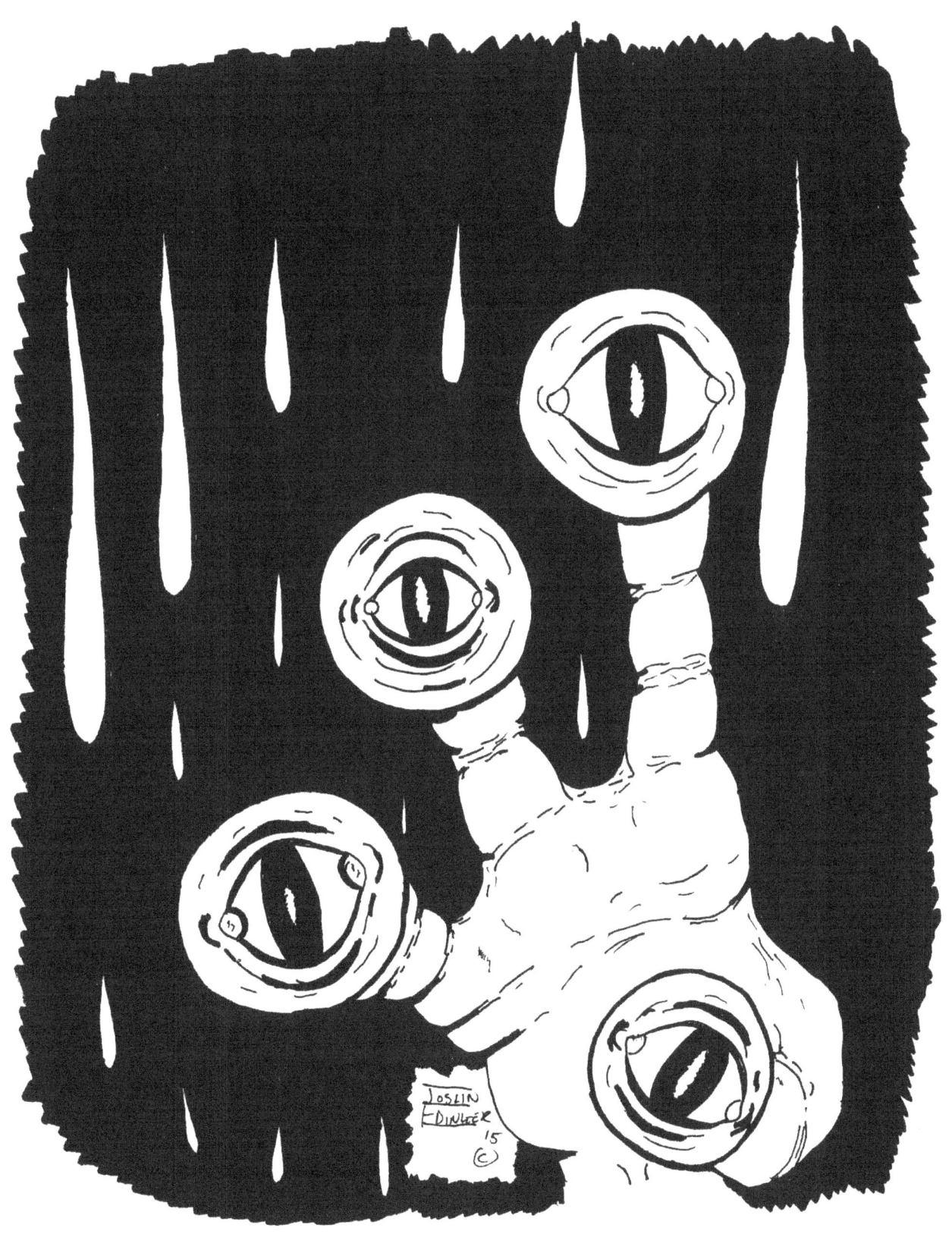

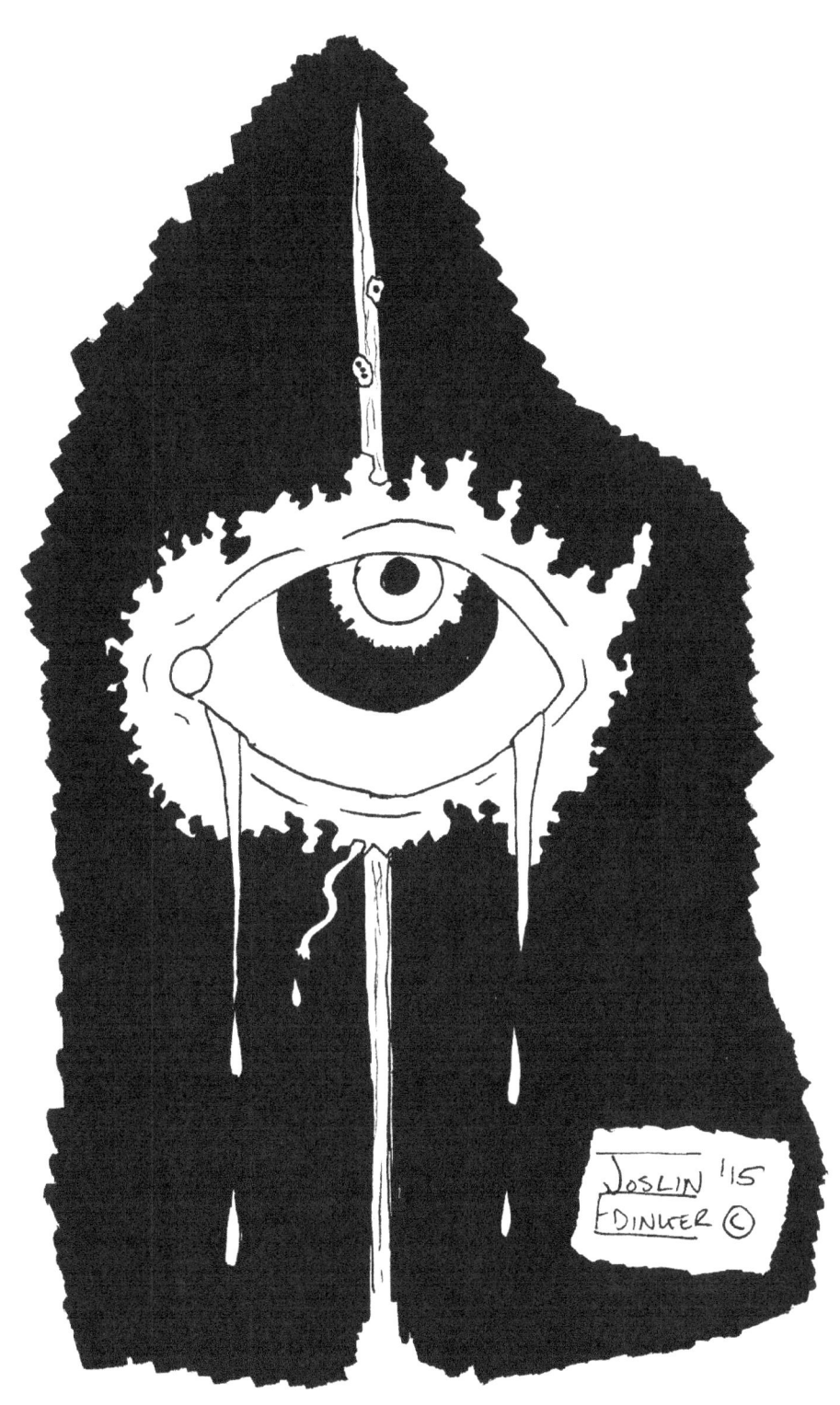

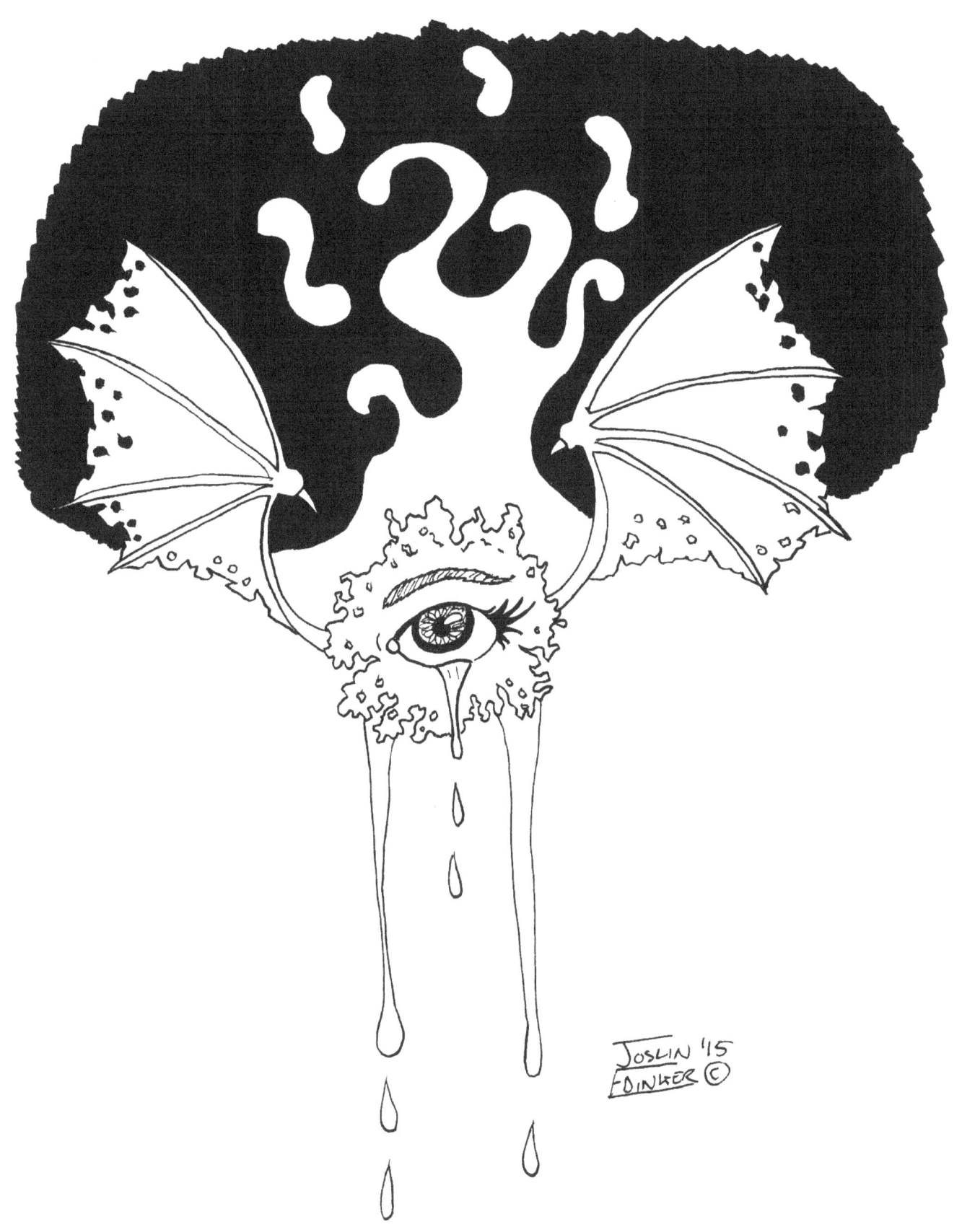

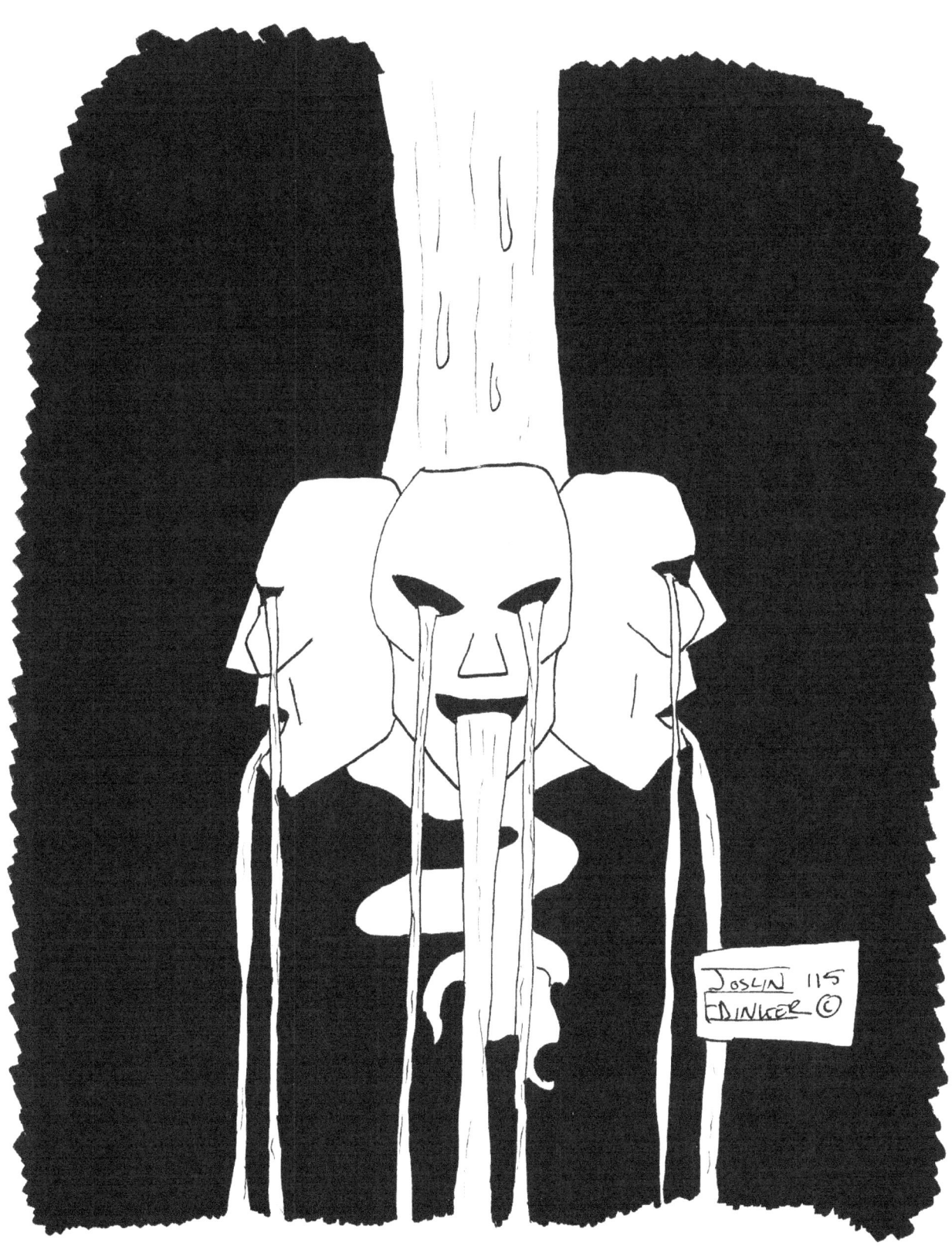

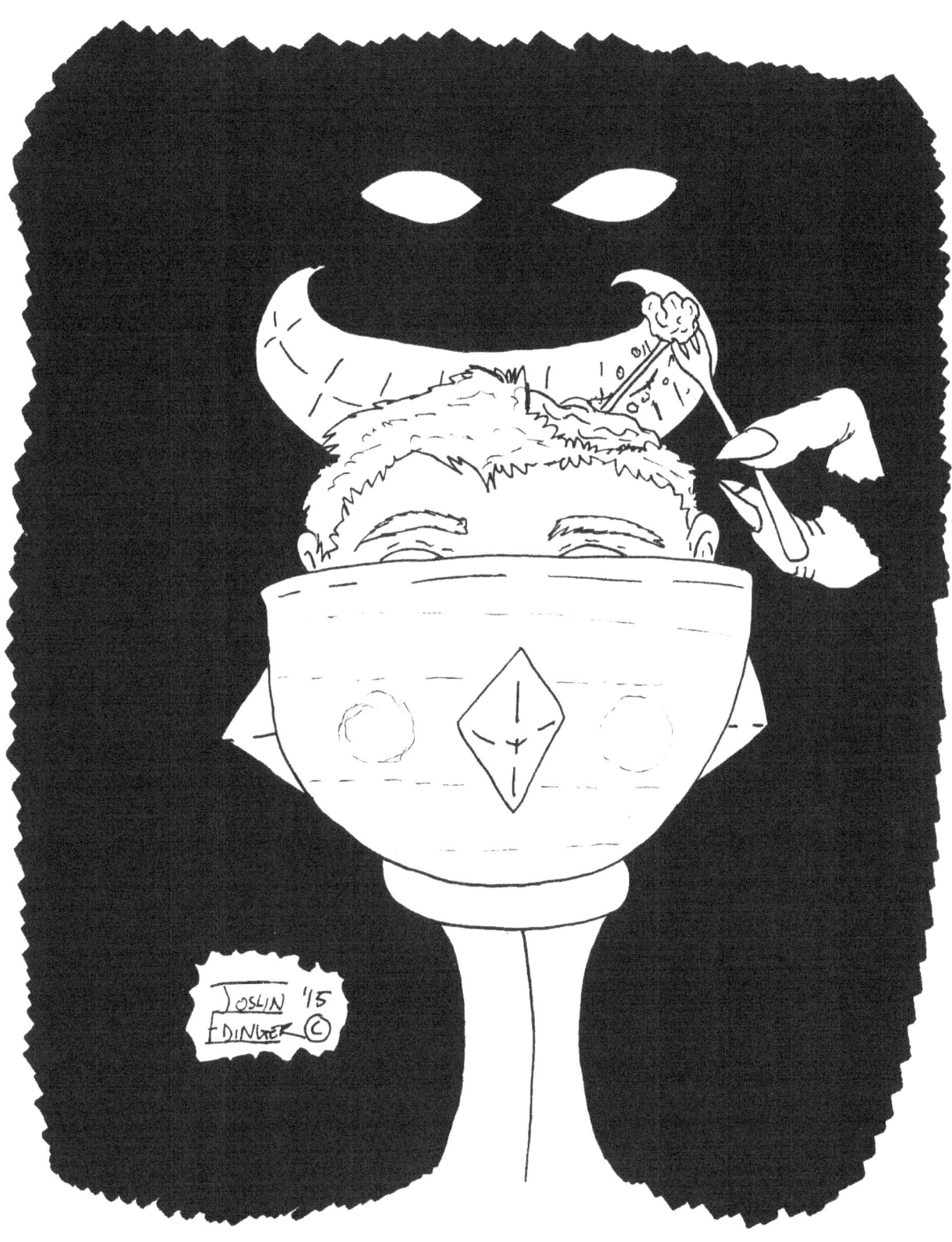

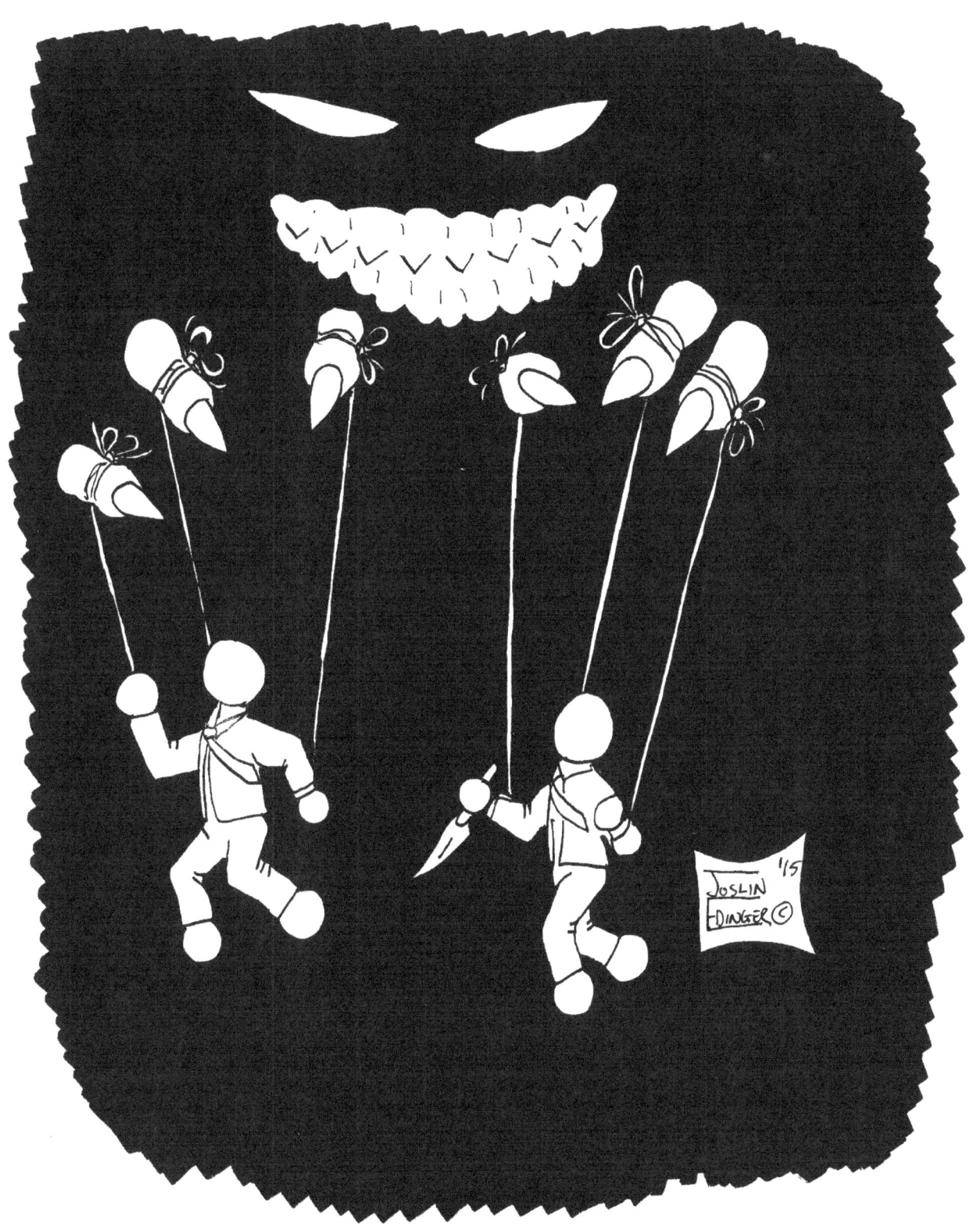

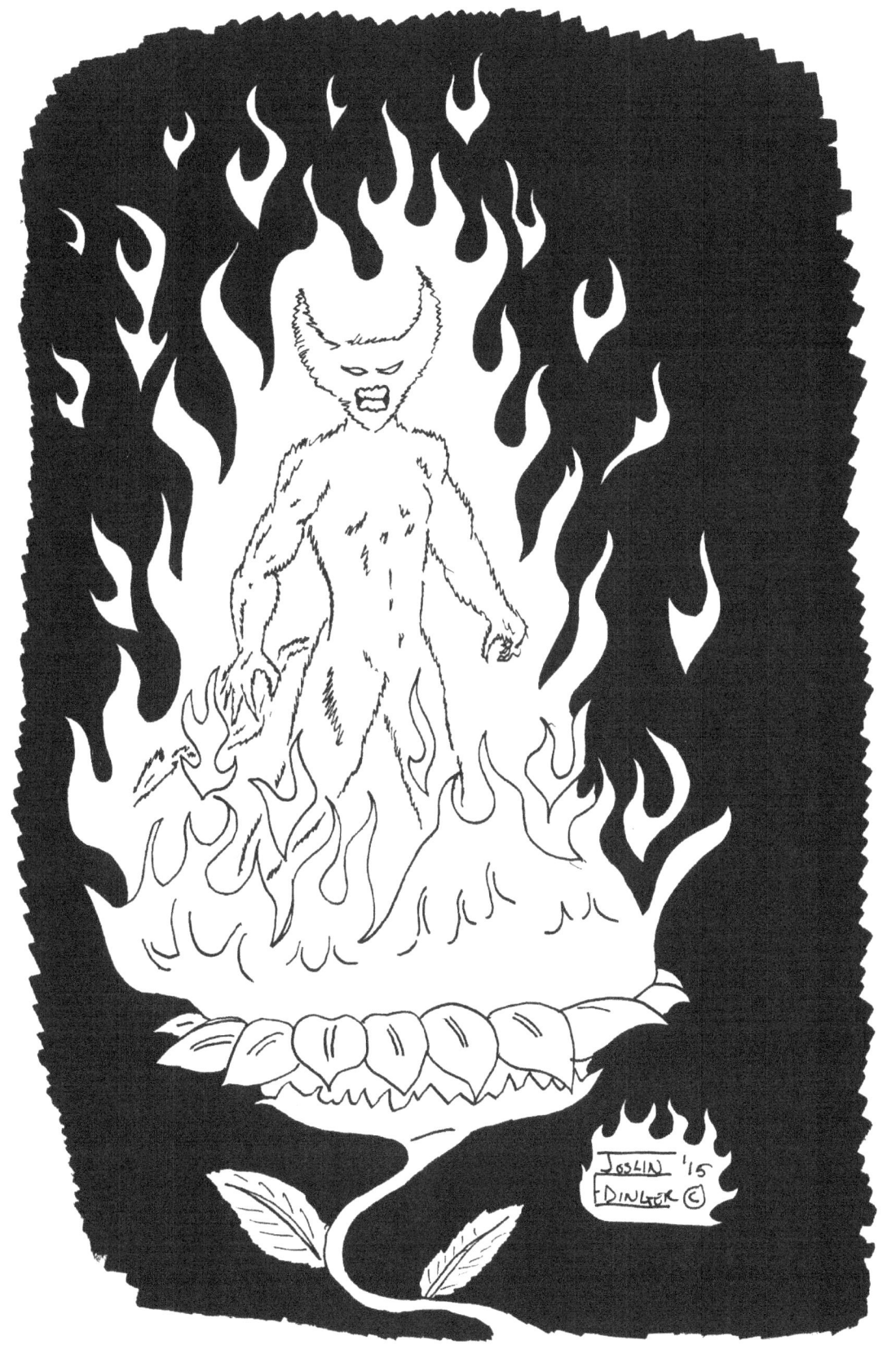

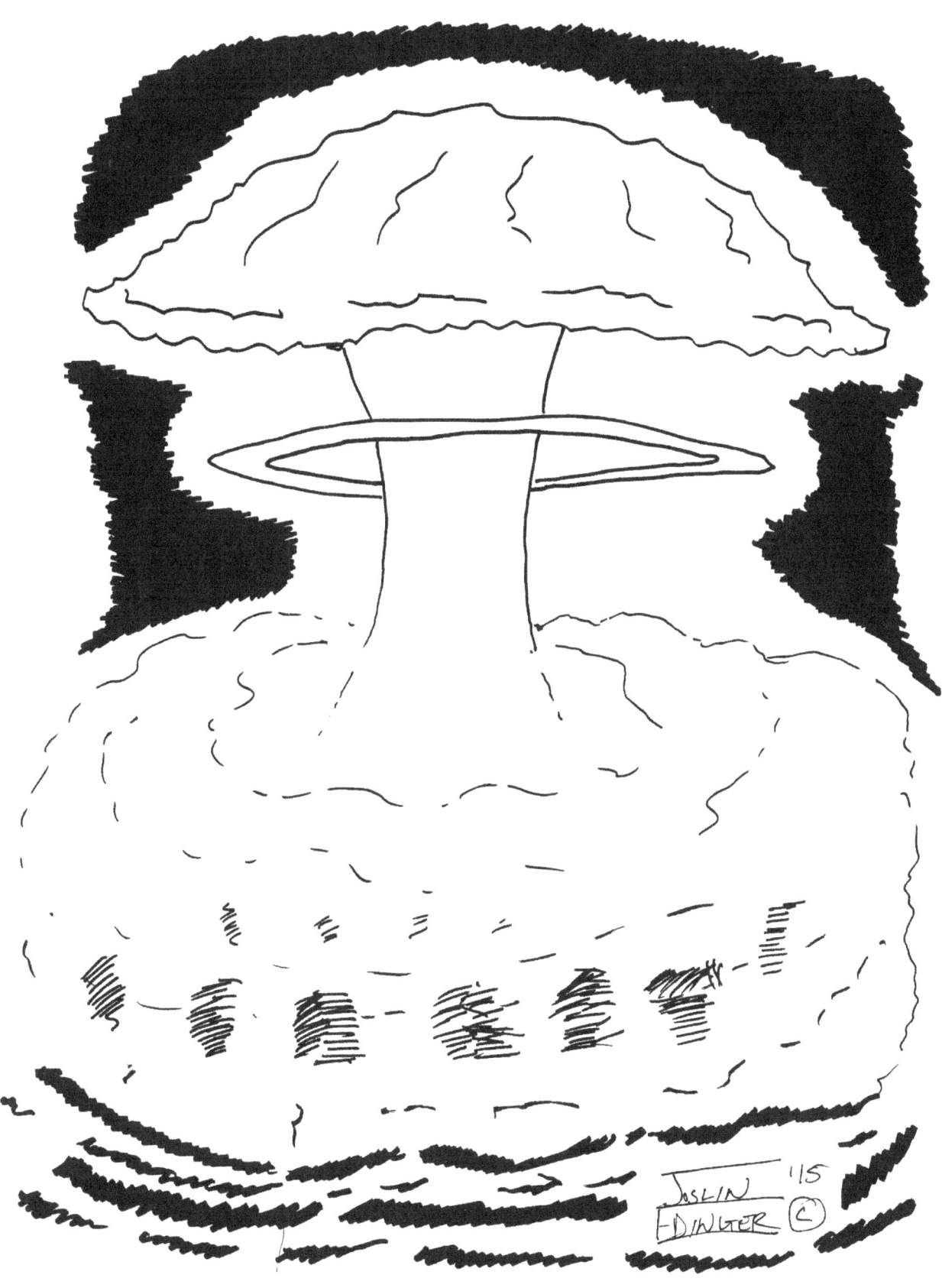

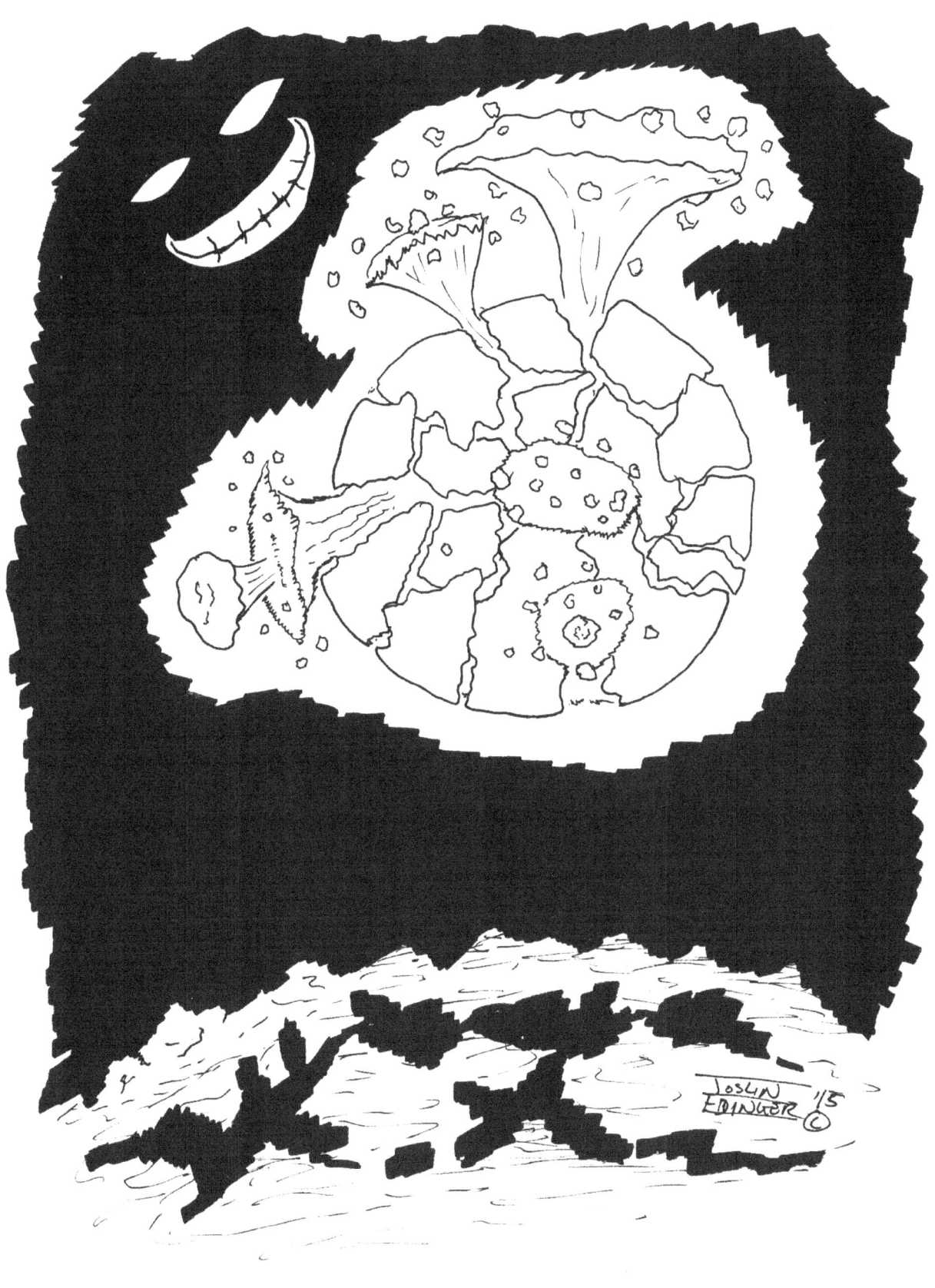

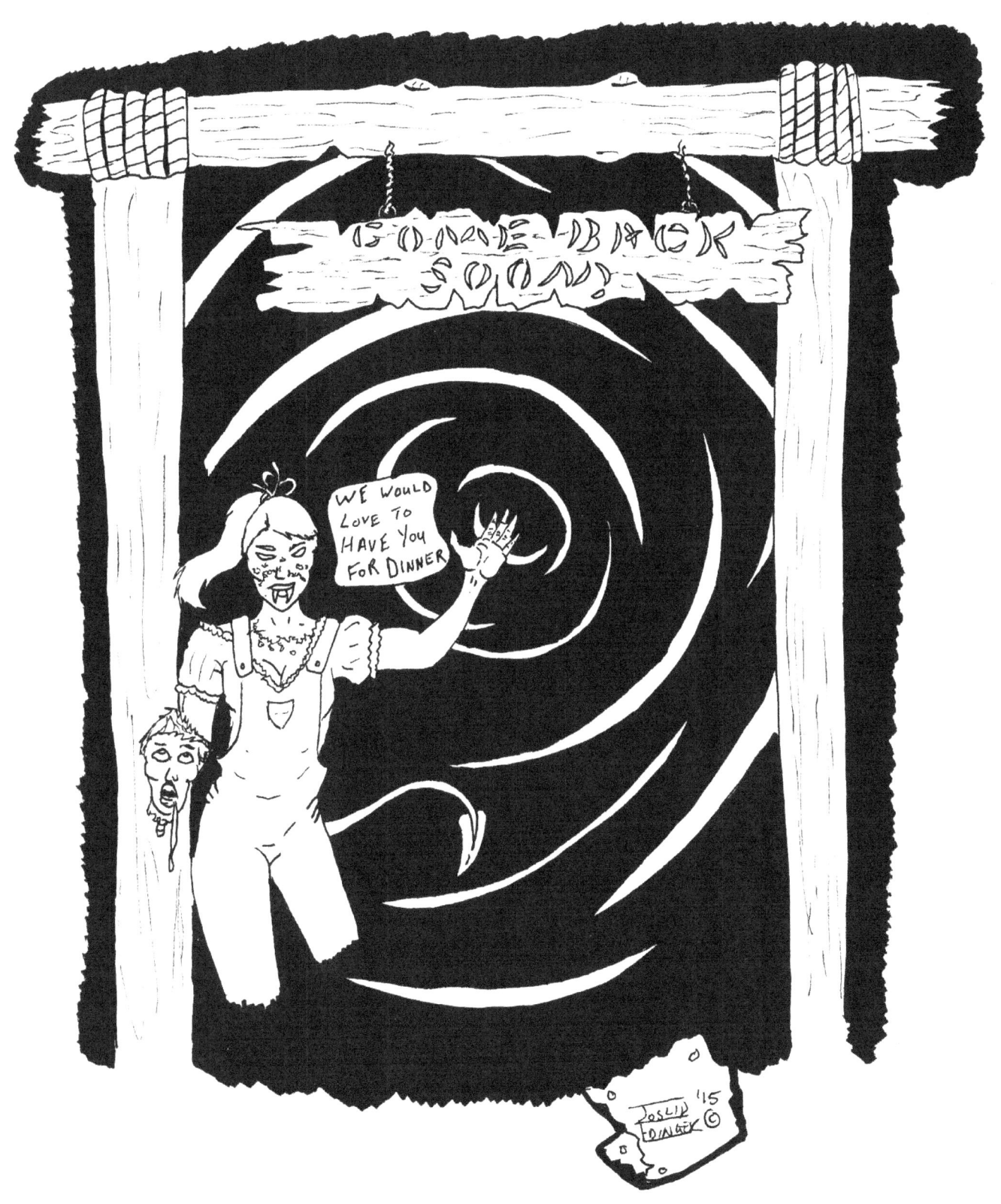

www.ingramcontent.com/pod-product-compliance
Lightning Source LLC
Chambersburg PA
CBHW080654190526
45169CB00006B/2114